T0313673

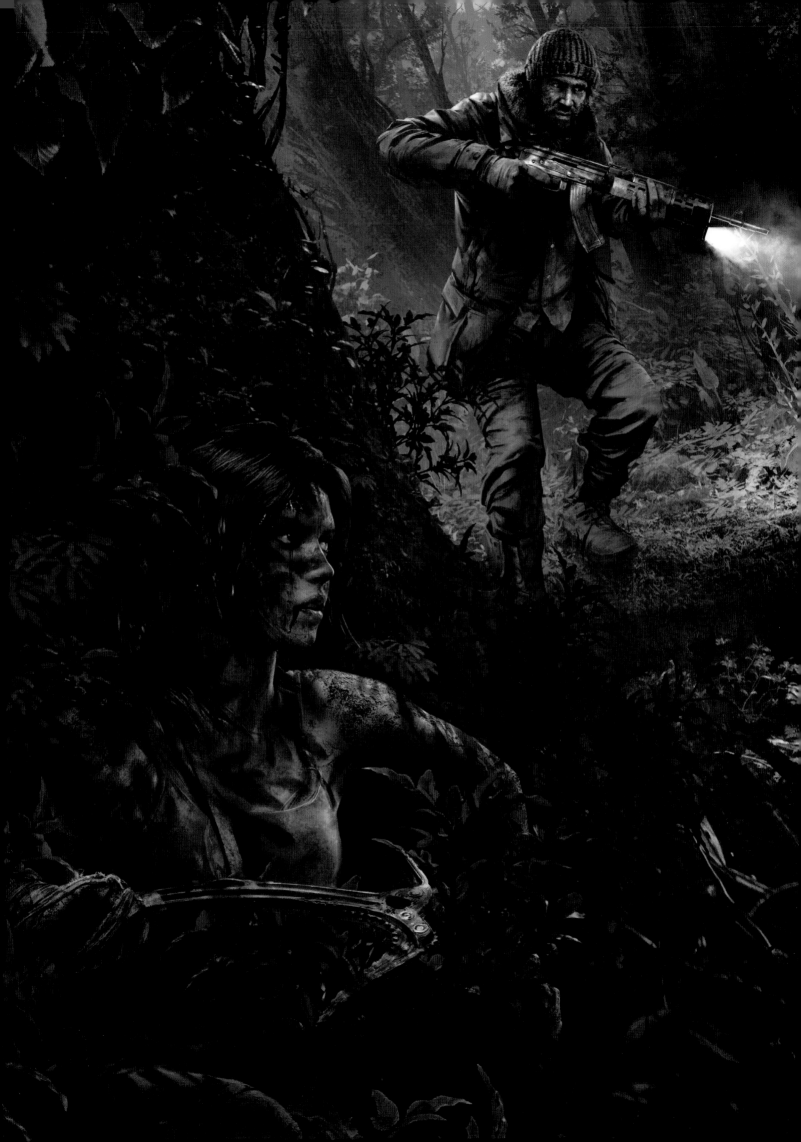

PREVIOUS PAGE: Art by Mark Castanon
THIS SPREAD: Art by Brenoch Adams

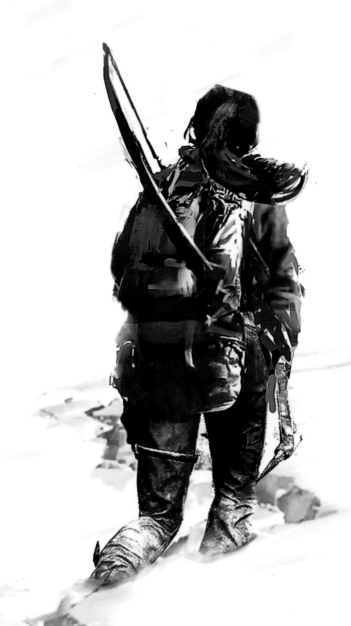

ISBN: 9781783299966
Titan Limited Edition ISBN: 9781783299973
ThinkGeek Limited Edition ISBN: 9781785651540

Published by Titan Books
A division of Titan Publishing Group Ltd.
144 Southwark St.
London
SE1 0UP

First edition: November 2015
10 9 8 7 6 5 4 3 2 1

RISE OF THE TOMB RAIDER © 2015 Square Enix Ltd.
All rights reserved.
RISE OF THE TOMB RAIDER, TOMB RAIDER, CRYSTAL
DYNAMICS, the CRYSTAL DYNAMICS logo, EIDOS, the EIDOS
logo and LARA CROFT are registered trademarks or trade-
marks of Square Enix, Ltd. SQUARE ENIX and the SQUARE
ENIX logo are registered trademarks or trademarks of Square
Enix Holdings Co., Ltd.

To receive advance information, news, competitions, and exclusive
offers online, please sign up for the Titan newsletter on our
website: **www.titanbooks.com**

Did you enjoy this book? We love to hear from our readers. Please
e-mail us at: **readerfeedback@titanemail.com** or write to Reader
Feedback at the above address.

No part of this publication may be reproduced, stored in a retrieval
system, or transmitted, in any form or by any means without
the prior written permission of the publisher, nor be otherwise
circulated in any form of binding or cover other than that in which
it is published and without a similar condition being imposed on
the subsequent purchaser.

A CIP catalogue record for this title is available from the British
Library.

Printed and bound in the United States and China.

Book design by **Amazing15.com**

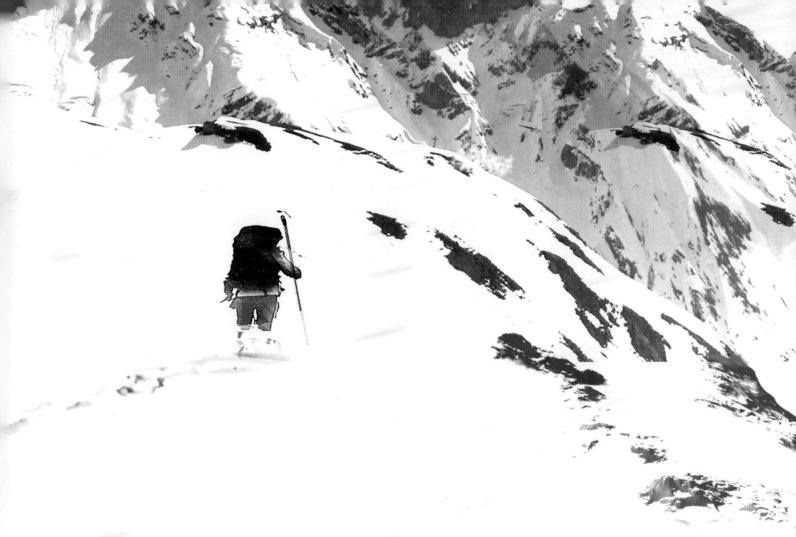

RISE OF THE
TOMB RAIDER®
THE OFFICIAL ART BOOK

ANDY McVITTIE AND PAUL DAVIES

FOREWORD AND INTRODUCTION BY
BRENOCH ADAMS, BRIAN HORTON,
AND NOAH HUGHES

TITAN BOOKS

CONTENTS

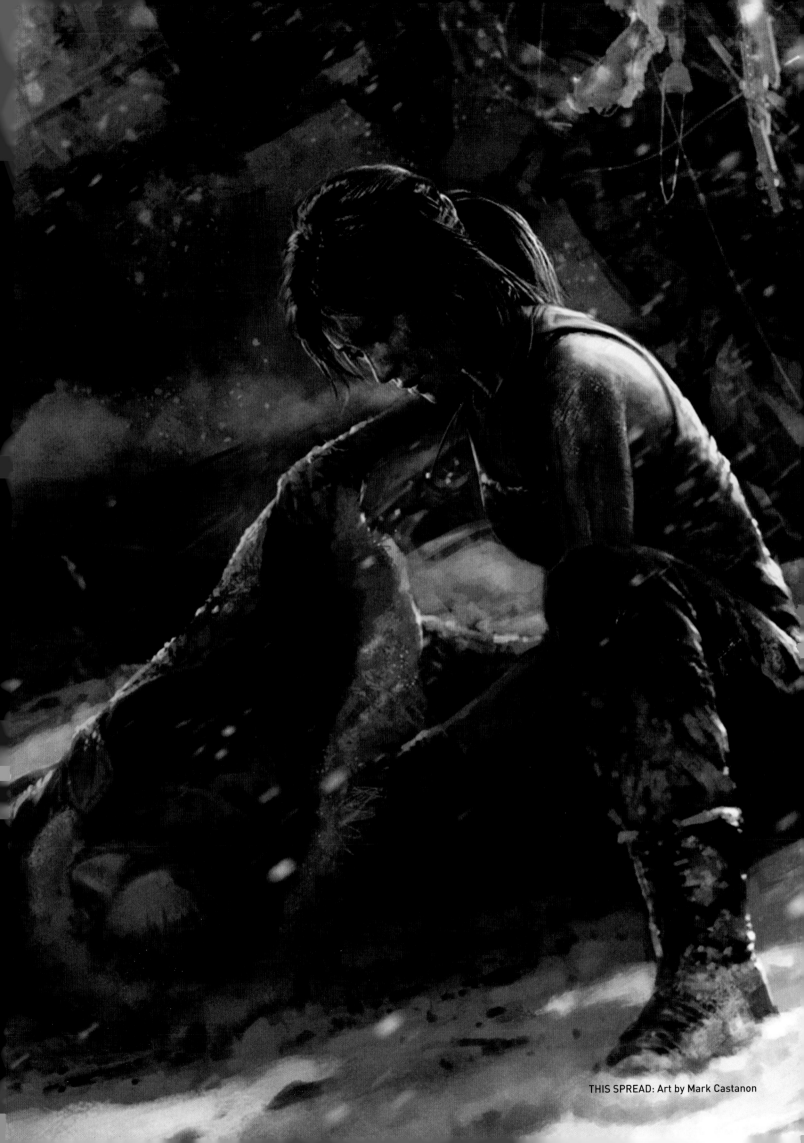

THIS SPREAD: Art by Mark Castanon

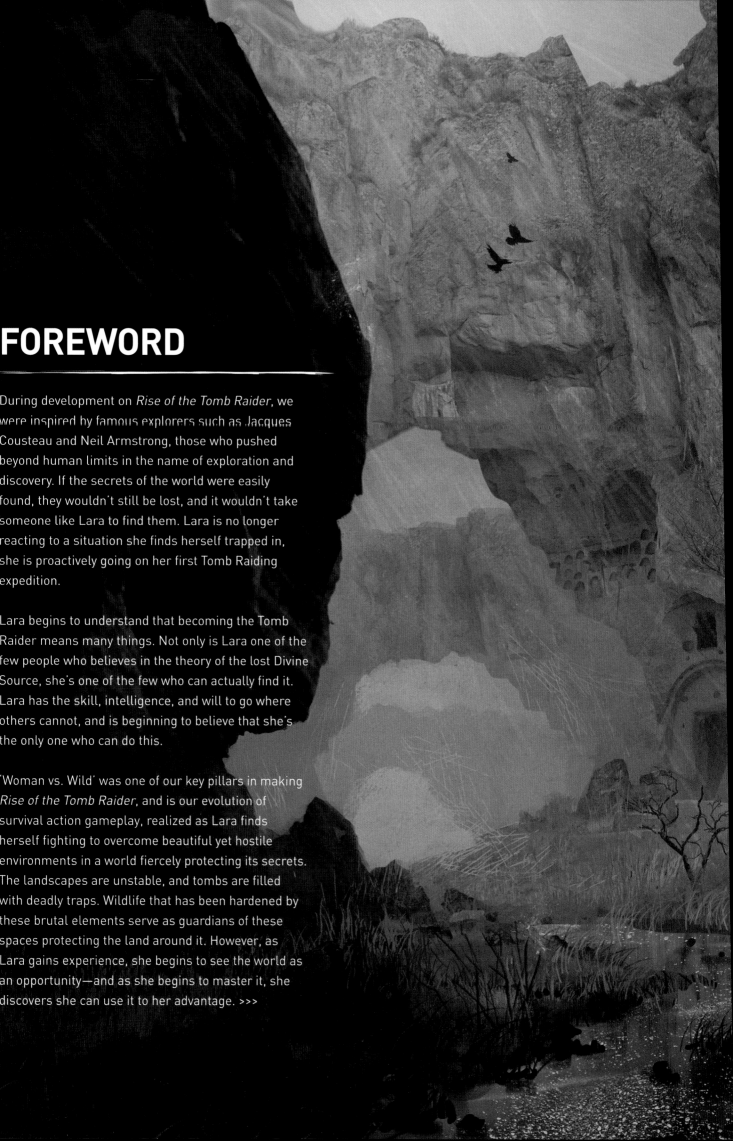

FOREWORD

During development on *Rise of the Tomb Raider*, we were inspired by famous explorers such as Jacques Cousteau and Neil Armstrong, those who pushed beyond human limits in the name of exploration and discovery. If the secrets of the world were easily found, they wouldn't still be lost, and it wouldn't take someone like Lara to find them. Lara is no longer reacting to a situation she finds herself trapped in, she is proactively going on her first Tomb Raiding expedition.

Lara begins to understand that becoming the Tomb Raider means many things. Not only is Lara one of the few people who believes in the theory of the lost Divine Source, she's one of the few who can actually find it. Lara has the skill, intelligence, and will to go where others cannot, and is beginning to believe that she's the only one who can do this.

'Woman vs. Wild' was one of our key pillars in making *Rise of the Tomb Raider*, and is our evolution of survival action gameplay, realized as Lara finds herself fighting to overcome beautiful yet hostile environments in a world fiercely protecting its secrets. The landscapes are unstable, and tombs are filled with deadly traps. Wildlife that has been hardened by these brutal elements serve as guardians of these spaces protecting the land around it. However, as Lara gains experience, she begins to see the world as an opportunity—and as she begins to master it, she discovers she can use it to her advantage. >>>

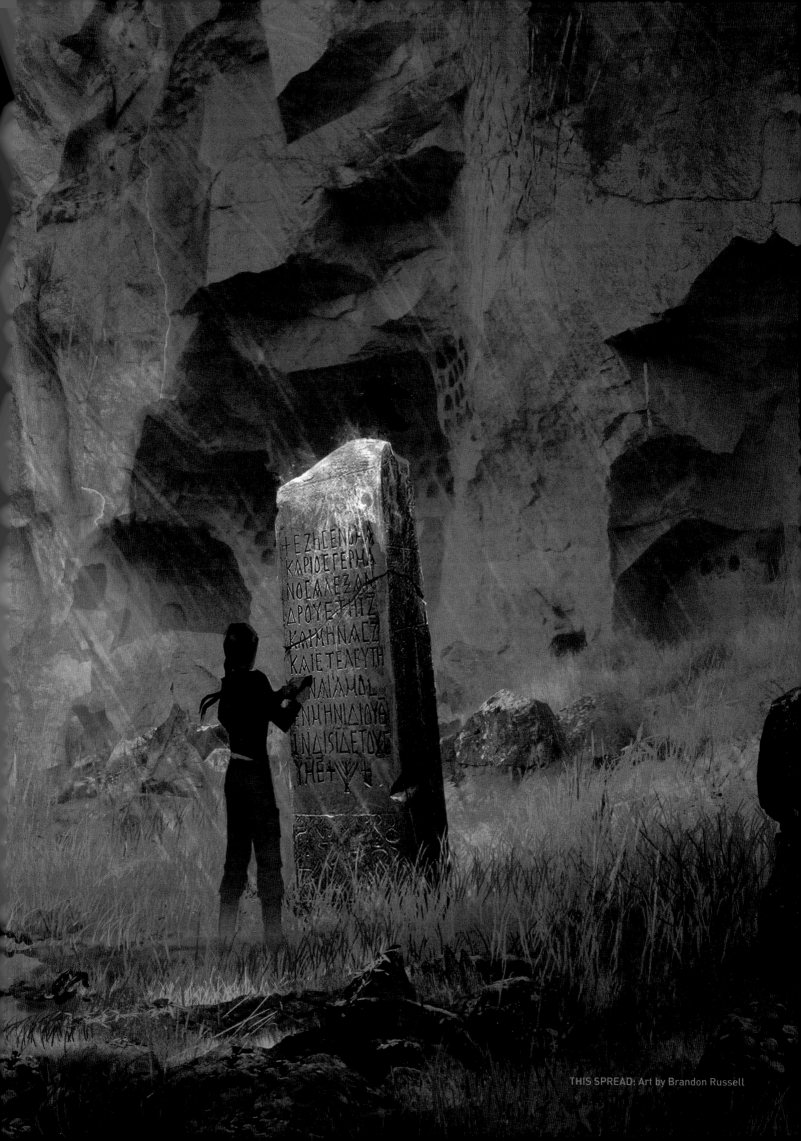

THIS SPREAD: Art by Brandon Russell

THIS SPREAD: Art by Brenoch Adams

"... we wanted to put the 'Tomb' back in *Tomb Raider*."

Lara needs to be smart and resourceful and utilize her survivalist toolkit to stay alive. She can hunt animals and scavenge for rare resources in a densely populated ecosystem, craft and customize makeshift gear and ammo, and tackle side missions to earn powerful and exotic items.

Lara knows that she's outgunned and outnumbered. She'll need to utilize guerilla combat tactics to even the odds. Players will be able to scale trees and dive underwater to avoid or take down enemies and players can configure Lara's gear, weapons, and ammo to suit their style.

Last but not least, we wanted to put the 'Tomb' back in *Tomb Raider*. We were really excited to take Lara on her first proactive Tomb Raiding expedition, and we know from listening to fans that they're excited to explore with her. These huge ancient spaces are littered with deadly traps, crypts, and dramatic 'nested' environmental puzzles.

This is the next chapter in Lara Croft's origin story, and in it we will see Lara evolve from a Survivor to the Tomb Raider.

Brenoch Adams | ART DIRECTOR
Brian Horton | GAME DIRECTOR
Noah Hughes | FRANCHISE DIRECTOR

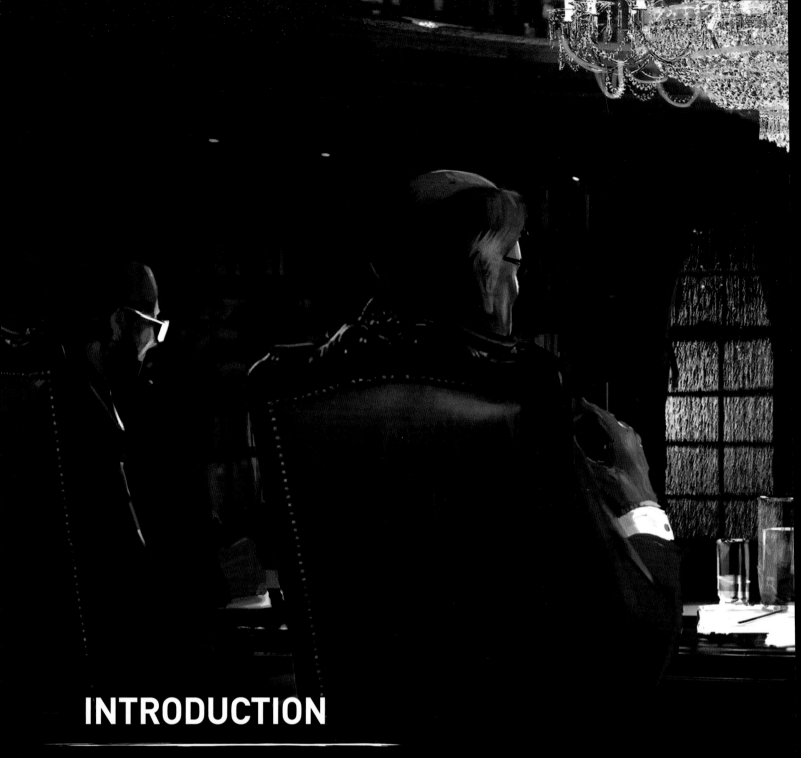

INTRODUCTION

Lara returns to London changed from the events on Yamatai—she is wracked with guilt from the loss of her mentor Roth and many others from the *Endurance*. The archaeological community has rejected her account of the events on the island, and the trust in control of her estate has frozen her assets. What Lara saw opened her eyes to a hidden world, and she is now driven to discover the truth behind it all.

Lara pursues her father's research on the immortal soul, which ultimately leads her to a mountain in remote Siberia where she discovers an ancient lost city. Lara also encounters dangerous new enemies who are intent on finding a hidden secret buried within the city's vast tombs—and they will kill any who stand in their way. Lara must race against time and use all her skills and ingenuity to combat these new foes, survive the harsh elements, and unlock the secret of the lost city of Kitezh before it falls into the wrong hands.

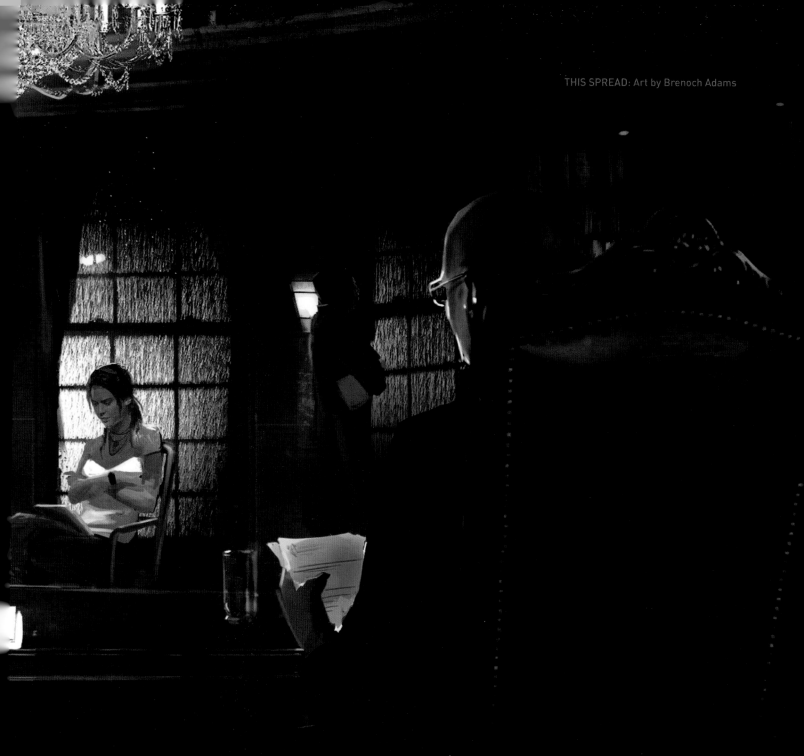

THIS SPREAD: Art by Brenoch Adams

"What makes someone reach beyond the boundaries of human experience—to face the unknown? As children we question the world around us. We learn, we accept and gradually we lose our capacity for wonder. Yet some do not... the explorers, the seekers of truth. It is these pioneers who define the future of mankind."

Lord Richard Croft

CHAPTER 1
CHARACTERS

In *Tomb Raider 2013*, Lara Croft glimpsed something she thought was impossible—proof of the existence of the immortal soul. Now, two years later, she finds herself alone in the world, searching for answers that could help her make sense of what she experienced. She's determined to find the truth—starting with her father's research, she embarks upon a new adventure following in the footsteps of a mysterious, ancient prophet. Lara's certainty that the world contains hidden truths grows with each step. But this time around, she's better equipped to deal with whatever lies ahead. And that, as art director Brenoch Adams explains, is a crucial consideration: "We're always looking for grounded realism and plausibility. If Lara is in an environment where she's cold we want to make sure she looks like she's supplementing herself accordingly. Not just with the weapons she carries, but with all of her clothing too. Nothing here is random; everything has a purpose and is strategically placed."

NOTE! For fans who have not yet completed the game, this chapter
includes details that could be considered plot spoilers.

THIS SPREAD: Art by Brian Horton

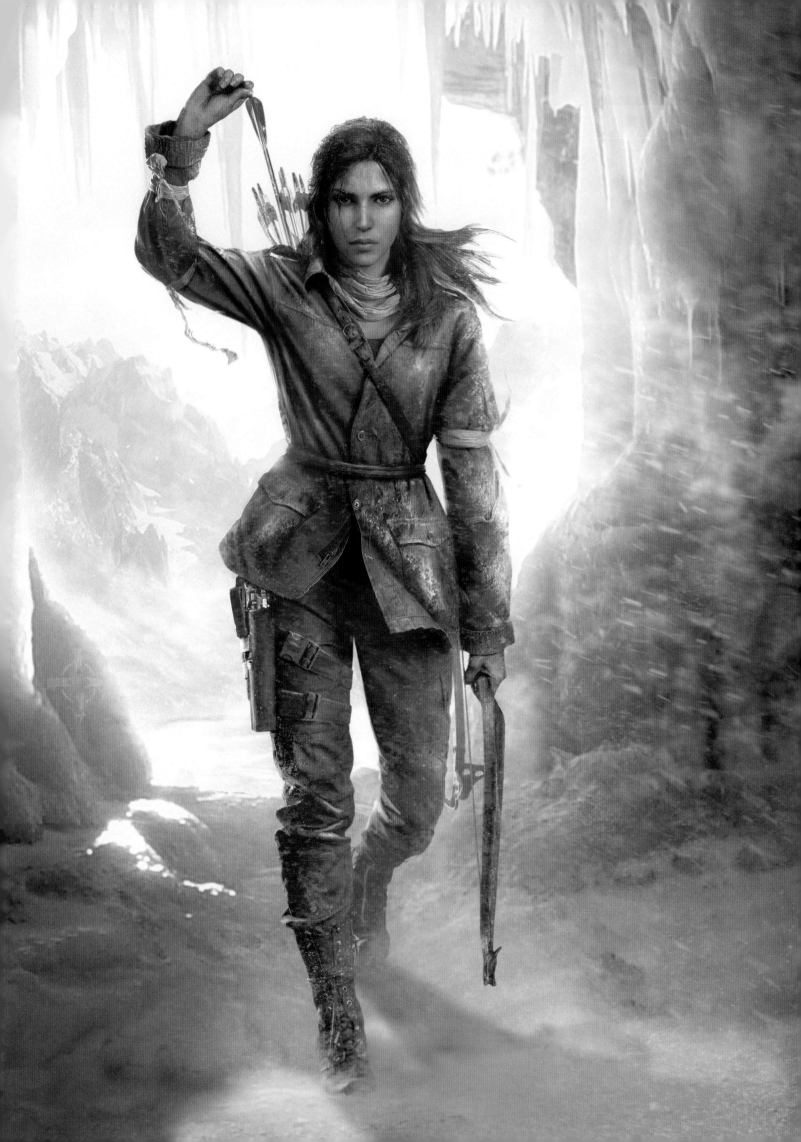

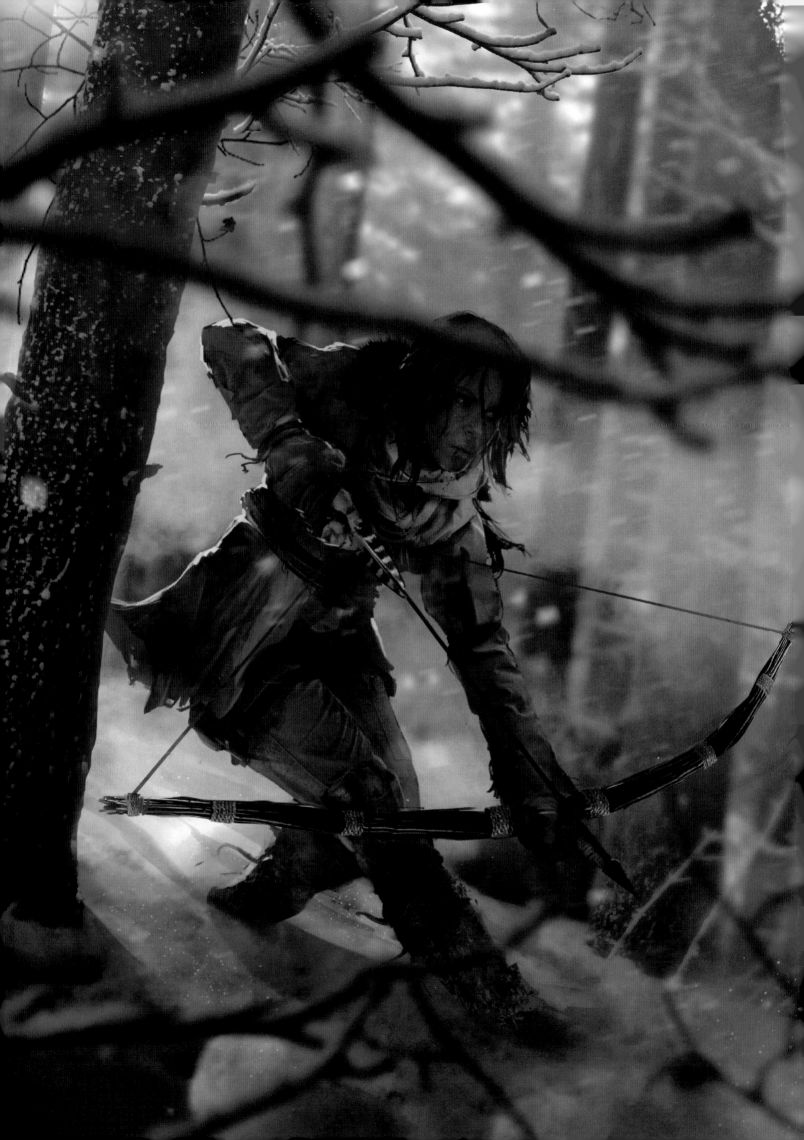

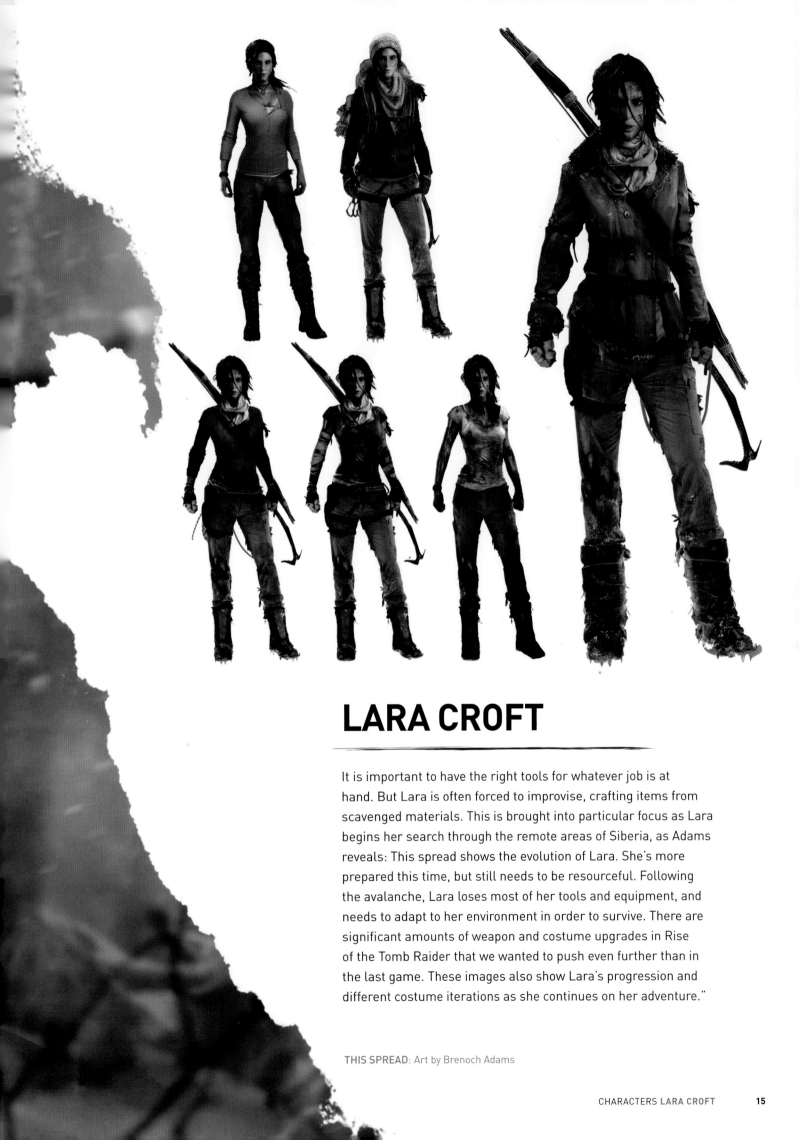

LARA CROFT

It is important to have the right tools for whatever job is at hand. But Lara is often forced to improvise, crafting items from scavenged materials. This is brought into particular focus as Lara begins her search through the remote areas of Siberia, as Adams reveals: This spread shows the evolution of Lara. She's more prepared this time, but still needs to be resourceful. Following the avalanche, Lara loses most of her tools and equipment, and needs to adapt to her environment in order to survive. There are significant amounts of weapon and costume upgrades in Rise of the Tomb Raider that we wanted to push even further than in the last game. These images also show Lara's progression and different costume iterations as she continues on her adventure."

THIS SPREAD: Art by Brenoch Adams

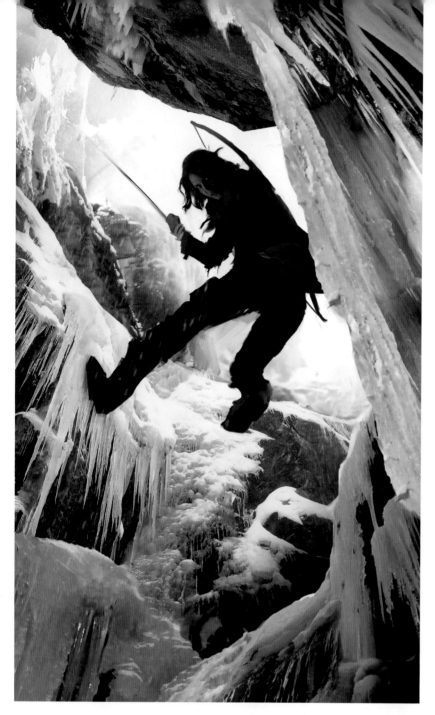

Lara is as adept at descending an icy chasm as she is exploring a frozen wilderness—but her peaceful solitude never lasts for long. Harsh conditions and fierce wildlife protect the secrets of the Siberian wilderness, and she must be prepared to fight for her life to survive.

LEFT/OPPOSITE: Art by Brenoch Adams
BELOW: Character iterations by Brandon Russell

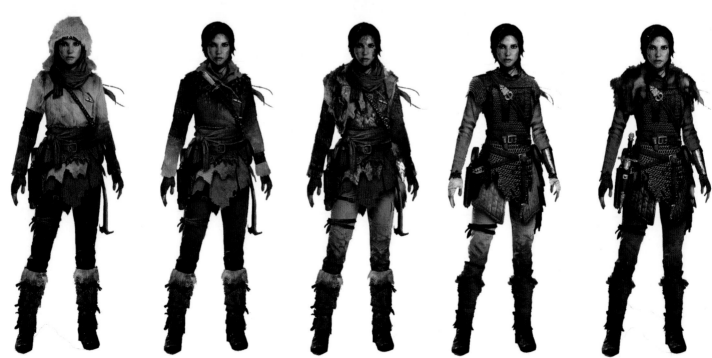

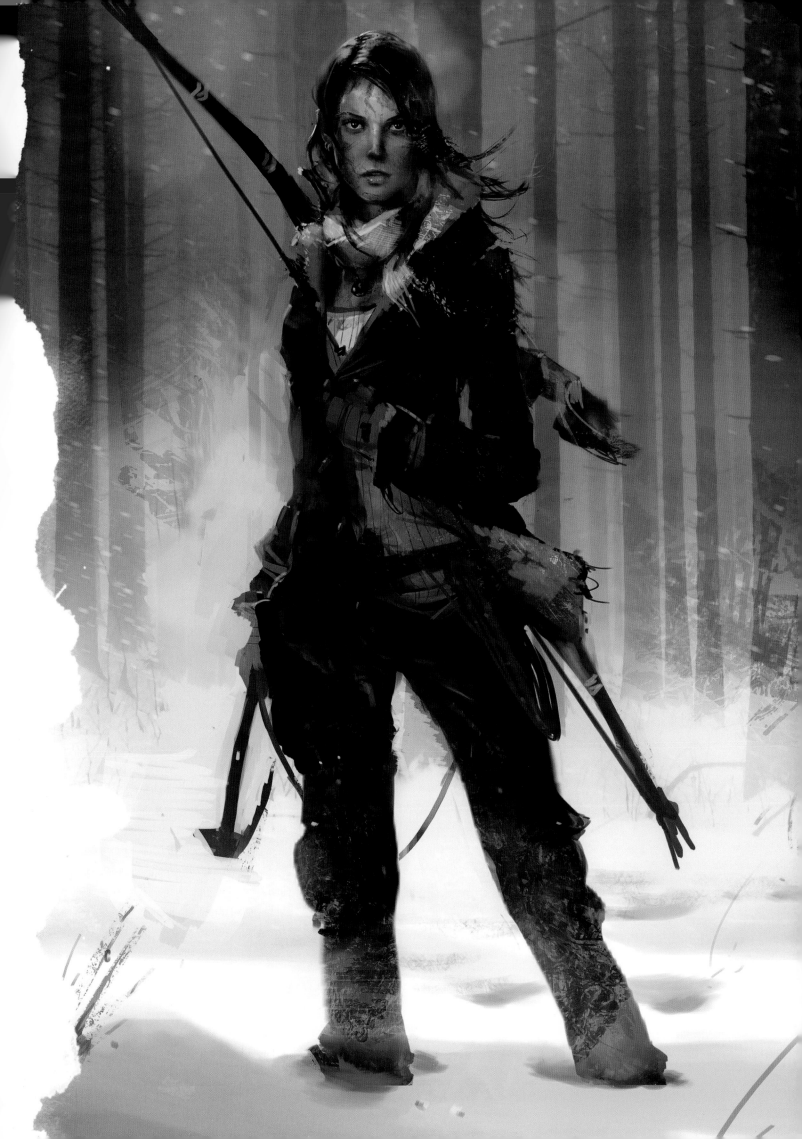

Bloodied and injured, but driven by her search for answers, Lara's resilience and ability to survive are defining aspects of her character. The images on this spread are examples of her different damage states, all of which react dynamically," explains Adams. "If Lara is in water her textures and her hair will be wet, and the water will eventually clean off any mud or blood. If she goes through a battle she'll become bloodied. Snow will accumulate on her when she is outside. There are multiple high-fidelity layers that we use to make her seem tied to the world. It's about how she reacts to it and how the world reacts to her."

ABOVE: Art by Brenoch Adams
RIGHT/OPPOSITE: Head iterations by Brian Horton

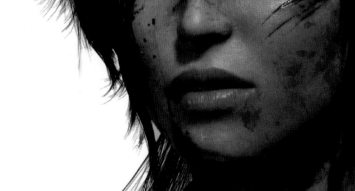

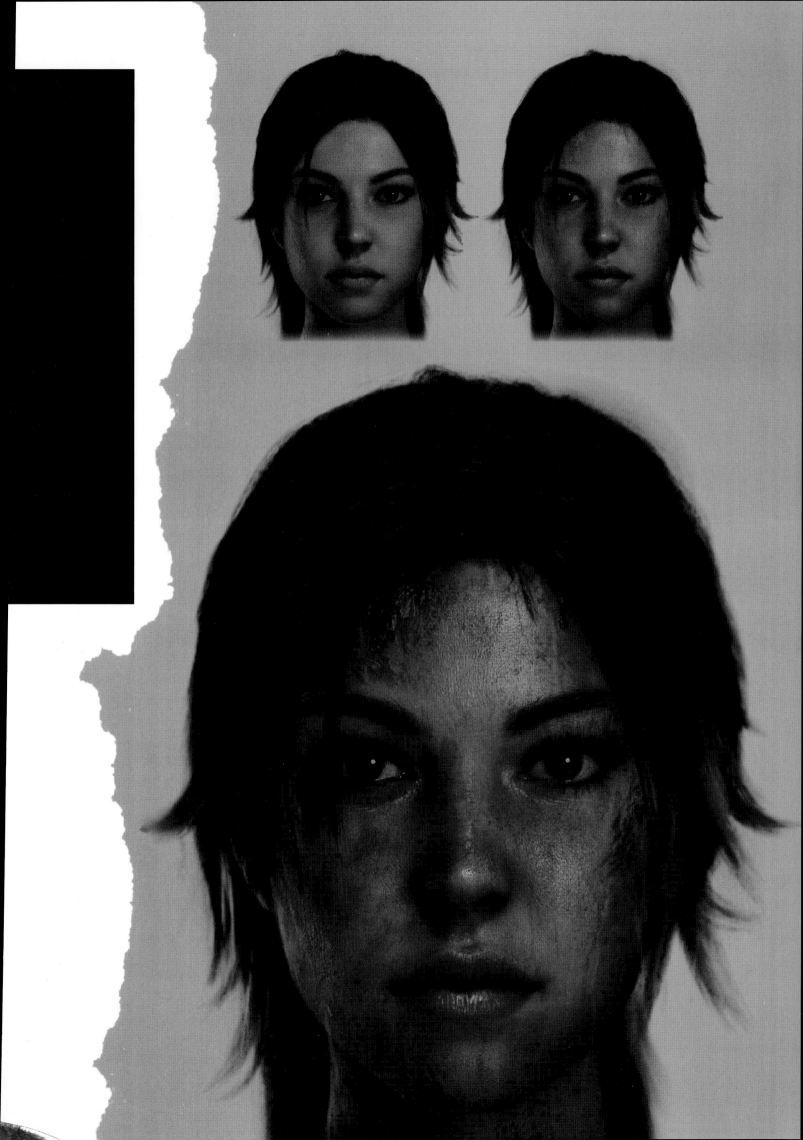

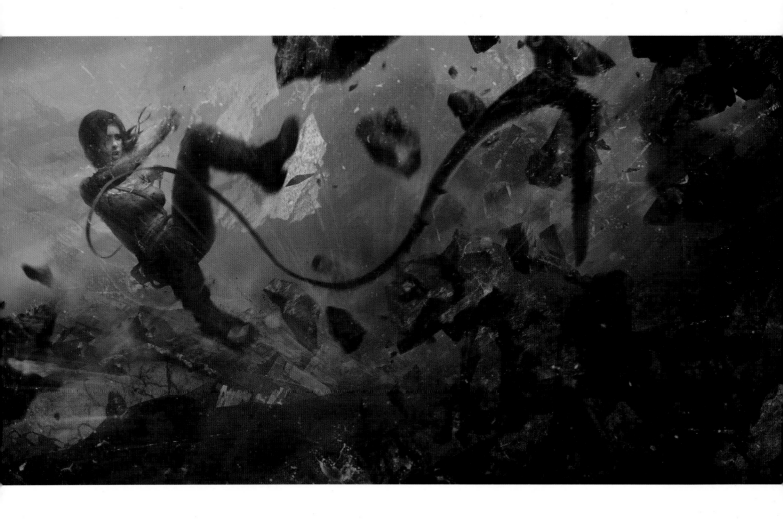

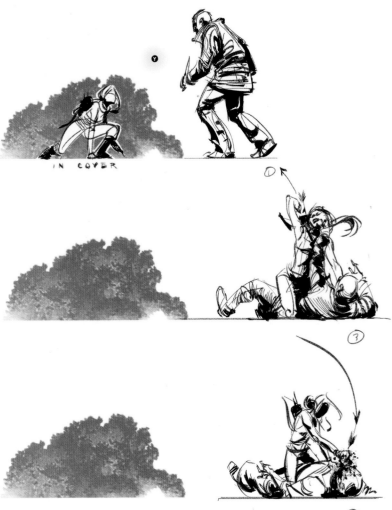

A cliff crumbles beneath Lara, sending her plummeting earthwards in a cascade of jagged stones. Hoping to catch her fall, she hurls her axe in a desperate act of survival. In the image at right, Lara stands at the threshold of an icy cave, searching for clues in the harsh landscape of the Siberian wilderness. To help visualize Lara's in-game finishing moves, senior concept artist Jeff Adams would illustrate storyboards such as the one to the left. These were intended to evoke the desired tone and sequencing of the moves, allowing animators to bring them to life.

ABOVE: Art by William Wu
LEFT: Storyboard sequence by Jeff Adams
OPPOSITE: Art by Brandon Russell

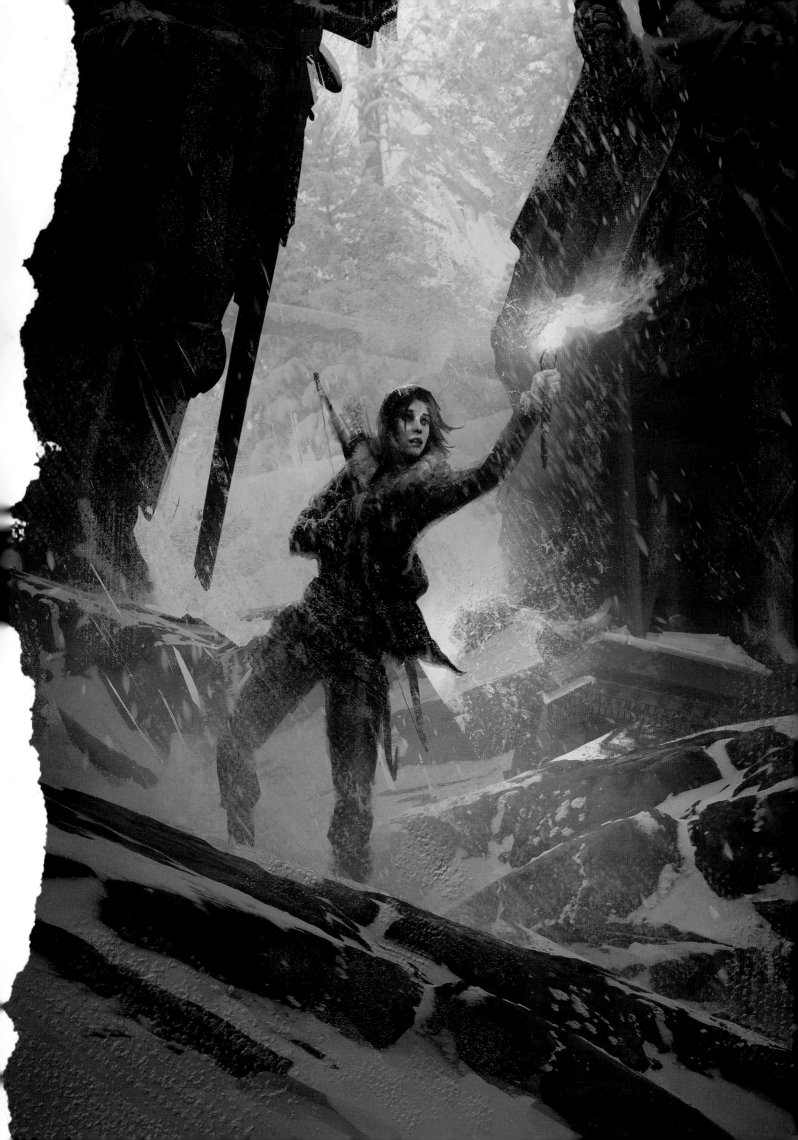

JONAH

From a humble cook on the ill-fated *Endurance* expedition to Lara's steadfast companion grasping the rope as she scales an especially treacherous cliff face, Jonah has also changed since his experiences in *Tomb Raider 2013*. The two years following the tumultuous events have not been kind to him. Returning in something of a tailspin and mourning the loss of his friend and mentor Roth, he has sought solace at the bottom of a bottle and lost himself in a series of dead-end jobs. His jovial nature has prevailed in spite of his circumstances, though, and he now finds stability back in the company his old friend Lara Croft. Jonah regards Lara as a sister and would do anything to protect her, even when it becomes apparent that she is more than capable of looking after the both of them. Jonah is nevertheless a fierce friend and staunch ally, willing to stand by her side even in the direst of circumstances.

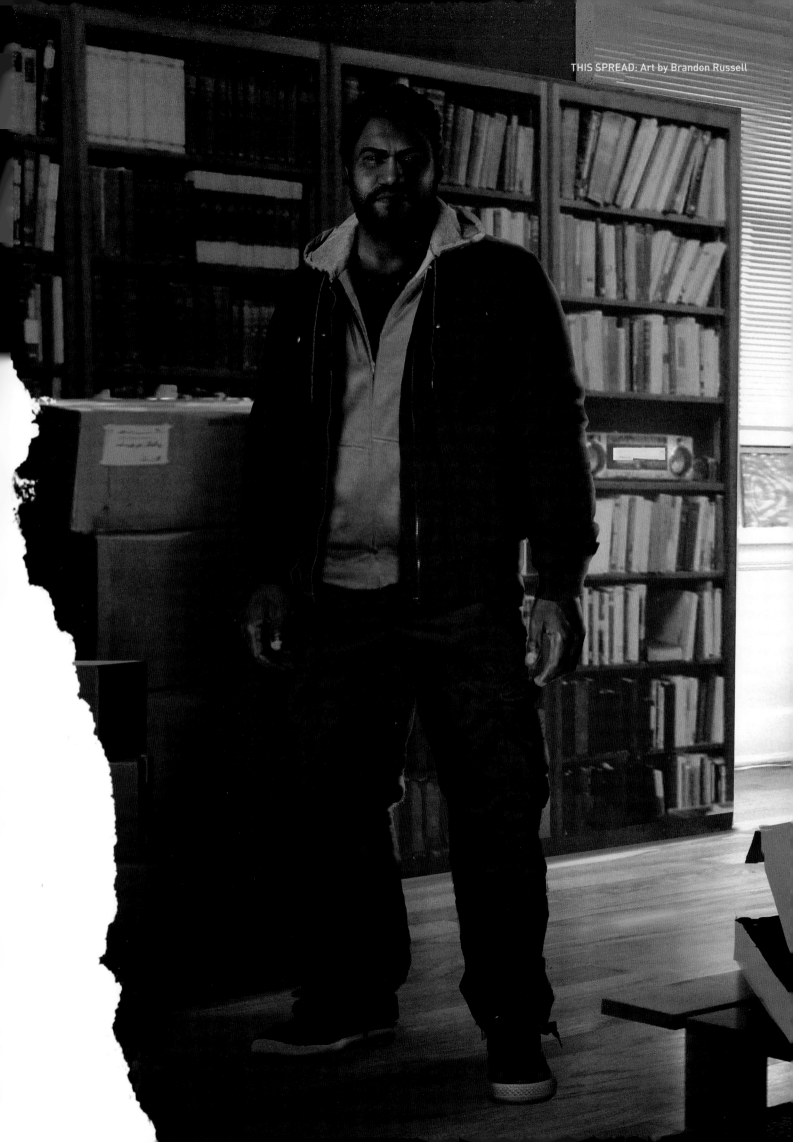

THIS SPREAD: Art by Brandon Russell

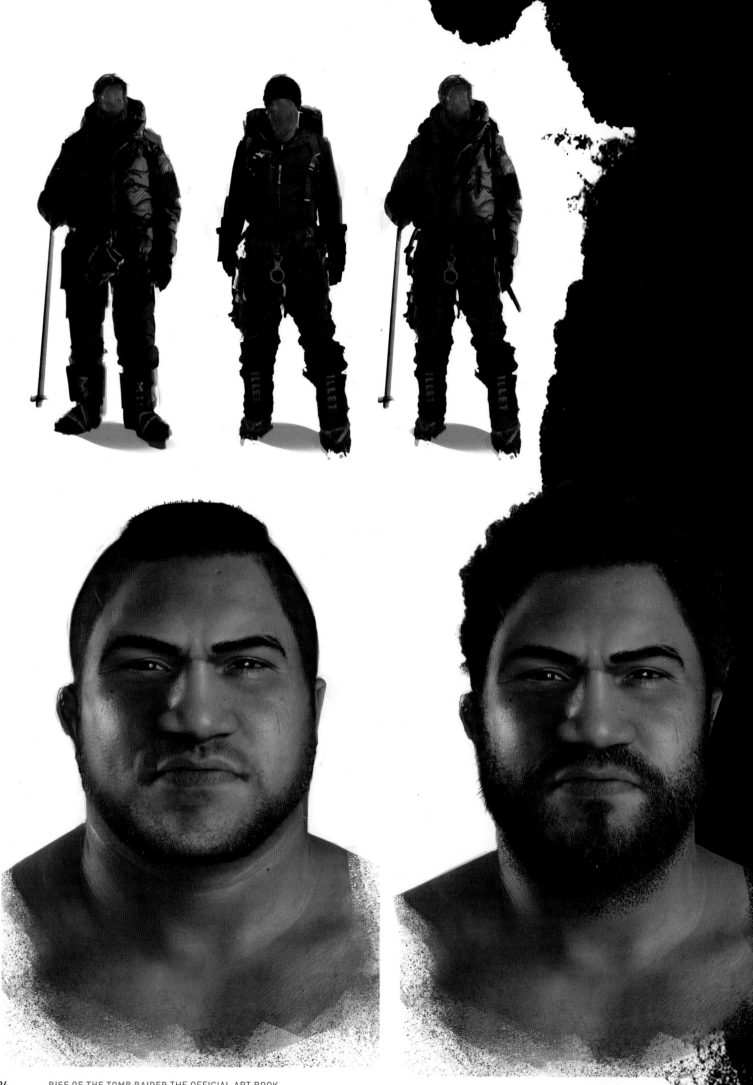

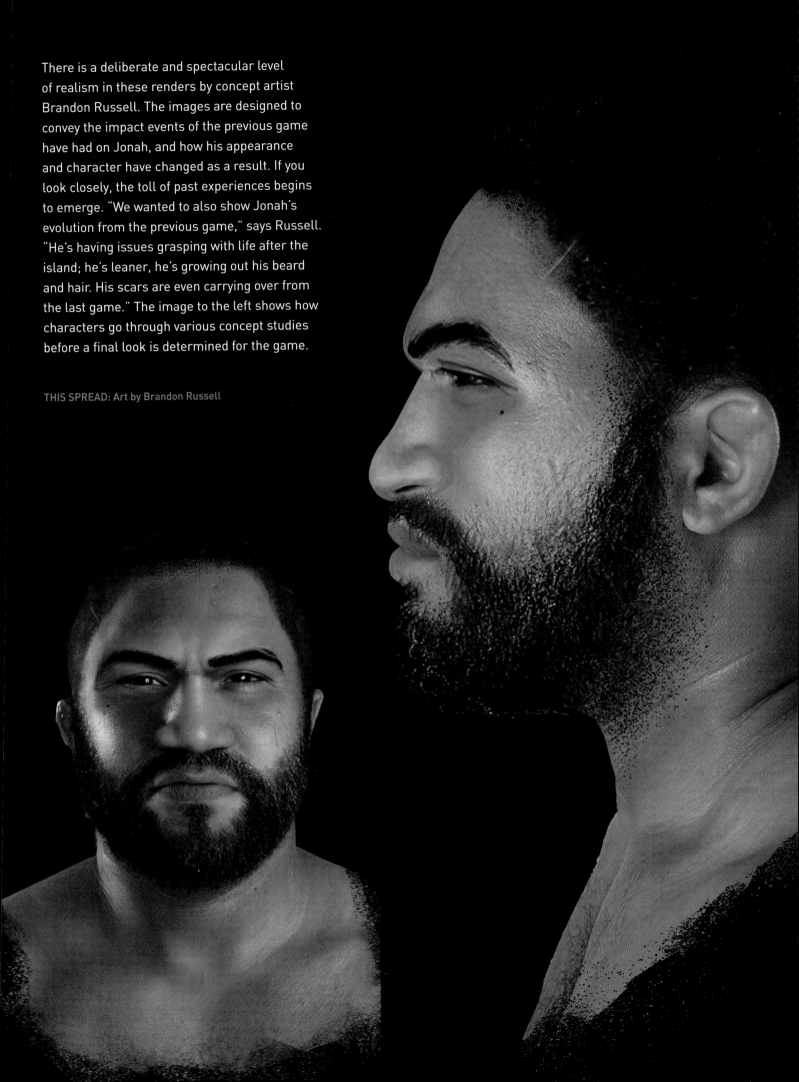

There is a deliberate and spectacular level of realism in these renders by concept artist Brandon Russell. The images are designed to convey the impact events of the previous game have had on Jonah, and how his appearance and character have changed as a result. If you look closely, the toll of past experiences begins to emerge. "We wanted to also show Jonah's evolution from the previous game," says Russell. "He's having issues grasping with life after the island; he's leaner, he's growing out his beard and hair. His scars are even carrying over from the last game." The image to the left shows how characters go through various concept studies before a final look is determined for the game.

THIS SPREAD: Art by Brandon Russell

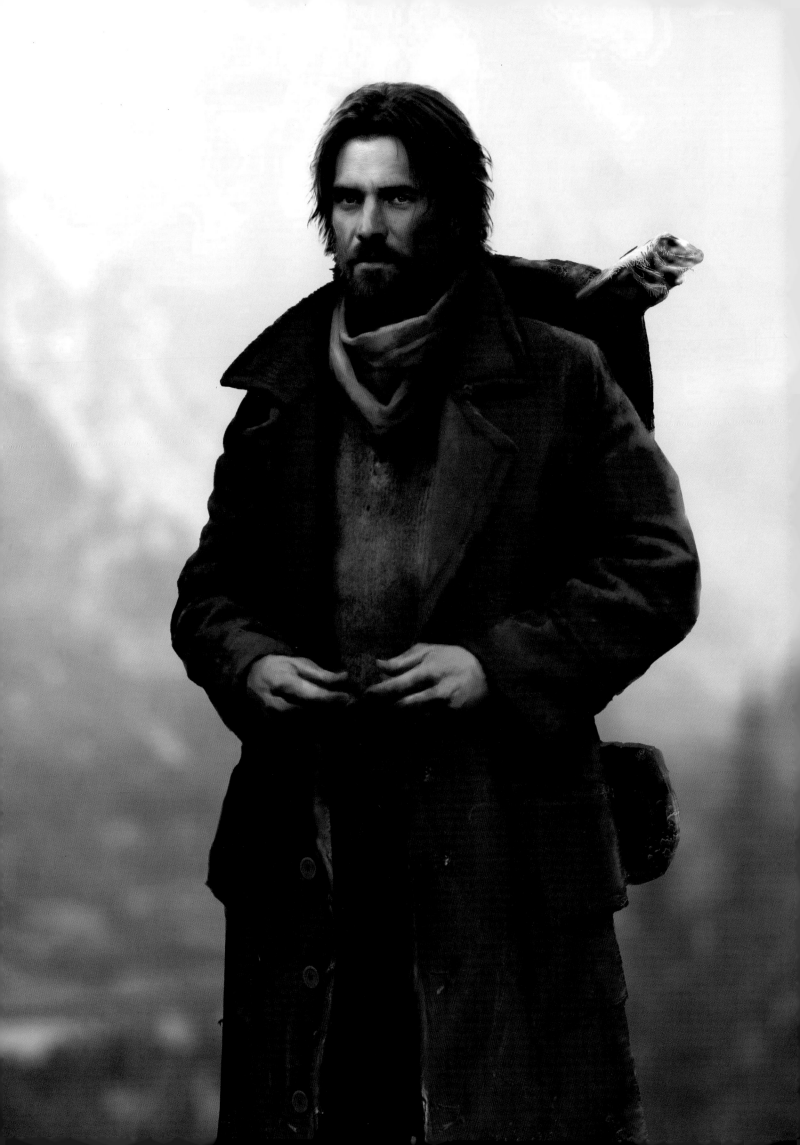

JACOB

Jacob is the spiritual leader of the Remnant people, who live isolated, deep in the Siberian wilderness. His humble appearance hides a secret that others are prepared to kill for. Since locking his soul in a mystical artefact called the Divine Source, he has lived for centuries, witnessing the lives and deaths of his family, friends, and the once great city of Kitezh. "We came at the final art direction for Jacob by creating a timeless look," explains Adams. "We did not want him to look like a love interest. He's mysterious and you can't really tell what time he's from—we wanted him to be ambiguous."

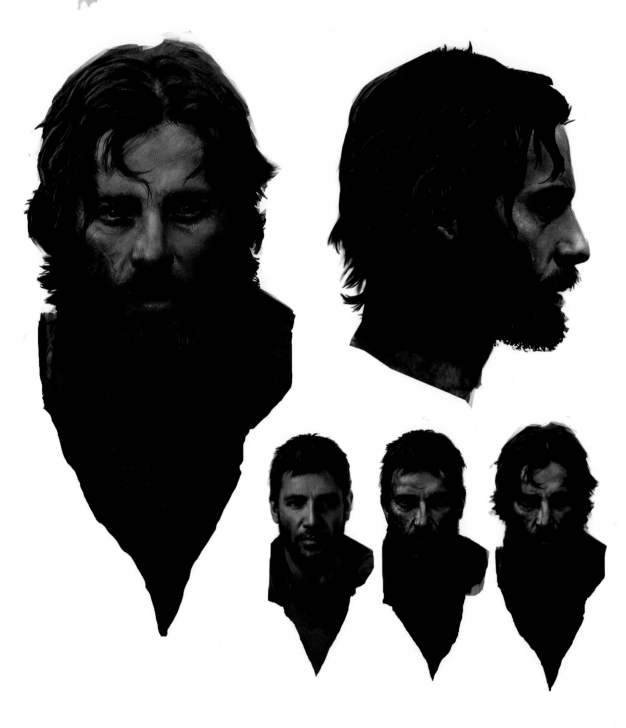

THIS SPREAD: Art by Brian Horton

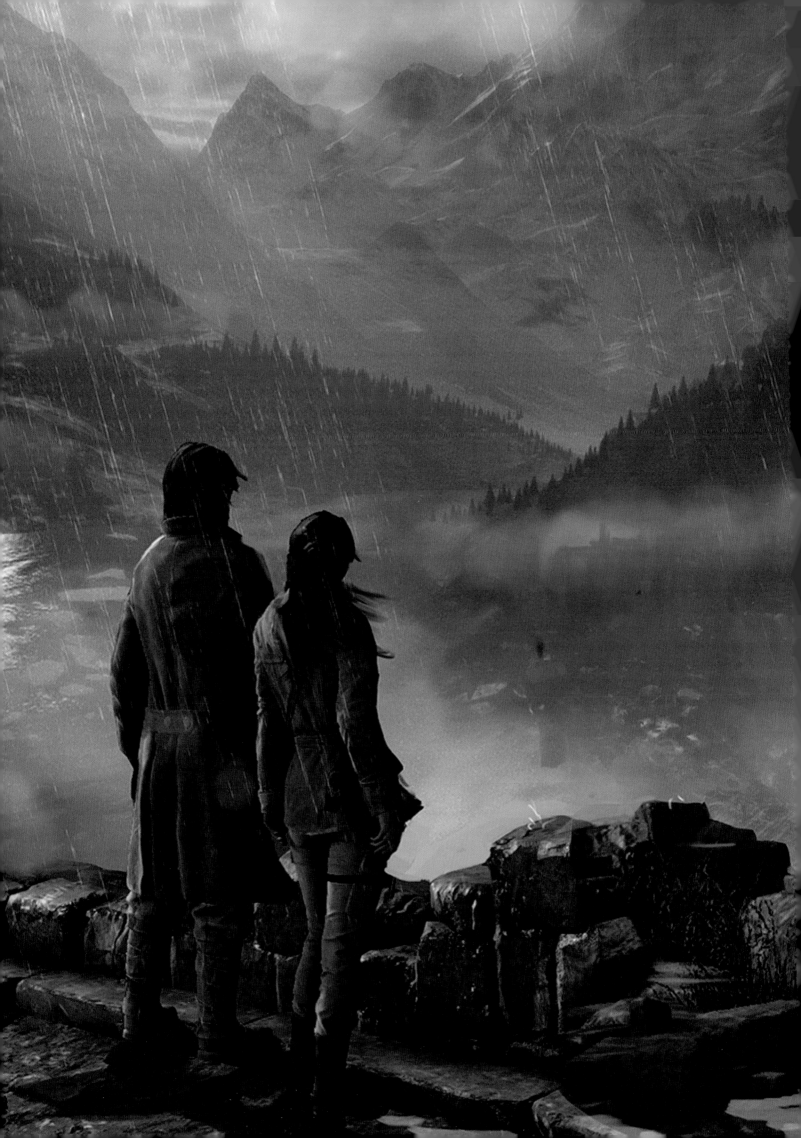

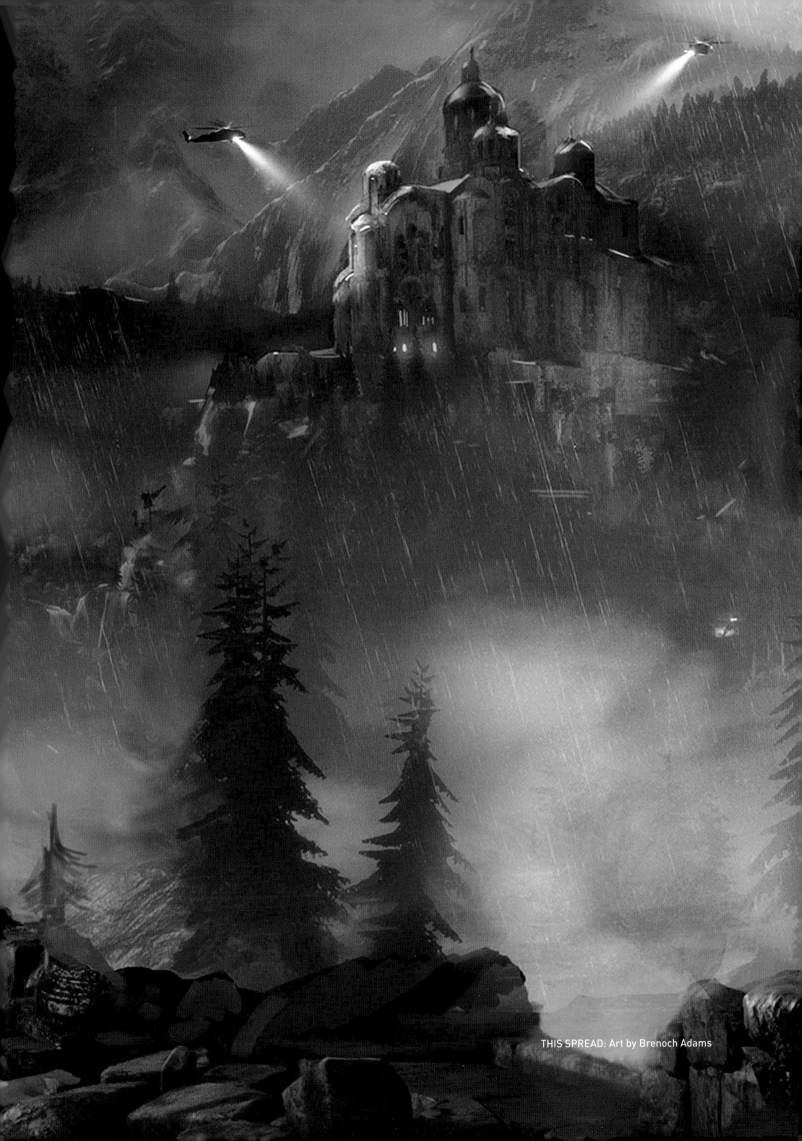

THIS SPREAD: Art by Brenoch Adams

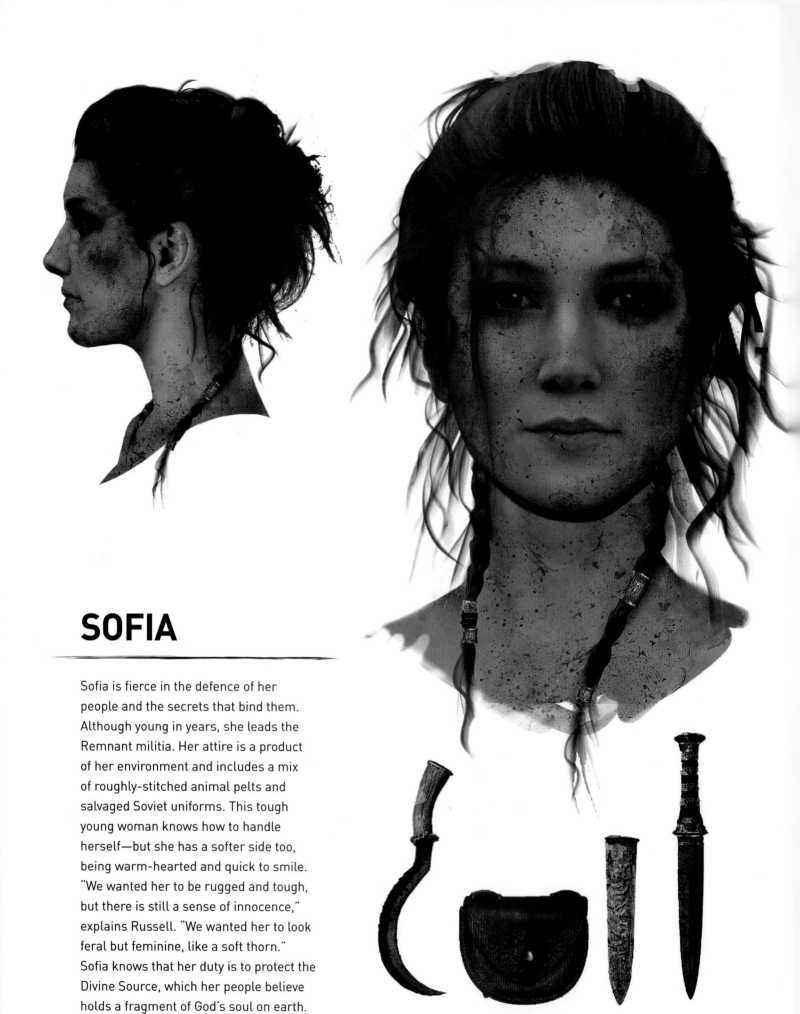

SOFIA

Sofia is fierce in the defence of her people and the secrets that bind them. Although young in years, she leads the Remnant militia. Her attire is a product of her environment and includes a mix of roughly-stitched animal pelts and salvaged Soviet uniforms. This tough young woman knows how to handle herself—but she has a softer side too, being warm-hearted and quick to smile. "We wanted her to be rugged and tough, but there is still a sense of innocence," explains Russell. "We wanted her to look feral but feminine, like a soft thorn." Sofia knows that her duty is to protect the Divine Source, which her people believe holds a fragment of God's soul on earth.

THIS SPREAD: Art by Brandon Russell

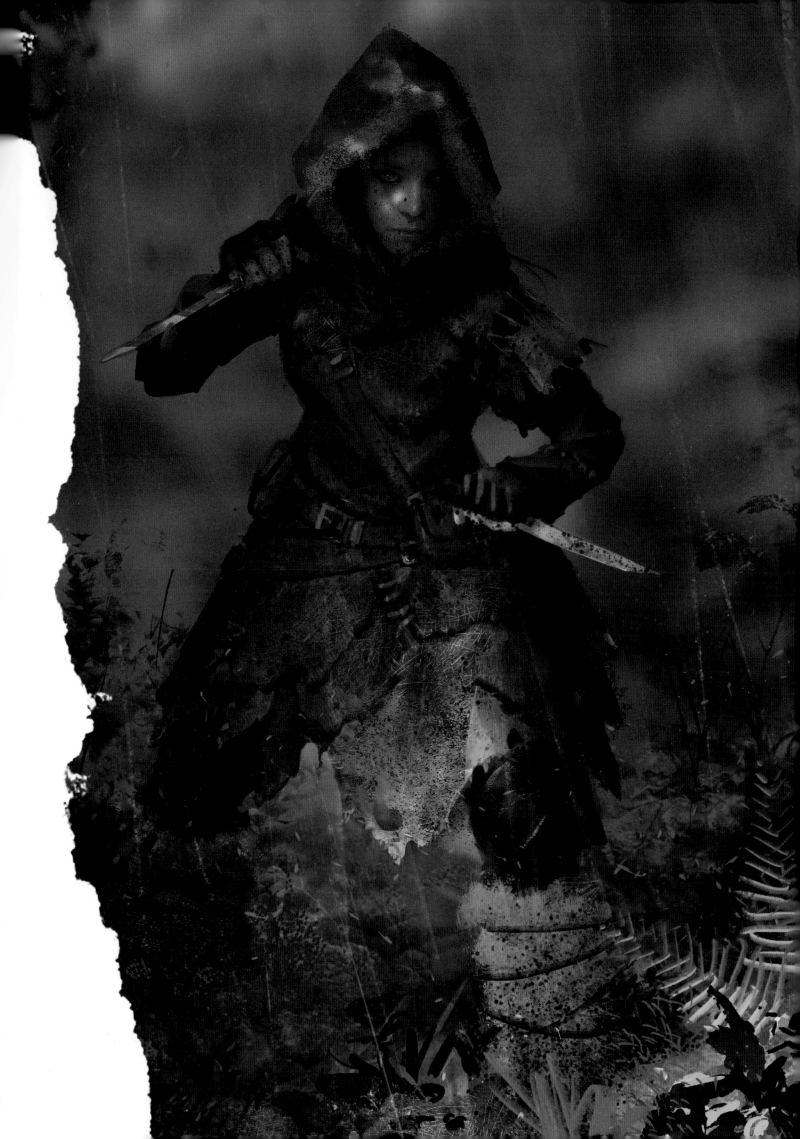

Clenched fists and a selection of militaristic outfits suggests an aggressive intent, but also underlines the remoteness of Sofia's village. "We wanted these iterations to make her look timeless," says Adams. "All of her clothing represents different layers of history. Sofia's items and clothing represent things that have been found, inherited, or scavenged from existing materials, because the Remnant people are so isolated. Her culture is one that was lost in time."

THIS SPREAD: Art by Brandon Russell

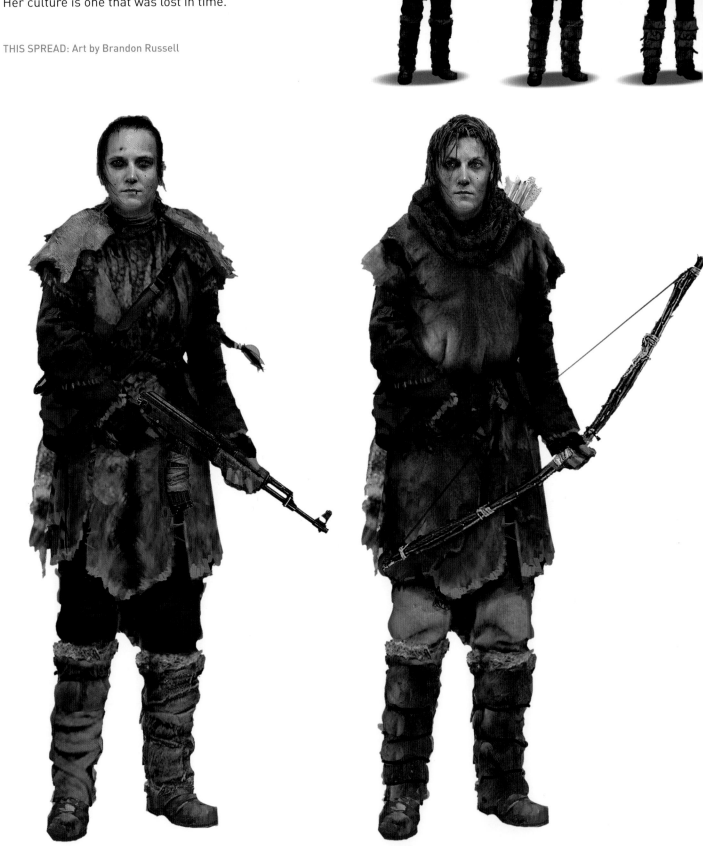

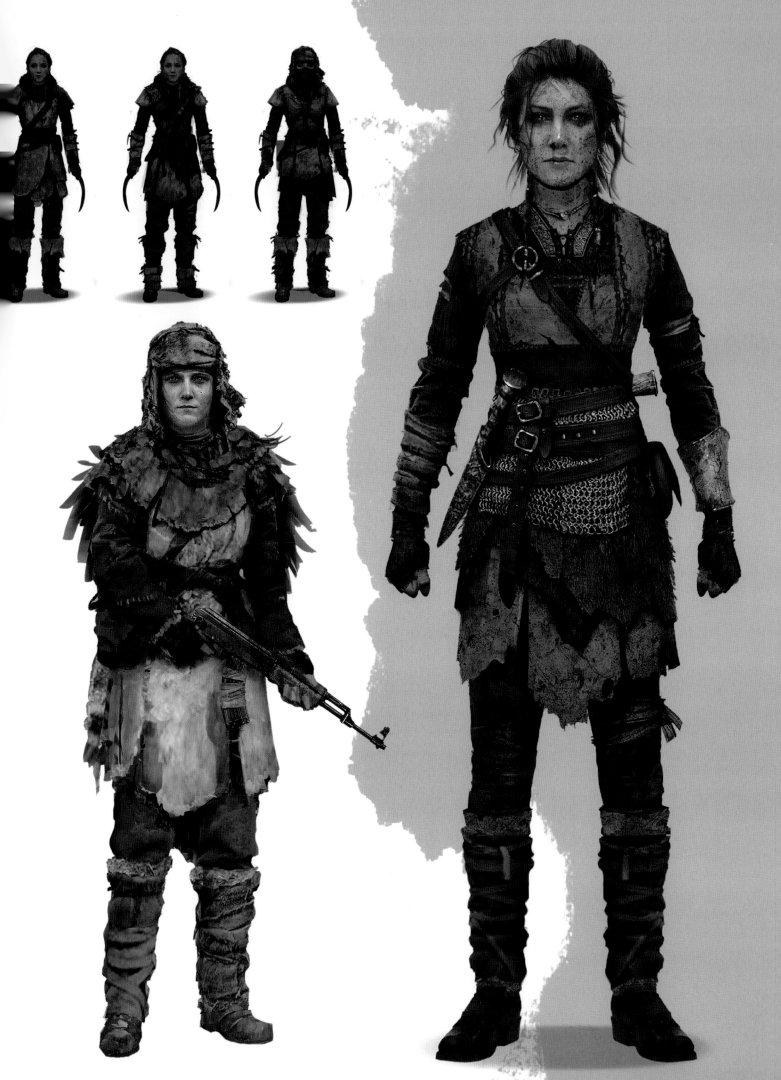

ANA

It is plain to see that Ana is not a healthy woman. She is the former lover of Lara's late father and lived with the Croft family for a number of years. Covertly, she is also a high-ranking member of Trinity, the shadowy religious group that is seeking the Divine Source. Ana intended to recruit Lord Croft to Trinity but, failing to do so, has now set her eyes on his spirited daughter. She believes Lara will help lead Trinity to their goal, so she has taken to subtly encouraging Lara in her adventures. Cold, calculating, impatient and intemperate, she wants nothing more than to find the artifact before her illness takes her. "She has a terminal illness so she's hunting for this life source to save herself," explains Russell. "We wanted her eyes to appear sunken in and red to show her suffering and that's why we also wanted to give her glasses, as she's hiding all this from Lara."

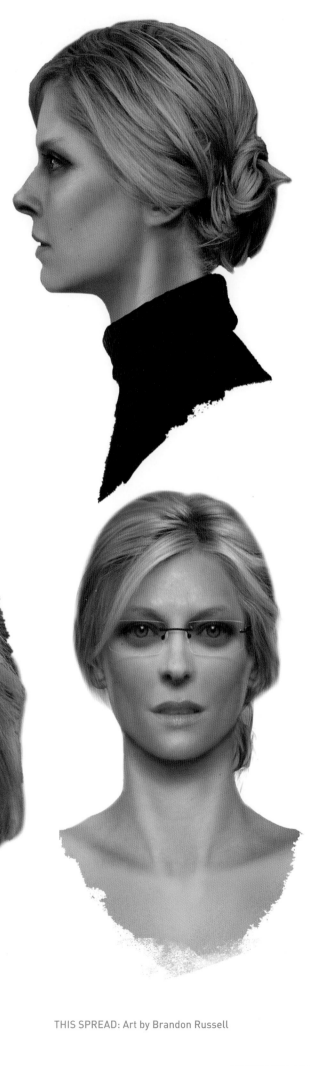

THIS SPREAD: Art by Brandon Russell

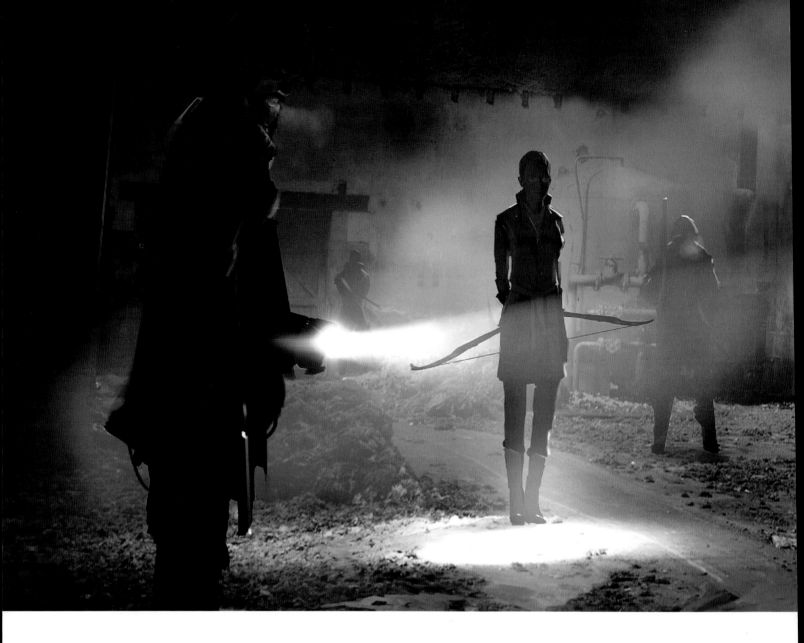

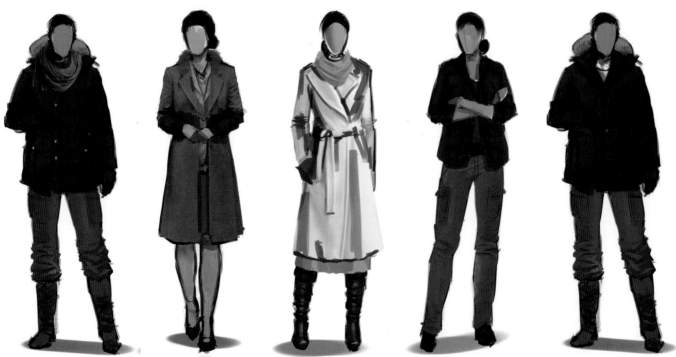

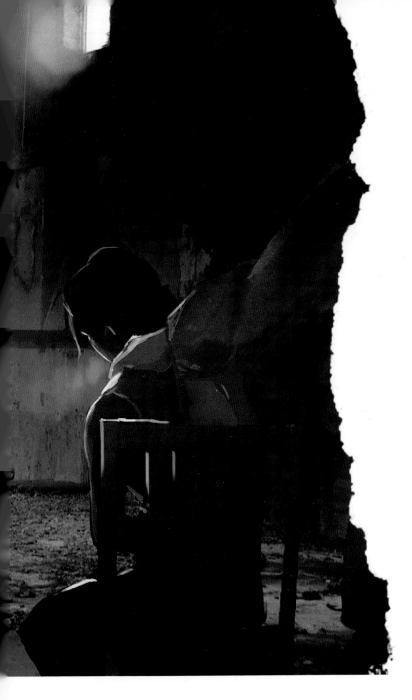

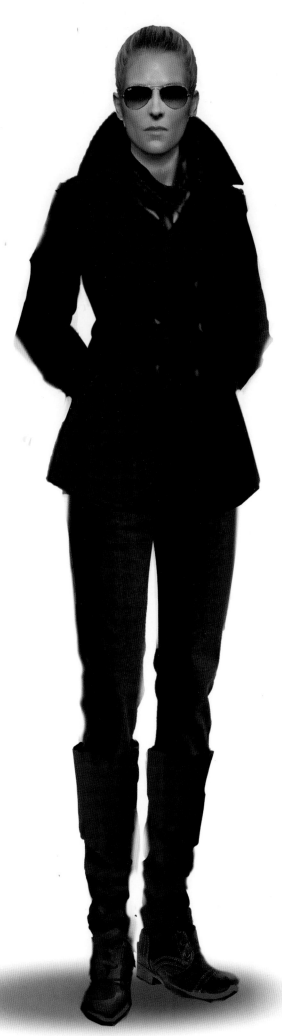

Ana's pallid complexion is a fitting complement to the hard lines and muted tones of her wardrobe. She and Lara share a connection in Lord Croft, although family values would appear to count for very little when Lara is captured and bound in a chair for interrogation. Both women are also driven by the need to master their own destinies. But where Lara seeks to live up to her father's legacy and realize her true potential, Ana desires nothing less than the installation of a new world order of immortal elites with her brother Konstantin at the helm. Illness and self-pity inform her deluded judgment, and when events reach a crescendo she is prepared to save herself by any means.

ABOVE: Art by Brenoch Adams
LEFT/RIGHT: Art by Brandon Russell

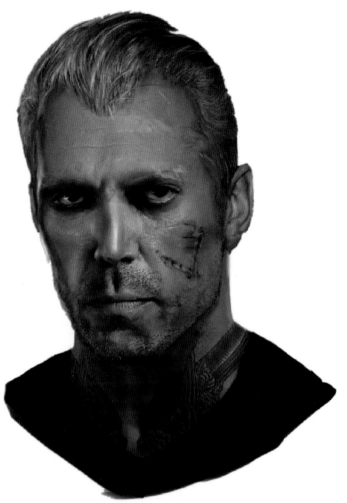

KONSTANTIN

If Konstantin has his parents to thank for his imposing stature and heavy brow, he owes his severe personality and penchant for violence to the Trinity organization, which took him in as a young child. Konstantin was raised in the organization alongside Ana, his older sister. When he was young, Ana inflicted the open stigmata wounds on his hands in order to convince Trinity that he was chosen by God to cleanse the world of sin. With this fire of destiny burning within him, Konstantin ascended the ranks of Trinity and eventually became an important leader within the organization, commanding a small army of devoted soldiers. He is utterly convinced that he is meant to become the general of God's army and seeks the Divine Source in order to achieve this goal. He also desires the artifact to save his ailing sister, although he is yet to realize the genuine motivations for her loyalty.

THIS SPREAD: Art by Brenoch Adams

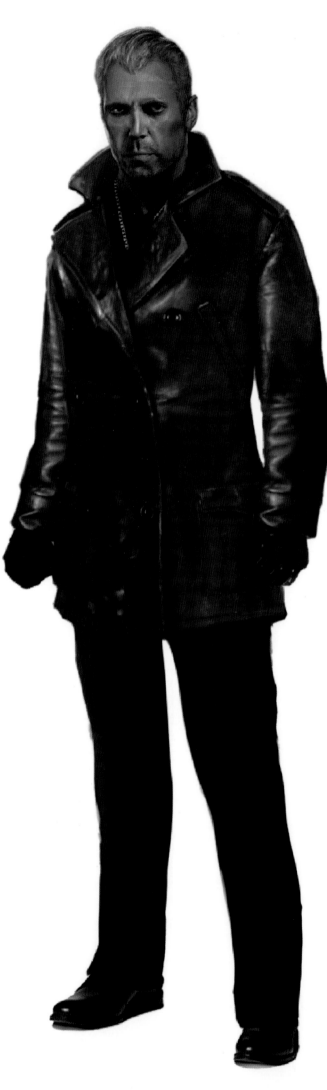

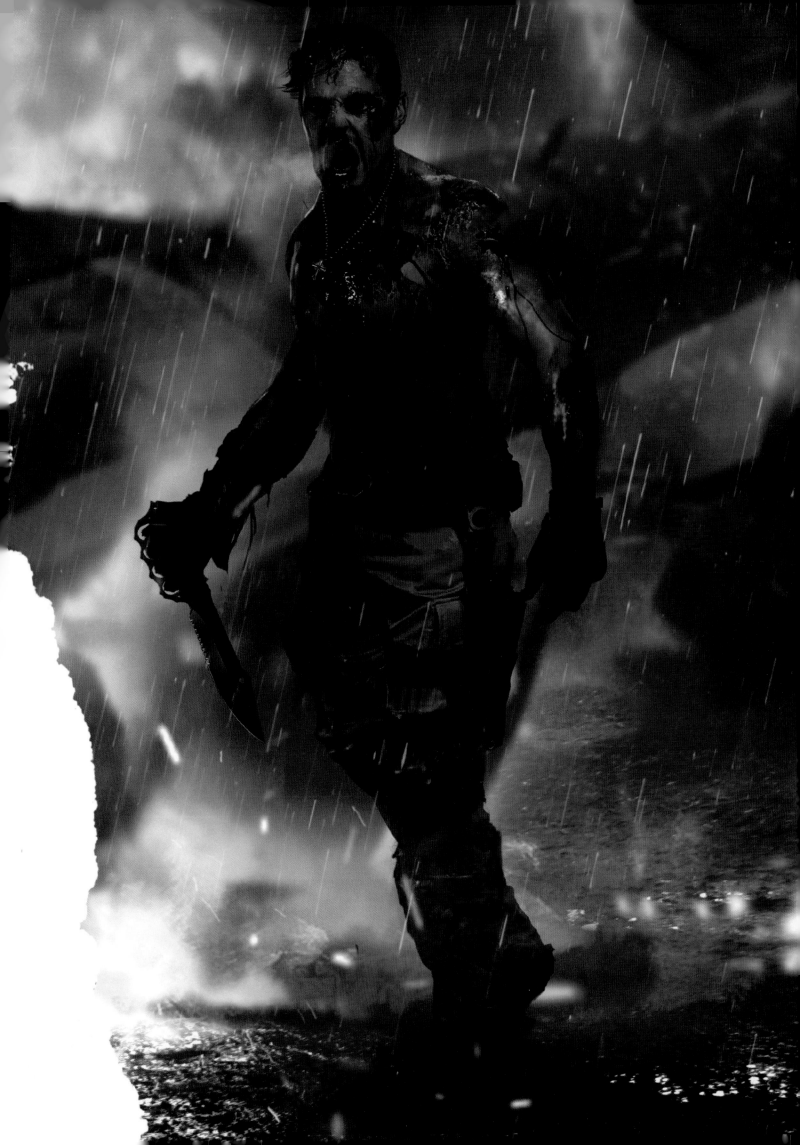

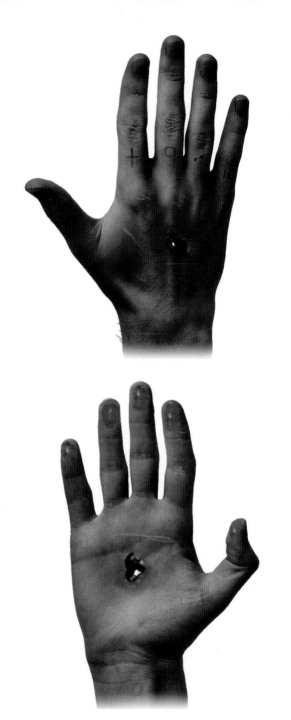

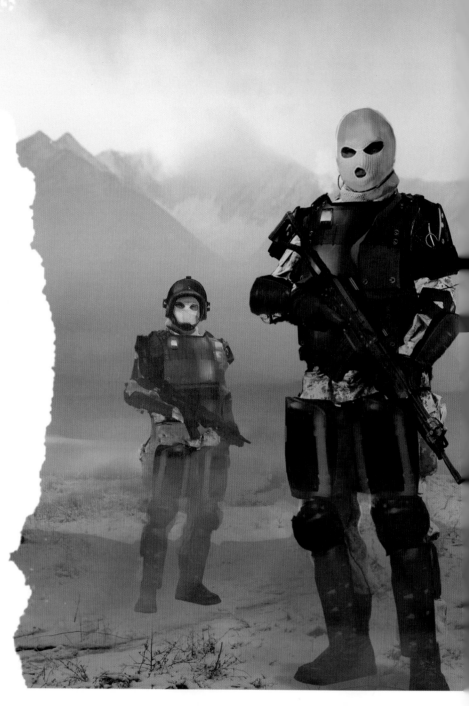

Konstantin is relentless in his pursuit of the divine source, he is willing to commit horrific acts of violence against any who get in his way. And yet the role he believes he is destined to fulfil is one of peace and selflessness; ridding the world of sin as the figurehead of a holy new world order. Brenoch Adams, who crafted these dramatic images, describes how this would-be messiah has changed throughout development: "He was always Ana's brother, but at the beginning we had him look like her twin. However, we ended up taking this out of the equation and separating them both as he pursued his religious, prophet-like status."

THIS SPREAD: Art by Brenoch Adams

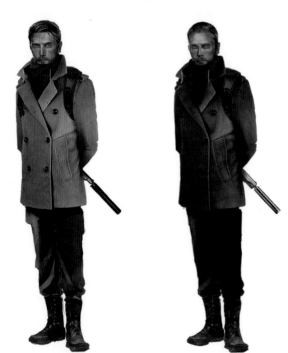

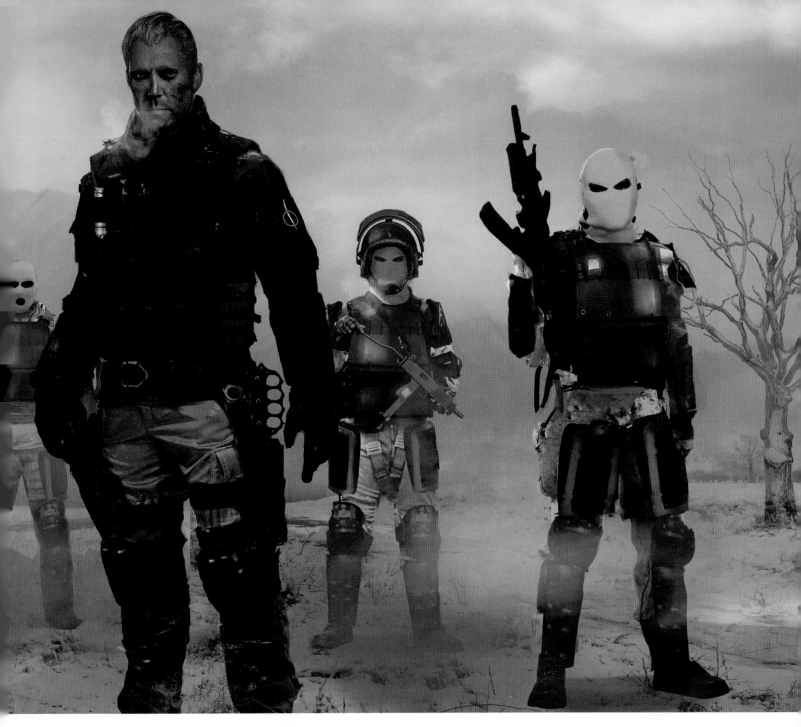

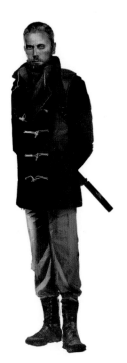

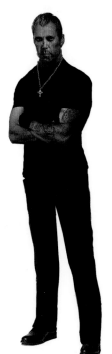

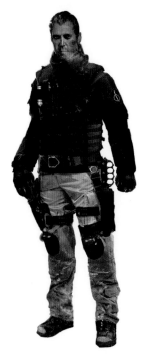

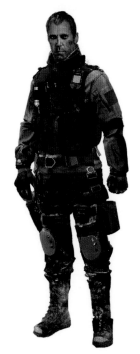

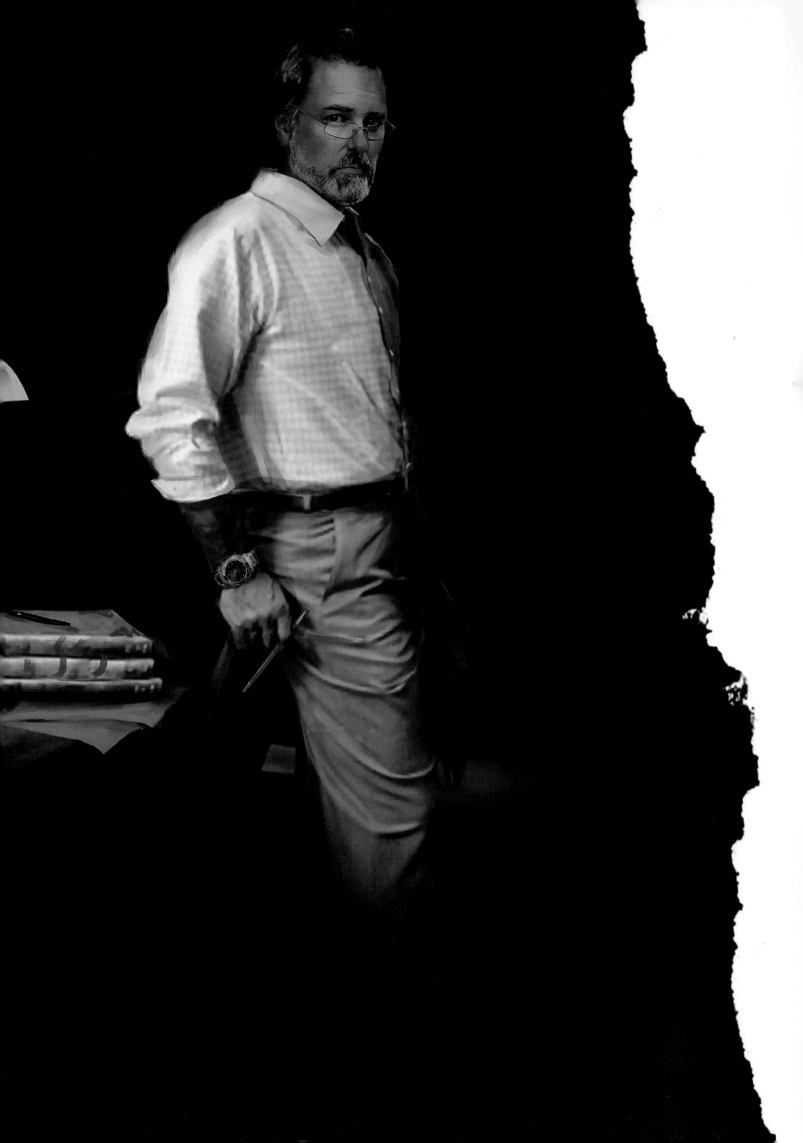

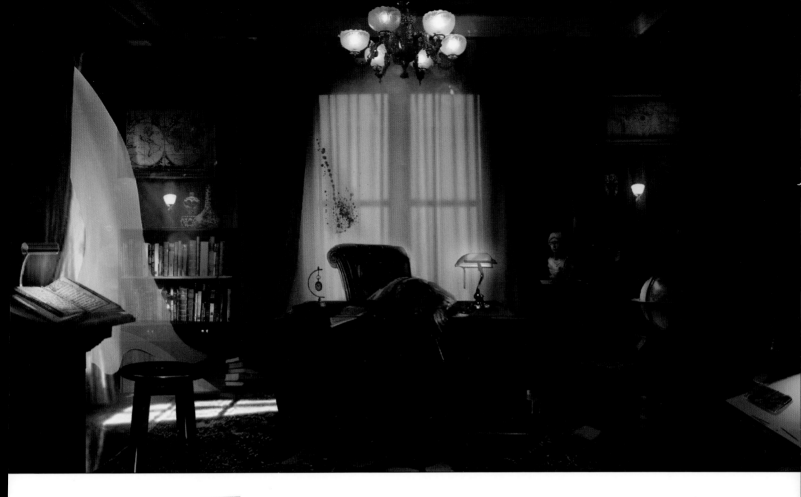

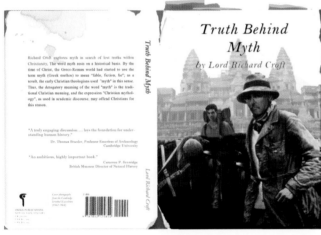

LORD CROFT

Lord Richard Croft lies slumped across his desk, the pistol in his hand a morbid reminder of the anxiety that informed his desperate act. Driven to desperation by the criticism of his peers, who disbelieved his outlandish claims about the source of eternal life, it is sadly ironic that this same obsession is now so vigorously pursued by his very own daughter. But he is fit and healthy in flashback, and a loving single father to the young Lara. His research keeps him away from home more than he'd like, even if his wealth is enough to ensure her comforts. Upon closer inspection, the burdens of worry are already beginning to show, though; the greying hair, lined face and increasingly erratic behaviour. "We wanted Lord Croft to look like an adventurer but not necessarily the guy who will go out there and get his hands dirty," says Brenoch Adams. "He funds expeditions and is keen to explore, but he has others do the heavy lifting."

TOP/OPPOSITE: Art by Brenoch Adams
ABOVE LEFT: *The Truth Behind Myth* book jacket designed by
Jeff Adams

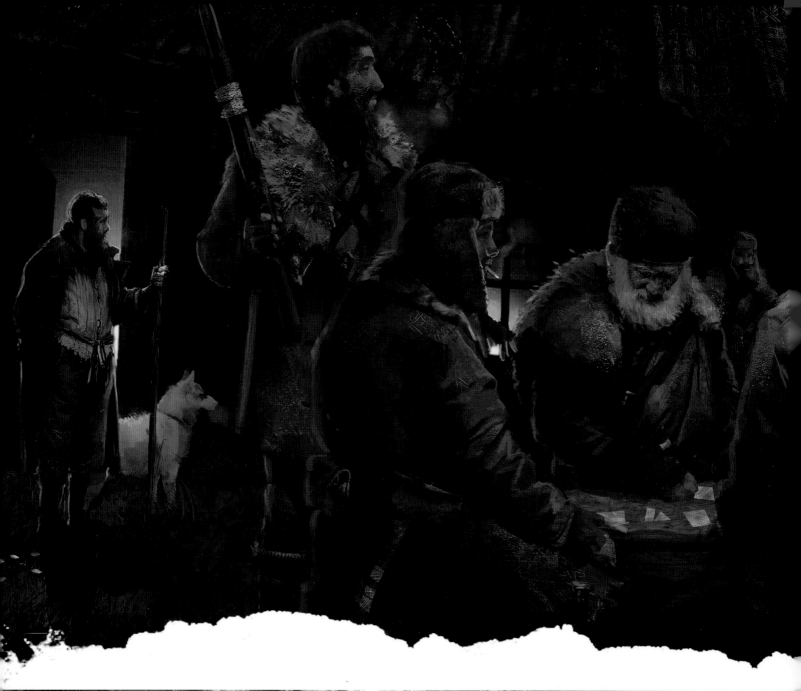

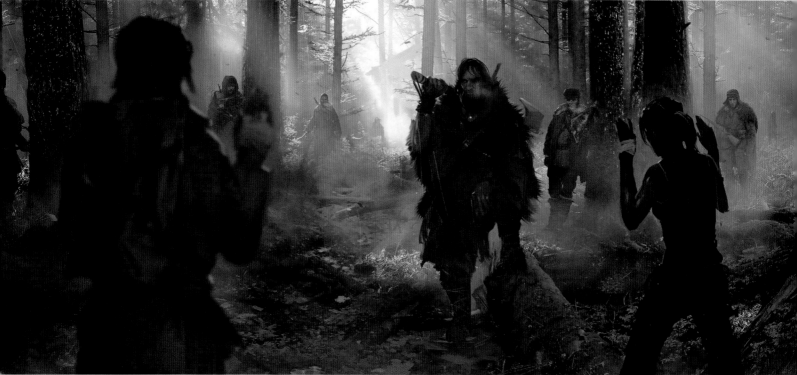

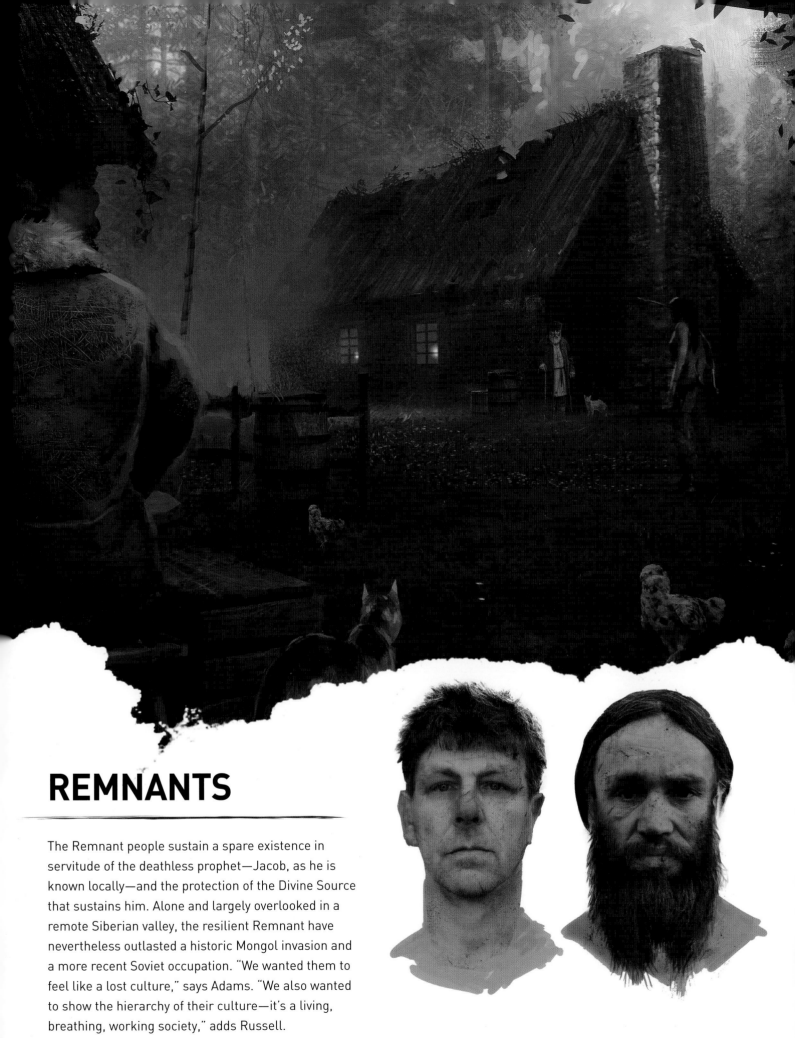

REMNANTS

The Remnant people sustain a spare existence in servitude of the deathless prophet—Jacob, as he is known locally—and the protection of the Divine Source that sustains him. Alone and largely overlooked in a remote Siberian valley, the resilient Remnant have nevertheless outlasted a historic Mongol invasion and a more recent Soviet occupation. "We wanted them to feel like a lost culture," says Adams. "We also wanted to show the hierarchy of their culture—it's a living, breathing, working society," adds Russell.

TOP/ABOVE: Art and head designs by Brandon Russell
LEFT: Art by Brenoch Adams

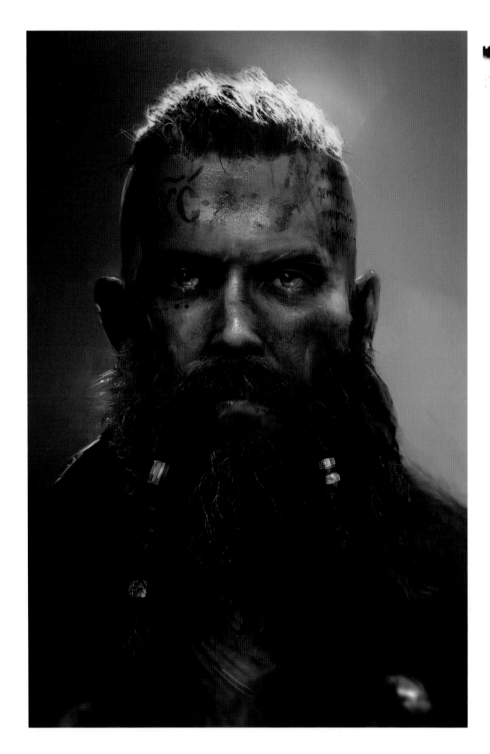

Weather-beaten faces and layered clothing attest to the severity of everyday existence for the Remnant, while distinct facial tattoos mark the more arcane aspects of their creed. Their outfits and armaments are supplemented with what was scavenged and repaired in the wake of the Soviet occupation. Every member of this insular society is trained in guerrilla fighting tactics, and all can skin an animal or fashion an effective bow and arrow from raw materials. However, it is thirty years since the Soviets were forced out and at the time of *Rise of the Tomb Raider*, they are less prepared for the brutality that heralds the arrival of Trinity.

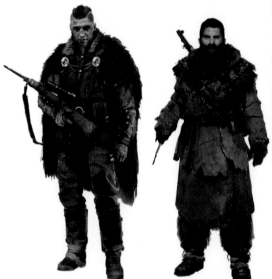

ABOVE: Art by Brenoch Adams
ABOVE RIGHT: Art by Brandon Russell
RIGHT: Art by Brandon Russell

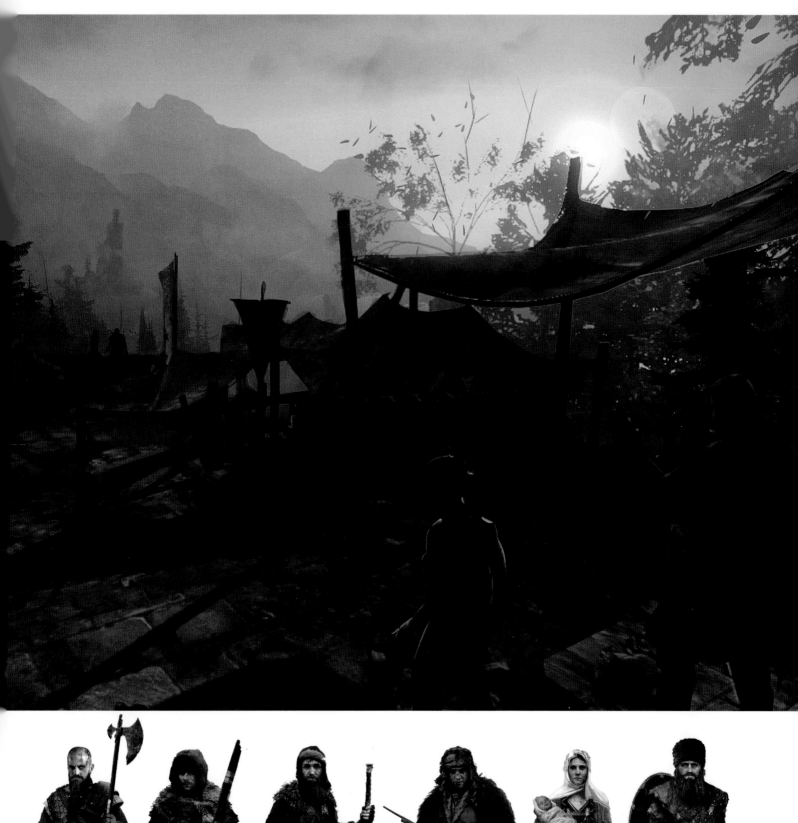

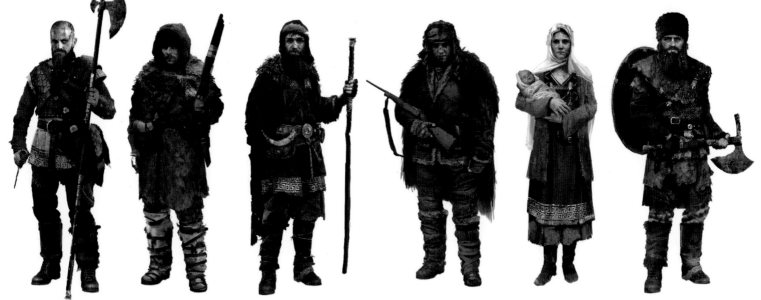

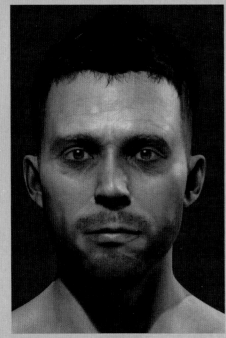

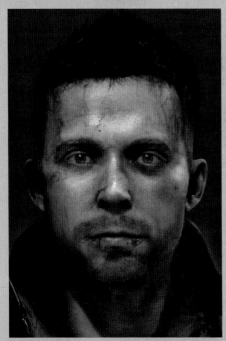

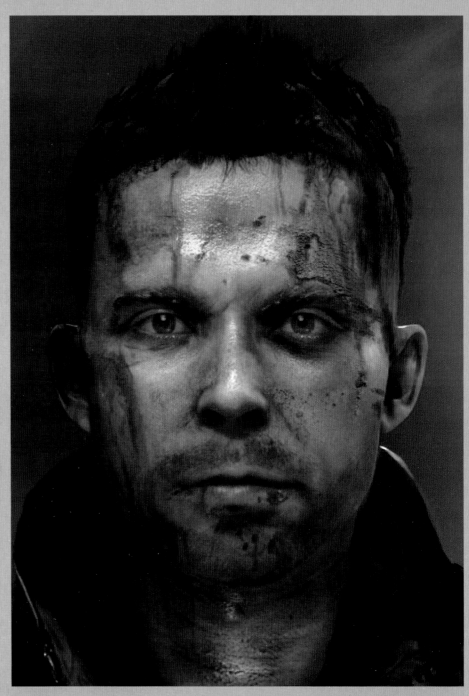

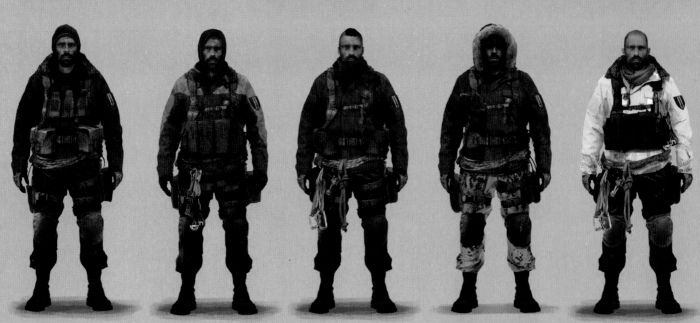

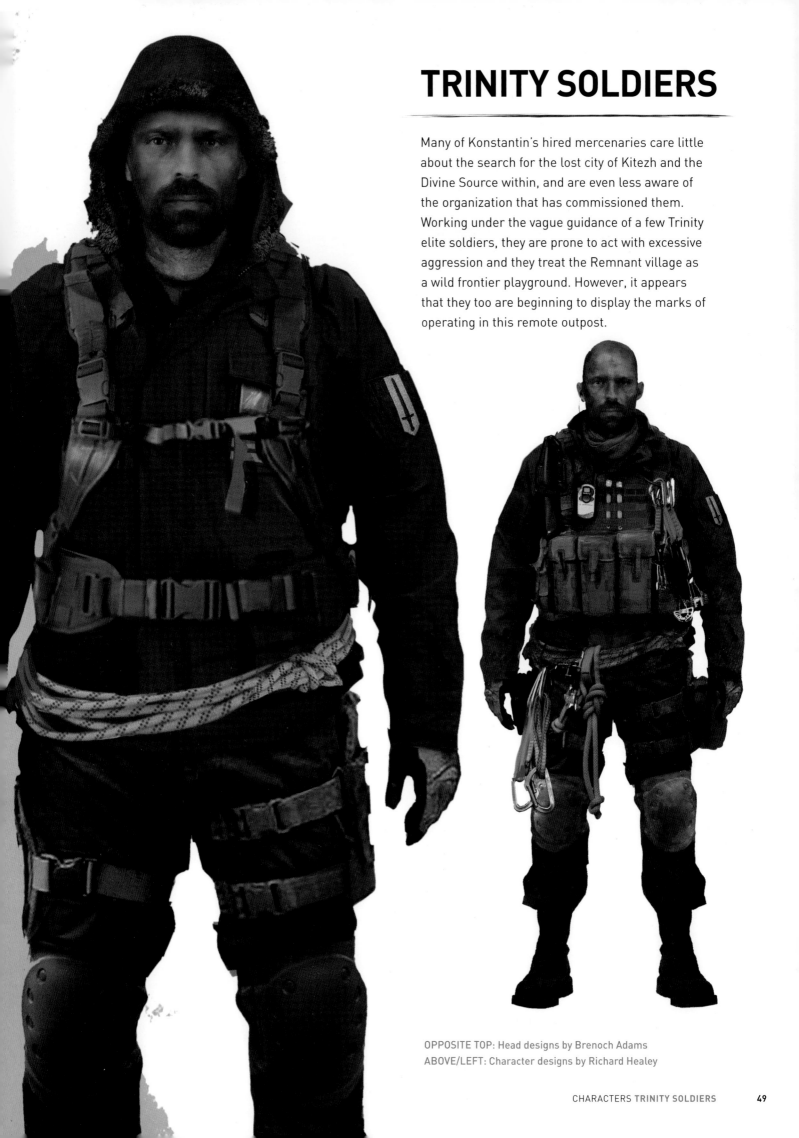

TRINITY SOLDIERS

Many of Konstantin's hired mercenaries care little about the search for the lost city of Kitezh and the Divine Source within, and are even less aware of the organization that has commissioned them. Working under the vague guidance of a few Trinity elite soldiers, they are prone to act with excessive aggression and they treat the Remnant village as a wild frontier playground. However, it appears that they too are beginning to display the marks of operating in this remote outpost.

OPPOSITE TOP: Head designs by Brenoch Adams
ABOVE/LEFT: Character designs by Richard Healey

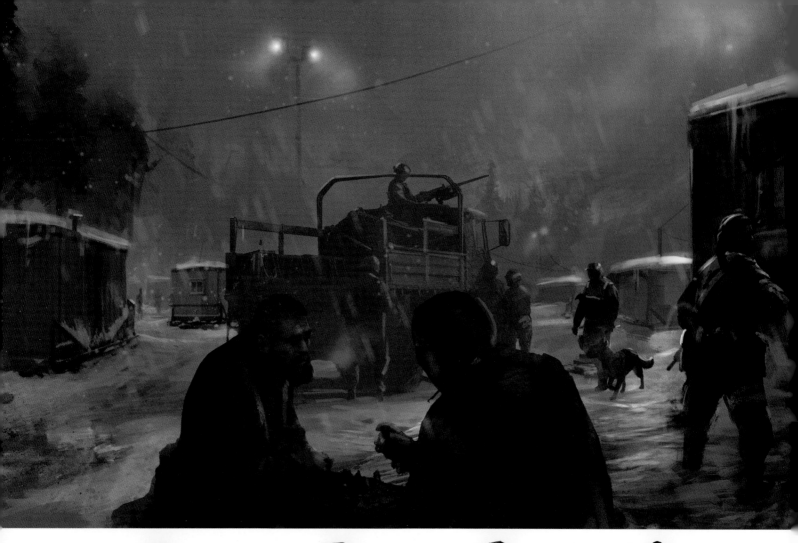

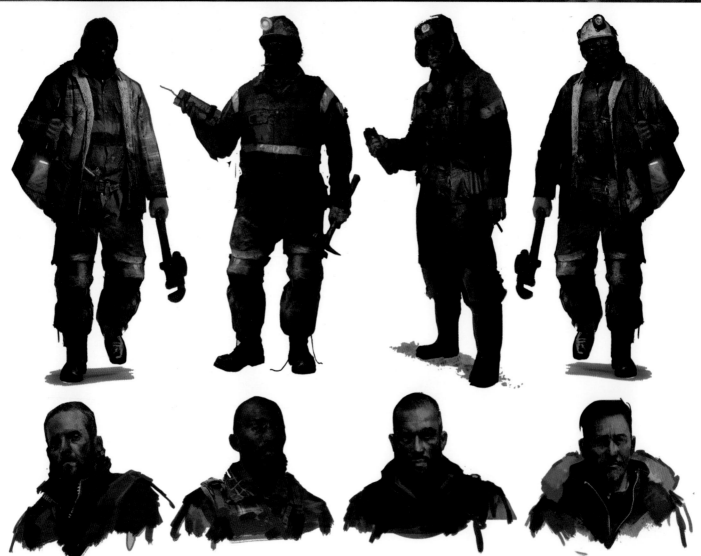

Konstantin has delved into the darker corners of the world of private military contractors in selecting recruits for his army. His men are untroubled by moral considerations and are willing to undertake dangerous assignments with a similarly casual disregard. Each is an exemplar of his specialism, though, be it mining, engineering, or a talent for violence. As long as Trinity's basic directives are fulfilled the hired men are left to their own devices; subjugating the Remnant villagers like some kind of conquering force.

THIS SPREAD: Art by Richard Healey

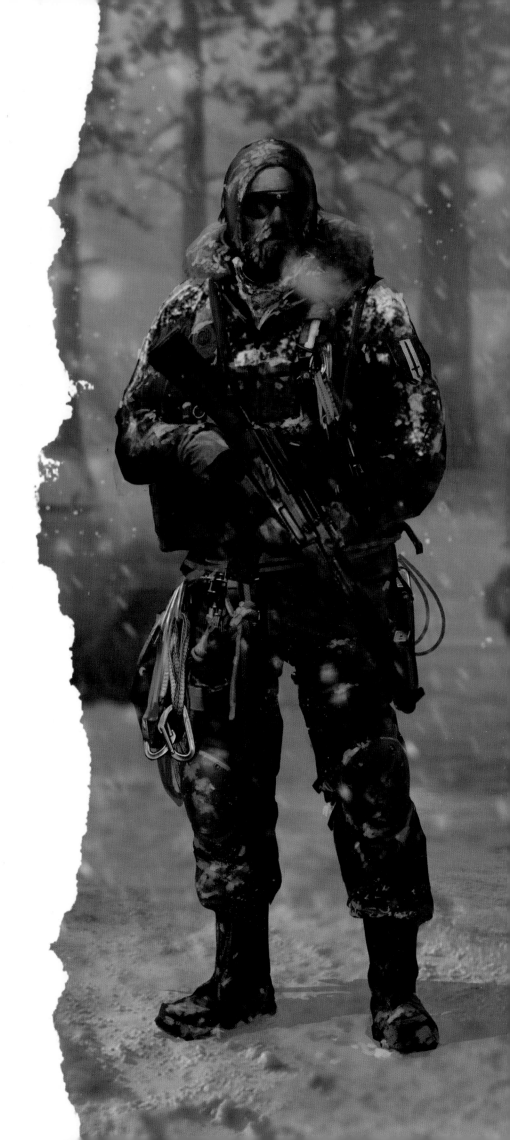

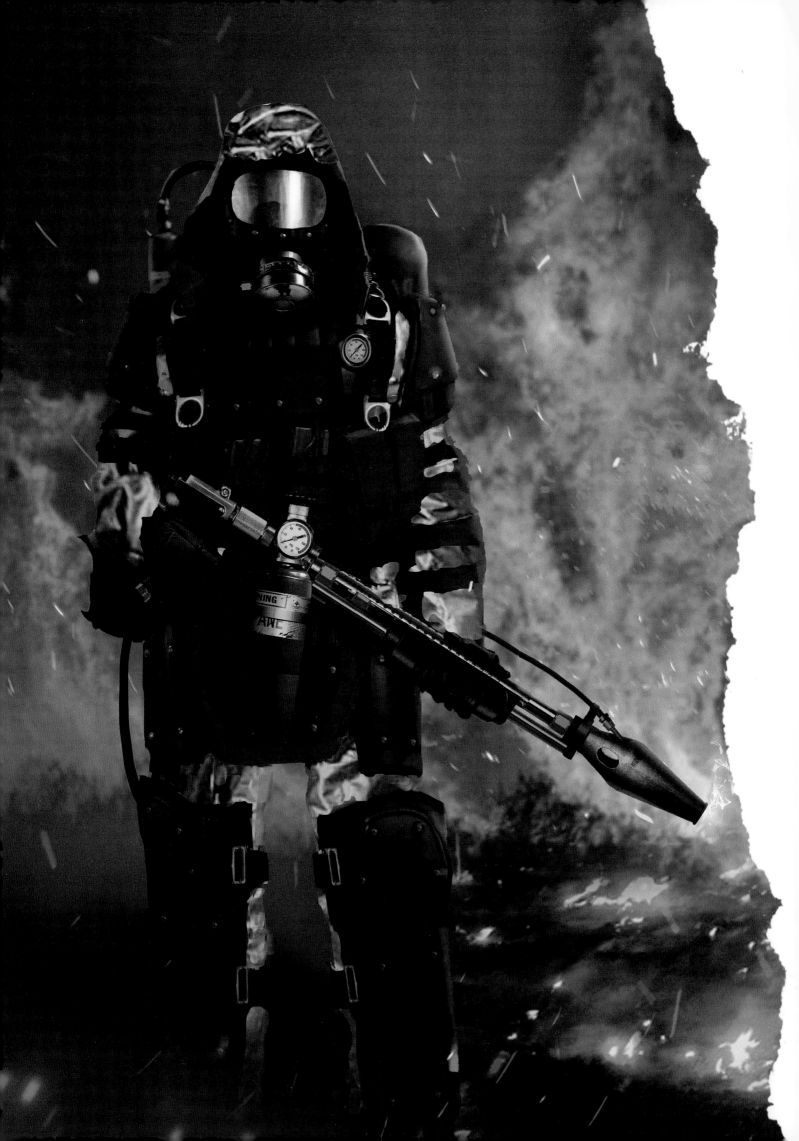

The Remnant villagers have only their wits, resolve and guerrilla fighting skills to offer in the face of Trinity's vicious assault. Well protected and better equipped, this Firefly wields a devastating flamethrower. More worrying, he also carries the fuel and breathing apparatus necessary to implement a sustained attack. The images below show a pair of armor and outfit iterations, while the picture to the left demonstrates how the operative is able to withstand an inferno of his own making. The Remnant forces are challenged to compete against Trinity's modern and sophisticated weapons of war.

THIS SPREAD: Art by Brandon Russell

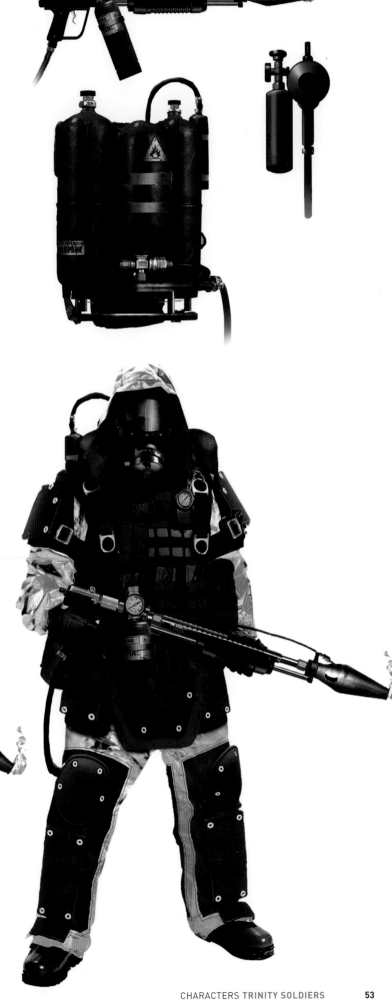

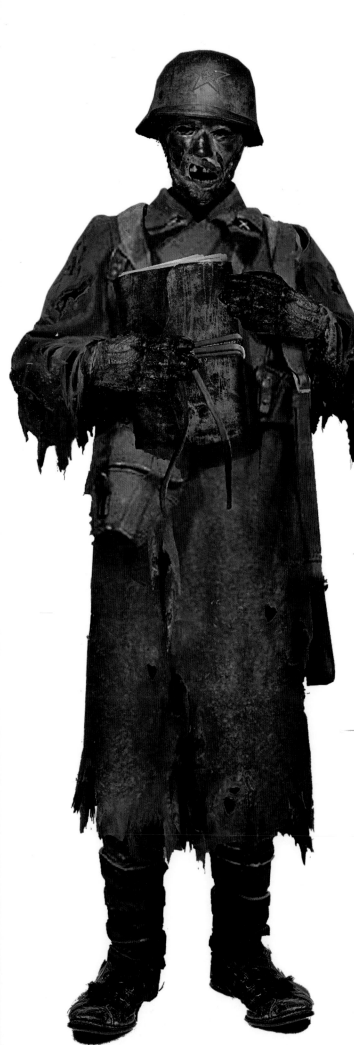

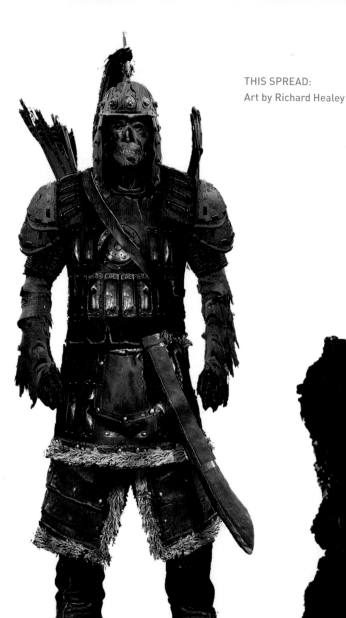

THIS SPREAD:
Art by Richard Healey

CORPSES

The remains of previous invaders make for a gruesome spectacle; mangled as they are by the ravages of time and yet cruelly preserved by the freezing temperatures of the Siberian wilderness. There are some among the Remnant who have witnessed the rise and fall of successive conquerors. However, these unfortunate souls have been literally frozen in time, their uniforms and outfits surviving to attest their origins, if not the precise nature of their deaths. "These corpses reveal layers of history and provide clues throughout the world," begins Adams. "They are variations of modern, Byzantine, Mongol, and Soviet layers. The images illustrate how all of these different civilizations have intertwined with one another."

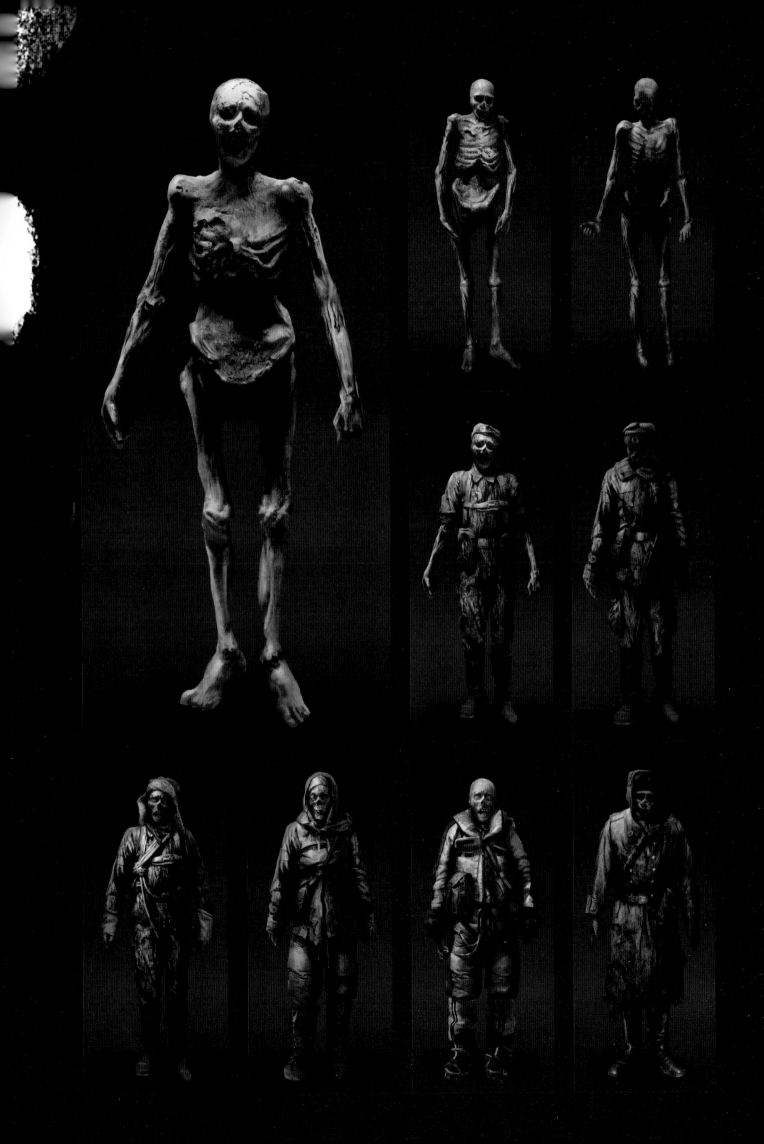

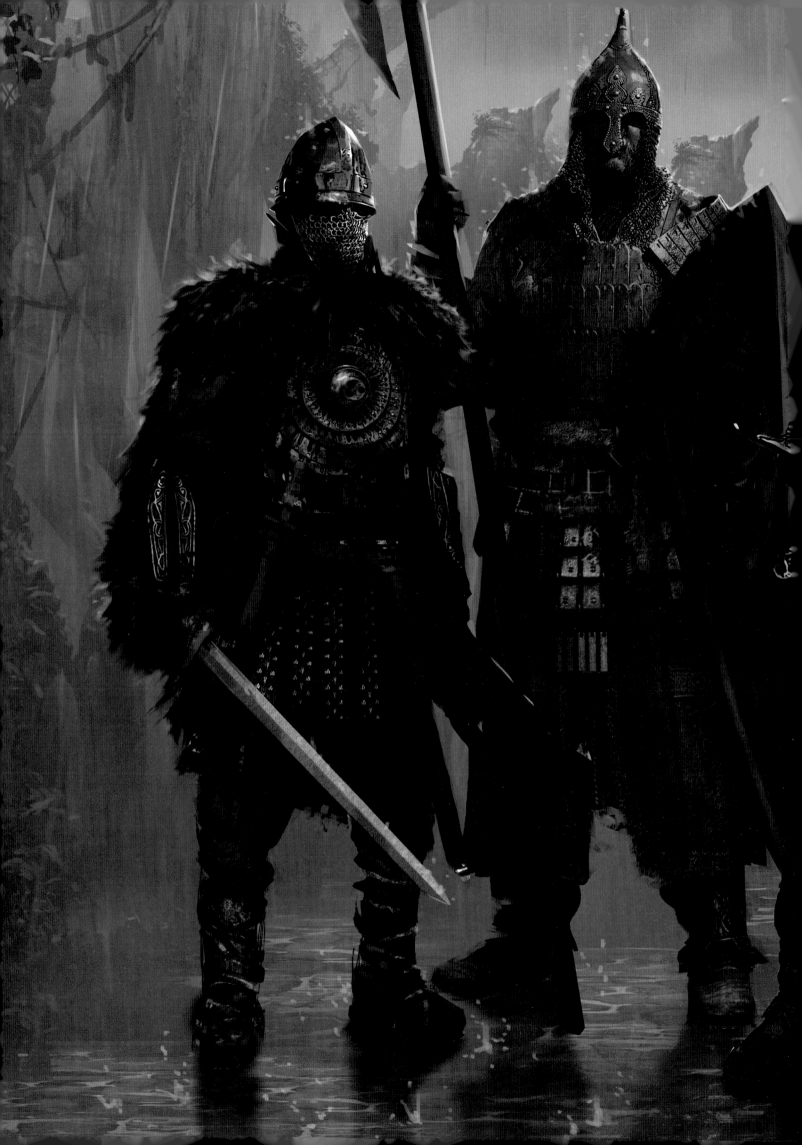

DEATHLESS ONES

The Deathless Ones are an ancient army who have given their souls to the Divine Source and sworn their allegiance to the prophet. Their origins date from the Byzantine era, when the young sons of wealthy families lost the favor of the successor to the emperor they had been guarding. Falling in with Jacob and his adherents when they were expelled from Constantinople, and protecting the pilgrims as they escaped to what would become their frozen homeland, the Deathless Ones are forever fated to patrol the lost city of Kitezh, protecting object that holds their souls. The chainmail and plate armor weighs heavily on the empty shells of these once proud warriors. In the present day, the Deathless Ones barely acknowledge the villagers as their descendants, they defend the Divine Source against all trespassers.

THIS SPREAD: Art by Brian Horton

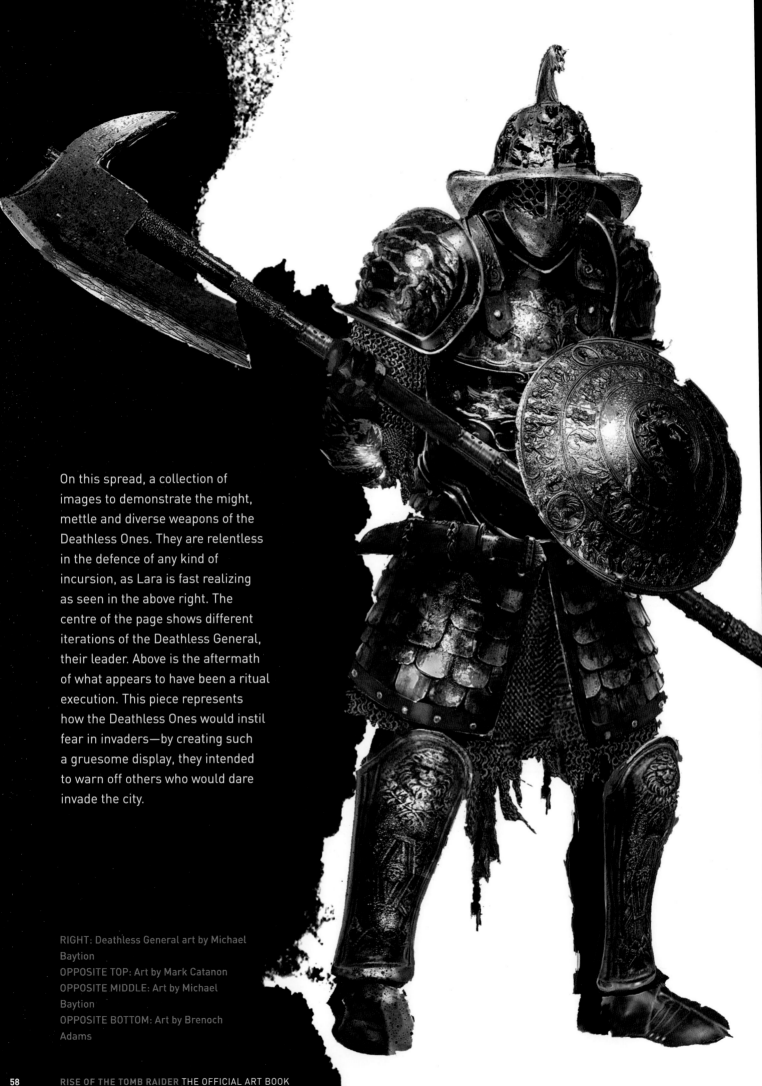

On this spread, a collection of images to demonstrate the might, mettle and diverse weapons of the Deathless Ones. They are relentless in the defence of any kind of incursion, as Lara is fast realizing as seen in the above right. The centre of the page shows different iterations of the Deathless General, their leader. Above is the aftermath of what appears to have been a ritual execution. This piece represents how the Deathless Ones would instil fear in invaders—by creating such a gruesome display, they intended to warn off others who would dare invade the city.

RIGHT: Deathless General art by Michael Baytion
OPPOSITE TOP: Art by Mark Catanon
OPPOSITE MIDDLE: Art by Michael Baytion
OPPOSITE BOTTOM: Art by Brenoch Adams

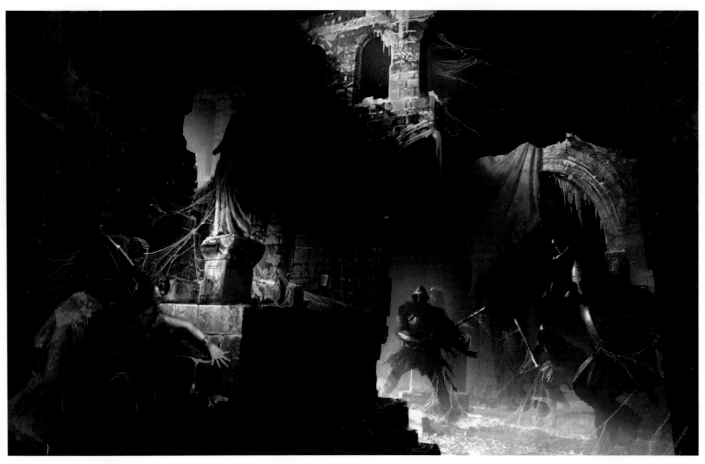

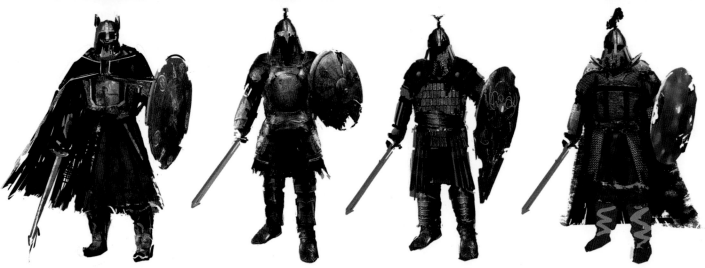

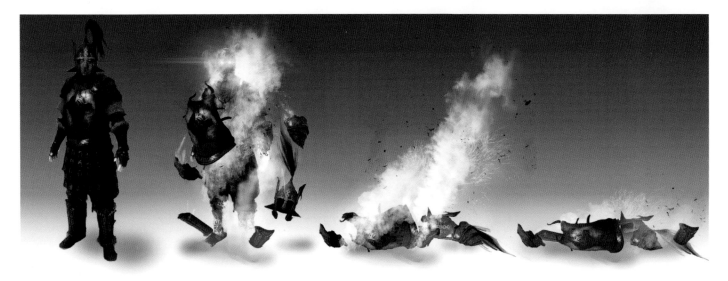

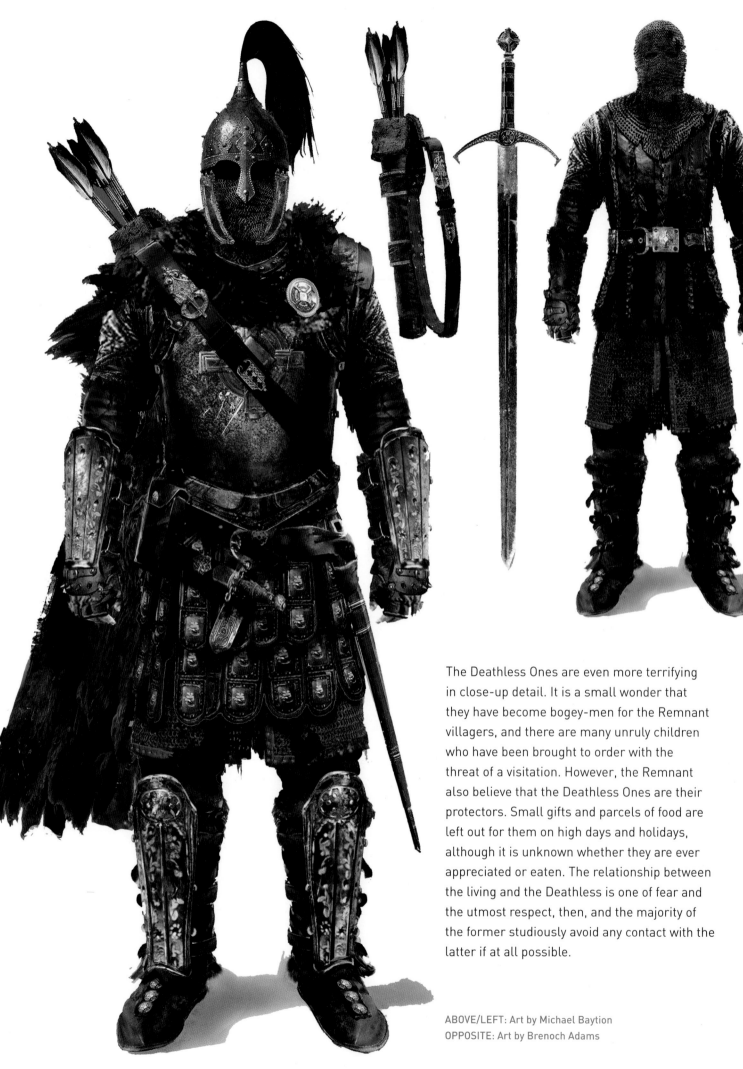

The Deathless Ones are even more terrifying in close-up detail. It is a small wonder that they have become bogey-men for the Remnant villagers, and there are many unruly children who have been brought to order with the threat of a visitation. However, the Remnant also believe that the Deathless Ones are their protectors. Small gifts and parcels of food are left out for them on high days and holidays, although it is unknown whether they are ever appreciated or eaten. The relationship between the living and the Deathless is one of fear and the utmost respect, then, and the majority of the former studiously avoid any contact with the latter if at all possible.

ABOVE/LEFT: Art by Michael Baytion
OPPOSITE: Art by Brenoch Adams

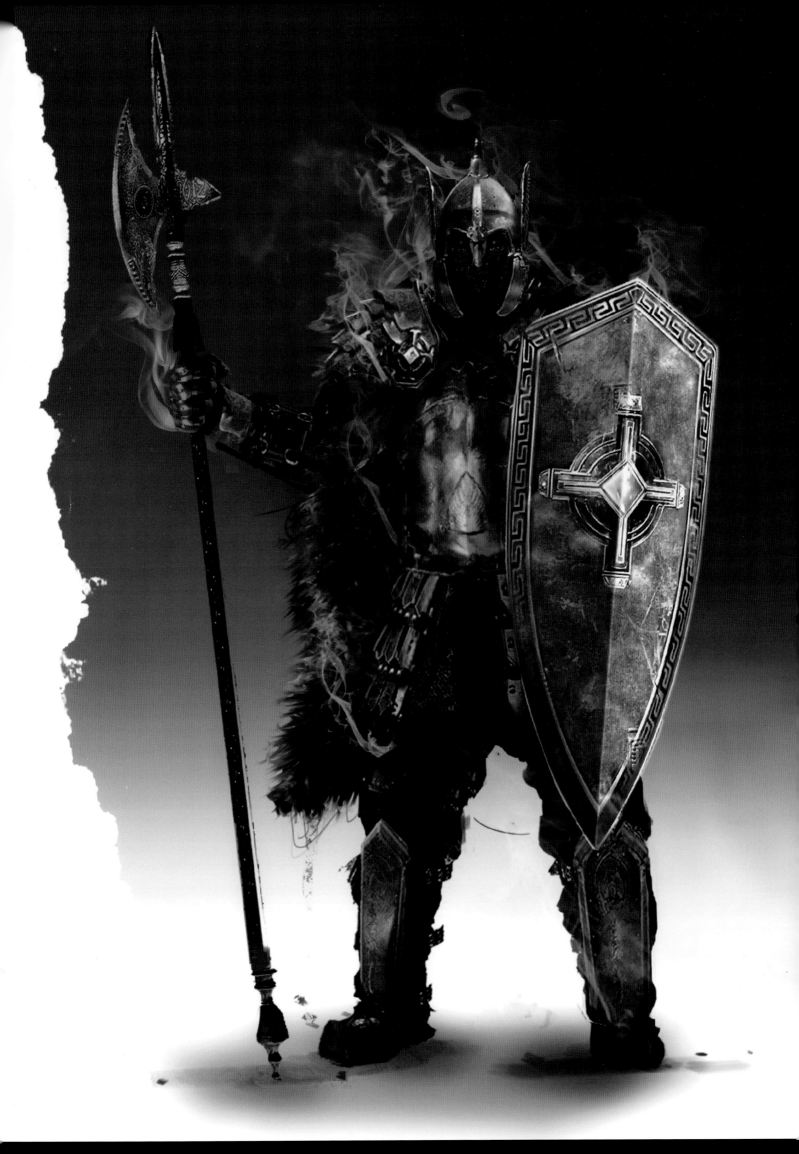

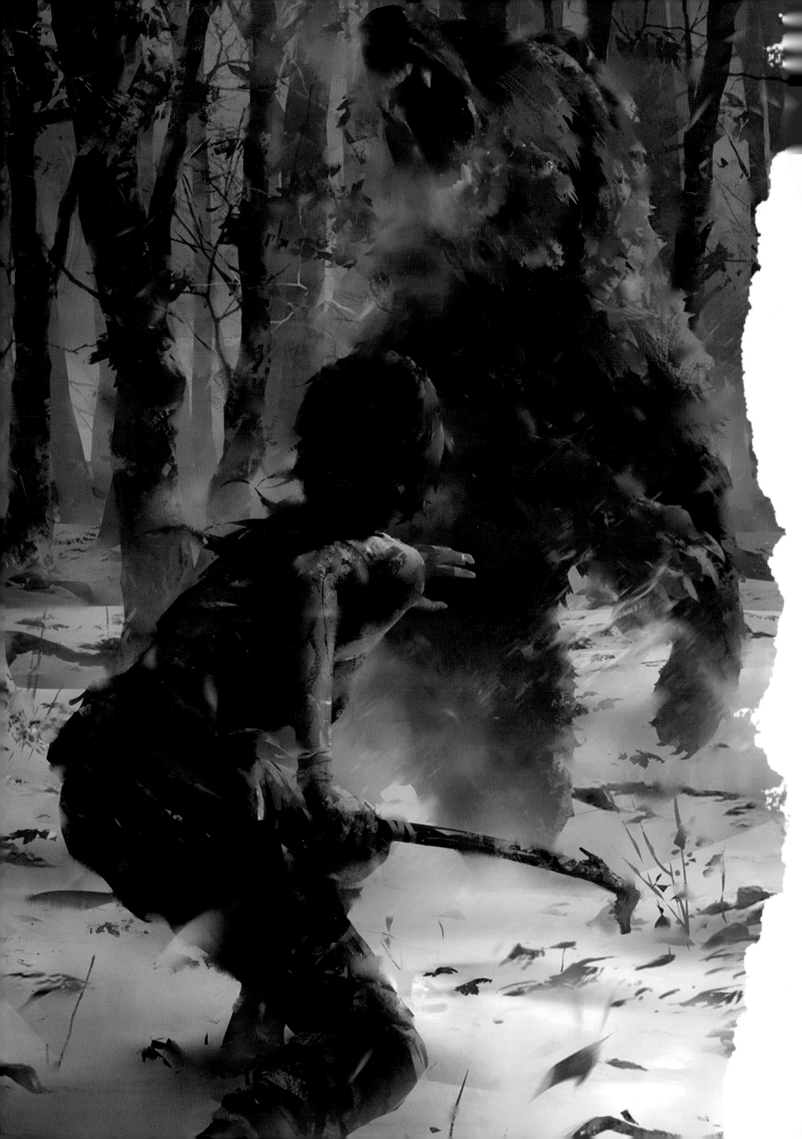

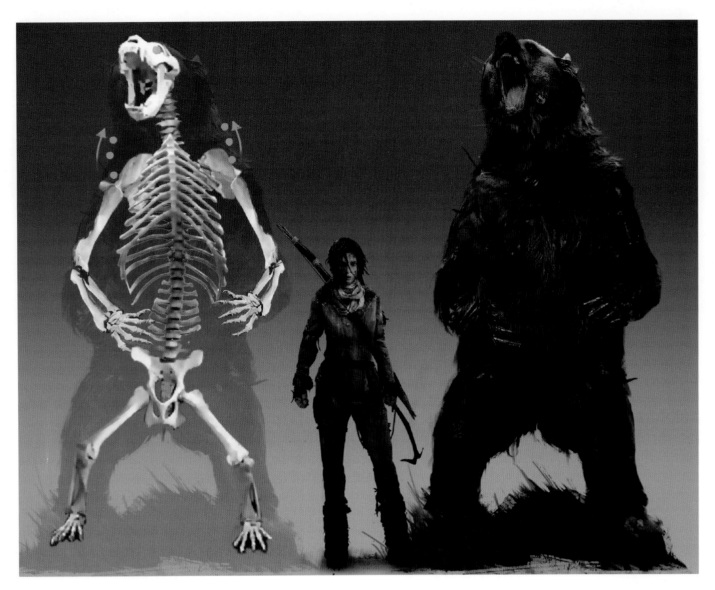

ANIMALS

Lara is a born survivor, but she has to be resourceful to survive in this harsh environment and she is sometimes forced to retreat until she has the requisite skills and weapons. She is surely outsized, if not always outmatched by the local bear population, while the sequence below shows that she should think carefully about where to hide from an attack. "We wanted to make sure that everything felt anatomically correct, so when the bear swipes at Lara it felt real and that the animators had these references to bring it all to life," adds Adams.

OPPOSITE: Art by William Wu
ABOVE/BELOW: Art by Brenoch Adams

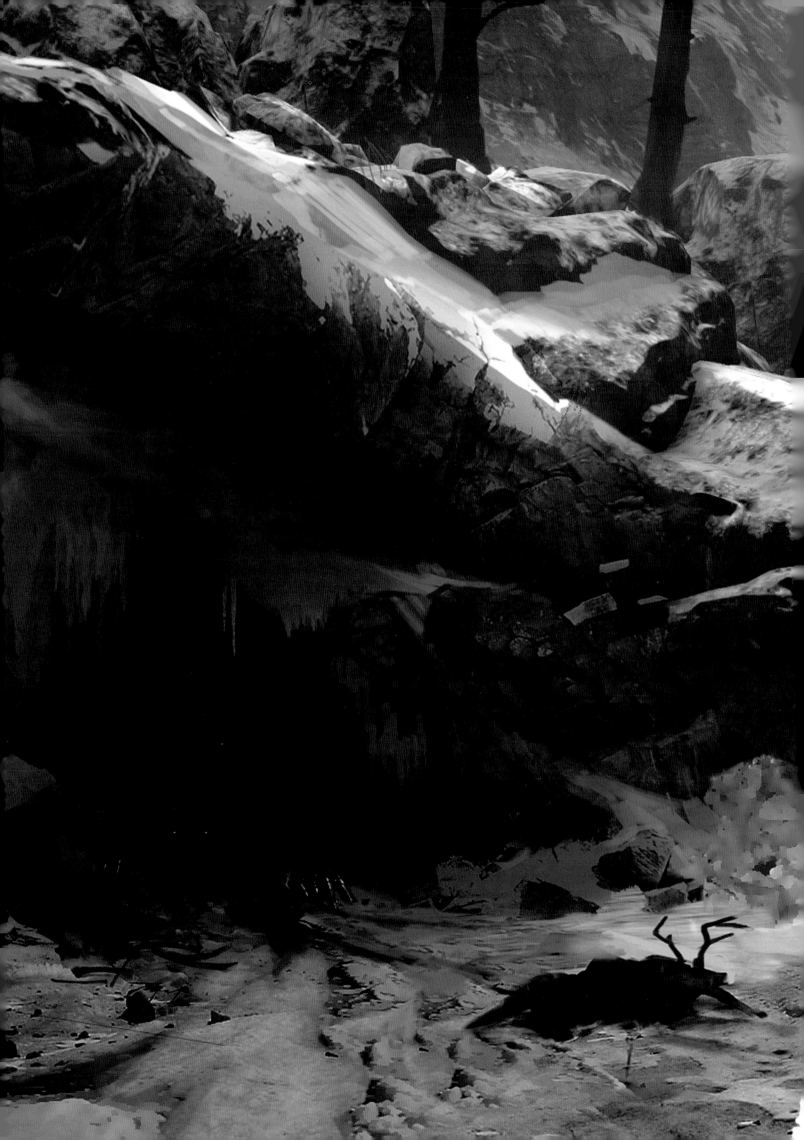

PREDATORS

The Siberian wilderness is a beautiful yet hostile environment. The indigenous animals are hardened by nature and protect the layers of secrets from all trespassers. Below, Lara repels an attack from the massive Bear. The wildlife is an ever-present threat in this remote region, as Russell explains: "These are the pockets of the world that are untouched by modern civilization. They're protected by these animals that are also hardened by the brutal landscape and environment. We also put the animals through the survival lens—the animals have scars, burn marks, and other elements to reflect the ruthless environment they live in."

OPPOSITE/BELOW: Art by Brenoch Adams
RIGHT: Wolf art by Michael Baytion

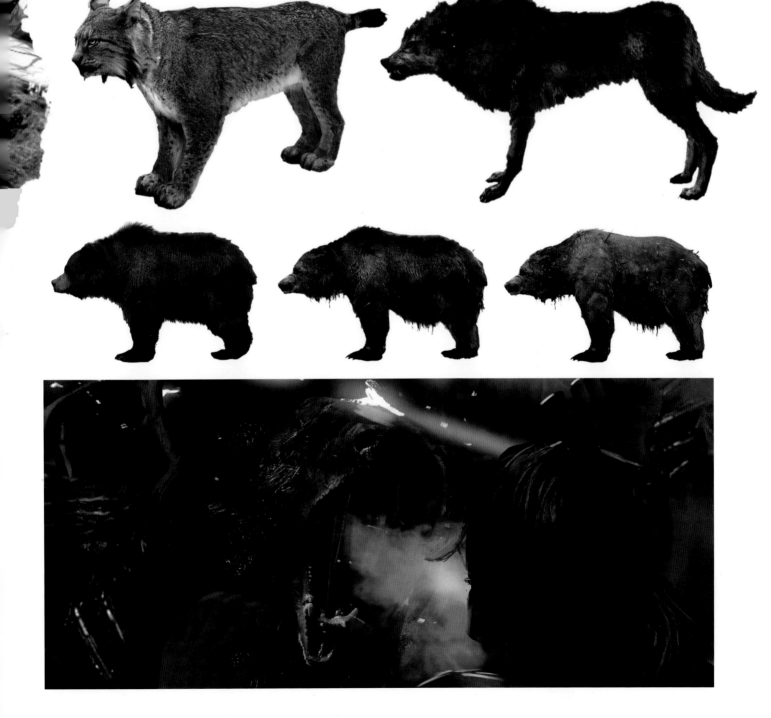

PREY

Whilst exploring the Siberian wilderness, Lara can employ her hunting skills to find food and the raw materials for crafting items. Sharp tusks and pointed antlers indicate that she will need to tread carefully in certain instances, though. "Gameplay-wise, we also wanted to make sure that there are different environments with different wildlife so Lara has to go and hunt these exotic animals to craft new items and resources," says Adams. "We also wanted to show different class systems, because certain materials are used from each for crafting."

THIS SPREAD: Art by Richard Healey

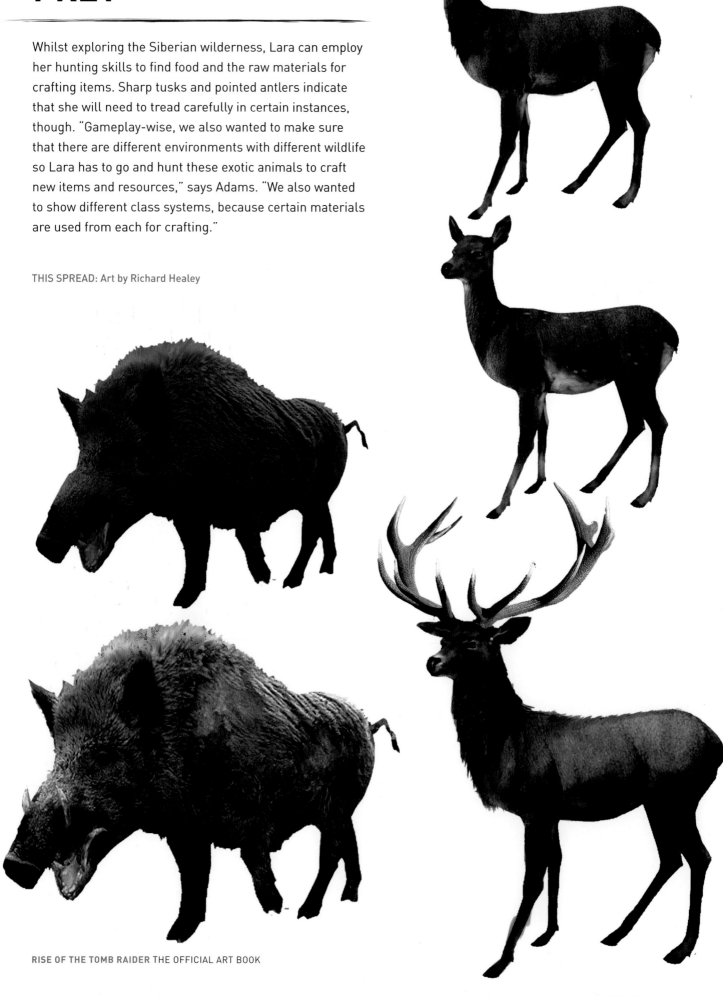

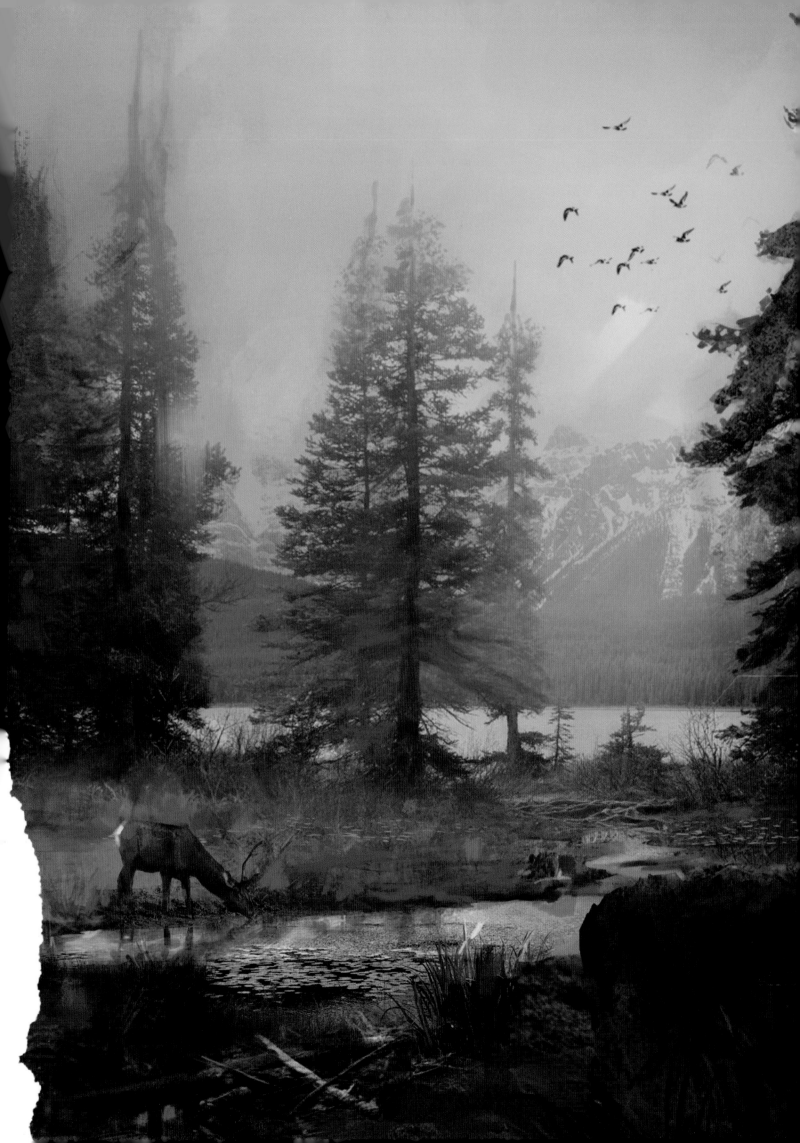

CHAPTER 2
WEAPONS AND PROPS

Lara is smart and resourceful, adapting to her environment in desperate situations to survive. Her chosen weapons and equipment reflect both her intentions and capabilities, whether through spontaneous self-preservation or calculated efficiency in the hunt. Environments, natural and manmade, present Lara with numerous options for tailoring gear to suit her needs. Even basic components may serve as deadly upgrades, while others require specialist parts to assemble. Without Lara's survival experience, however, even the most valuable of objects appear as useless bits and pieces.

NOTE! For fans who have not yet completed the game, this chapter includes details that could be considered plot spoilers.

THIS SPREAD: Art by Brandon Russell

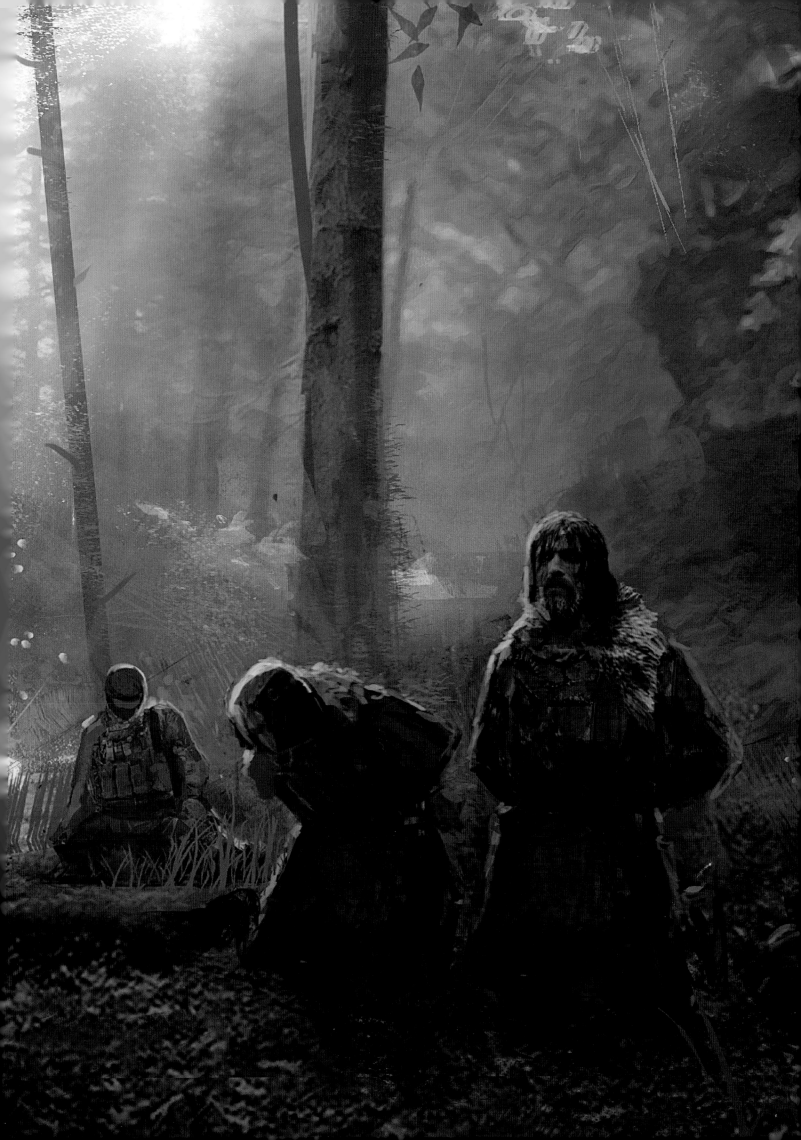

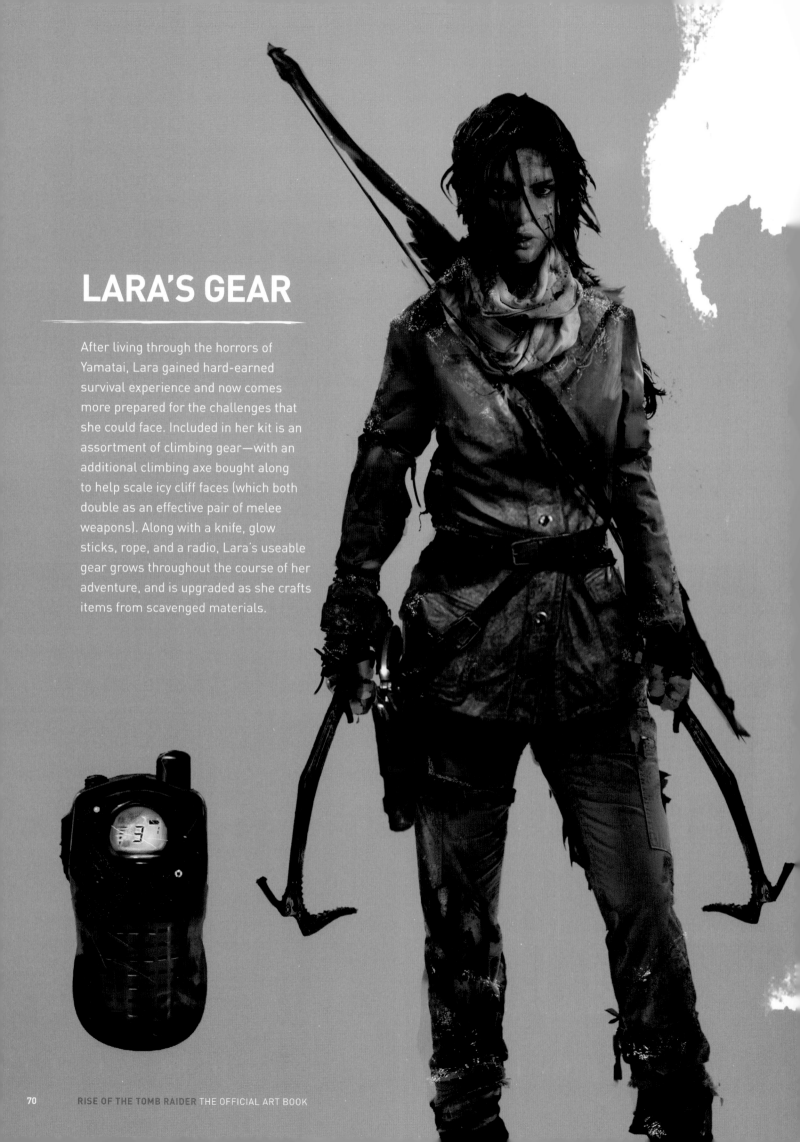

LARA'S GEAR

After living through the horrors of Yamatai, Lara gained hard-earned survival experience and now comes more prepared for the challenges that she could face. Included in her kit is an assortment of climbing gear—with an additional climbing axe bought along to help scale icy cliff faces (which both double as an effective pair of melee weapons). Along with a knife, glow sticks, rope, and a radio, Lara's useable gear grows throughout the course of her adventure, and is upgraded as she crafts items from scavenged materials.

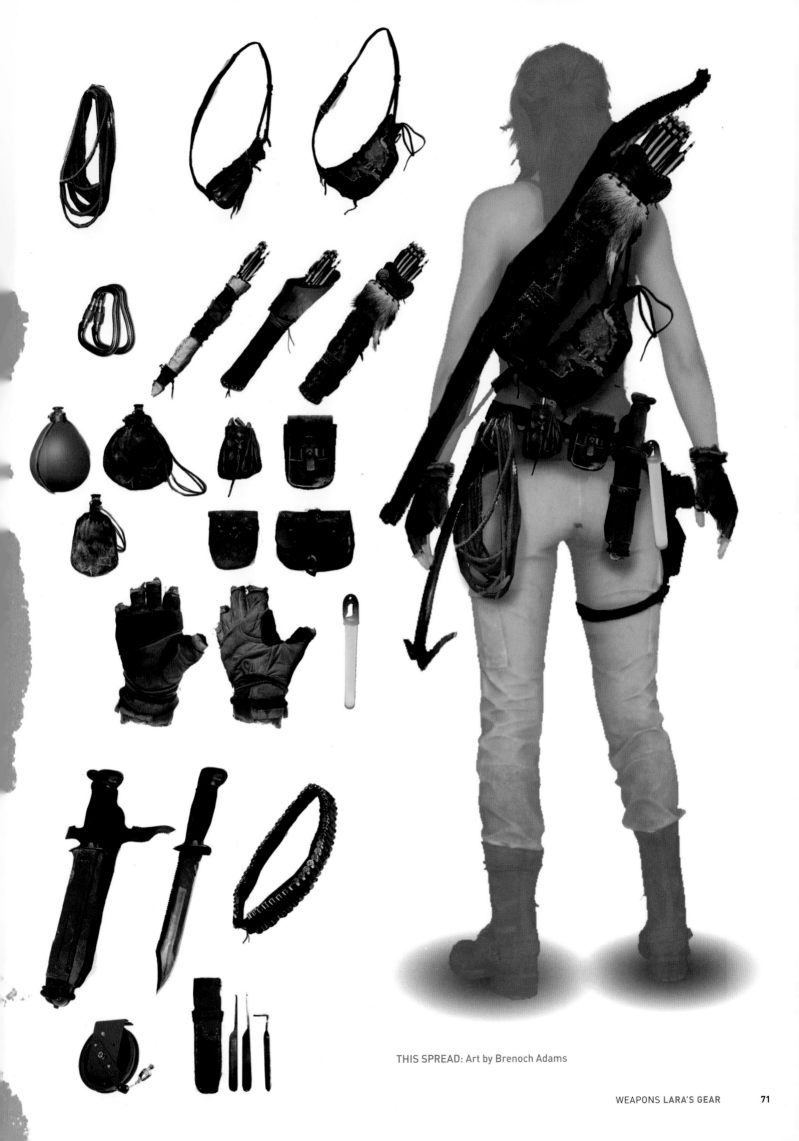

THIS SPREAD: Art by Brenoch Adams

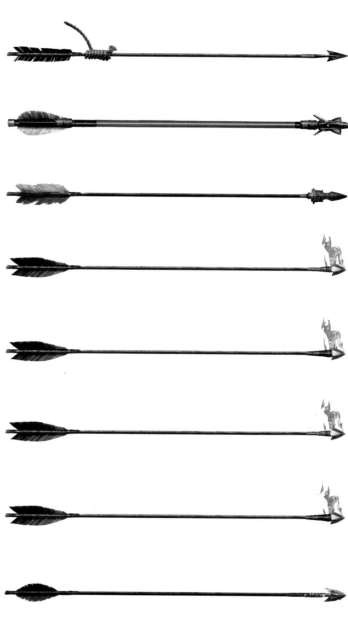

ABOVE: Pickaxe design by Brenoch Adams
RIGHT/OPPOSITE: Arrow and bow designs by Mark Castanon

Throughout the game, there are sixteen unique resources that Lara can collect and use in the upgraded crafting mechanic, leading to multiple purpose-built examples of bow and arrows. As in her previous adventure on the island of Yamatai, Lara is able to use a variety of arrows—from offensive piercing and explosive arrows to tailor-made rope arrows for climbing structures or breaking open doors. In addition to these, Lara learns how to craft fire arrows, which can be used against enemies and to light specific objects on fire. Along with her signature bow, Lara has her climbing axes that double as a tool to climb and a weapon in combat.

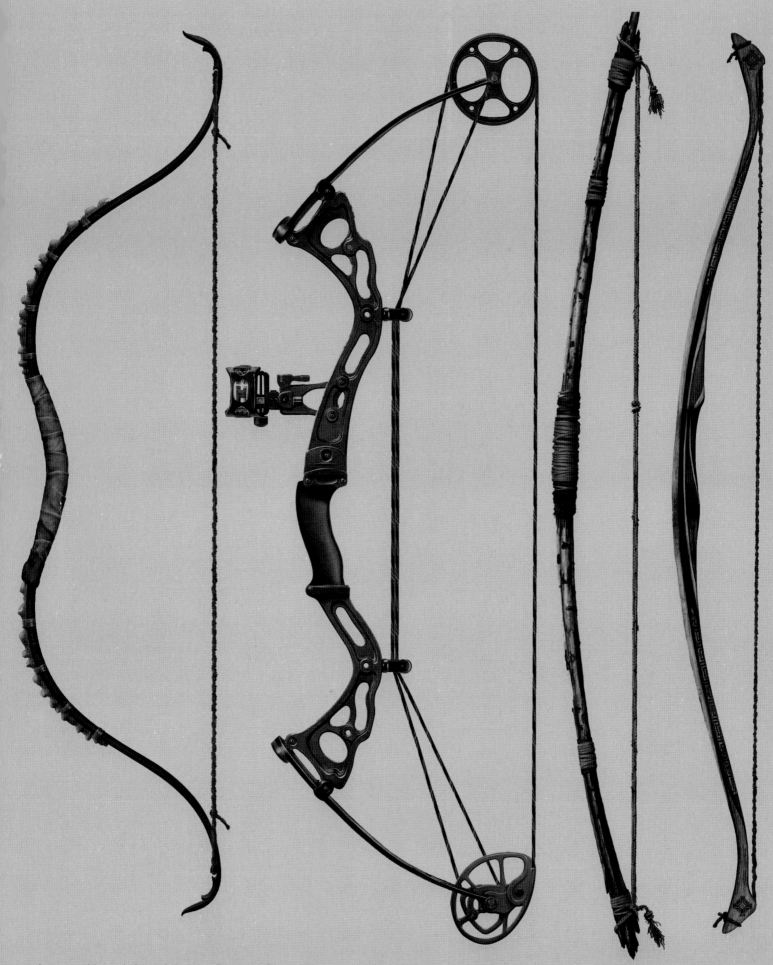

Arranged here left to right: the Recurve Bow, Compound Bow, Makeshift Bow, and Ancient Horn Bow, illustrating the variety of base examples available to Lara. Distinctive silhouettes and textured qualities embellish the level of detail and are an essential part of Lara's survivalist ensemble.

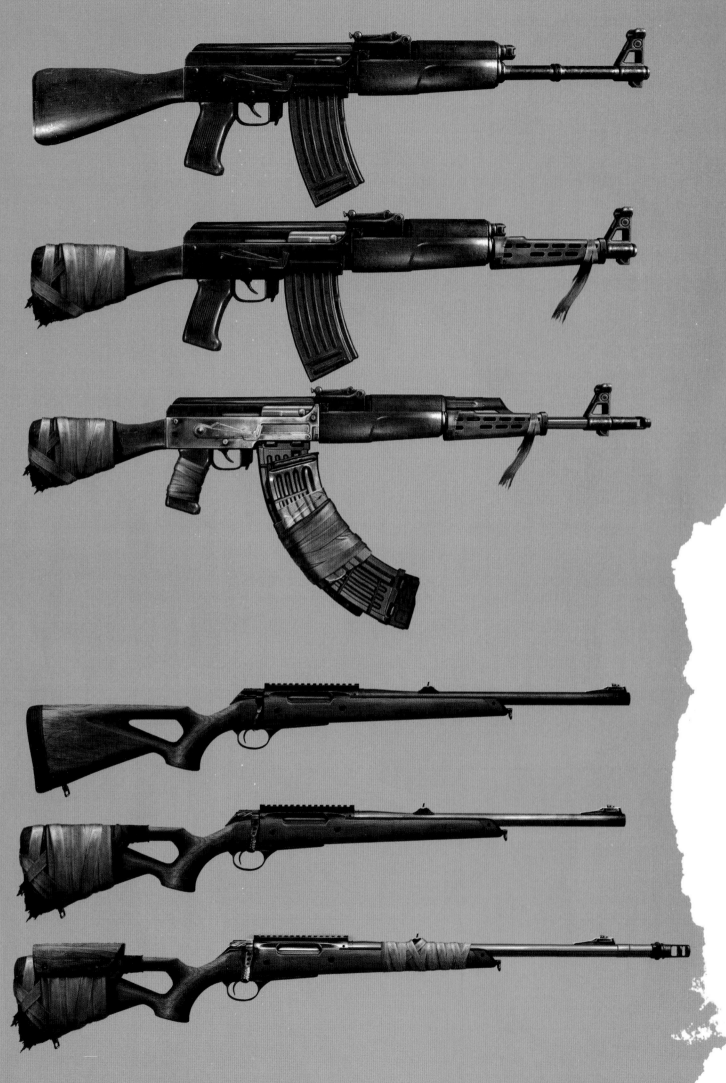

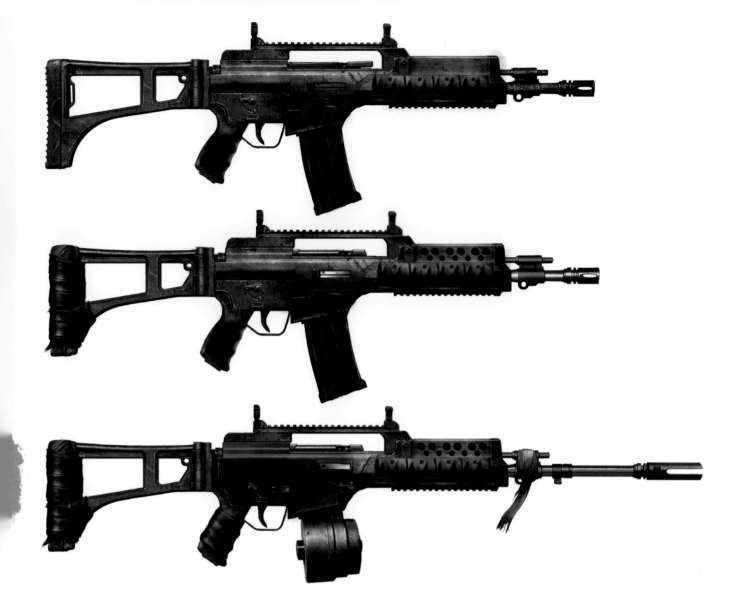

GUNS

These assault and bolt-action rifles drastically change as Lara upgrades them throughout the game. Duct taped magazines and bandaged barrels are counterbalanced with reinforced rifle butts, all very tidily constructed by an expert hand. The silenced sub-machine gun (*left*) has its butt plate wrapped to avoid slippage, decreasing spread and kickback. All are an extension of Lara's willpower in one form or another, highlighting her sheer practicality and occasionally lethal creativity.

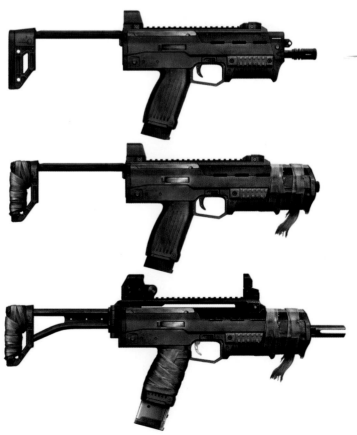

THIS SPREAD: Art by Mark Castanon

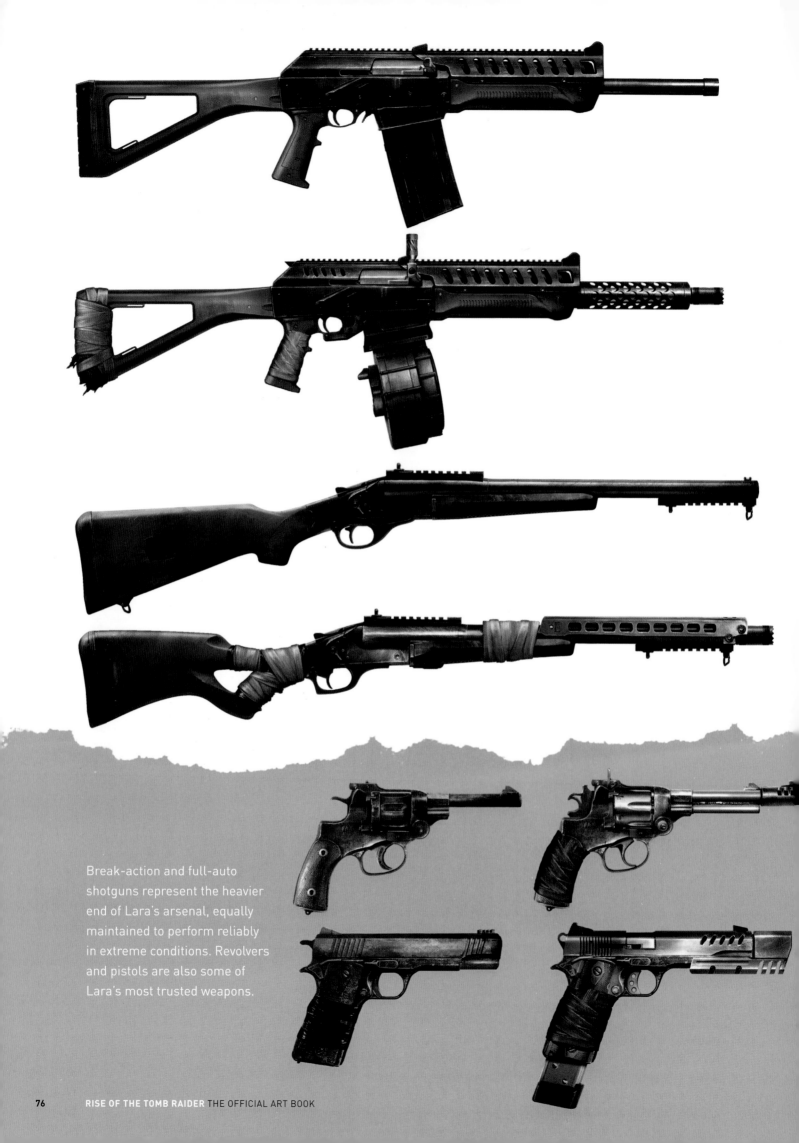

Break-action and full-auto shotguns represent the heavier end of Lara's arsenal, equally maintained to perform reliably in extreme conditions. Revolvers and pistols are also some of Lara's most trusted weapons.

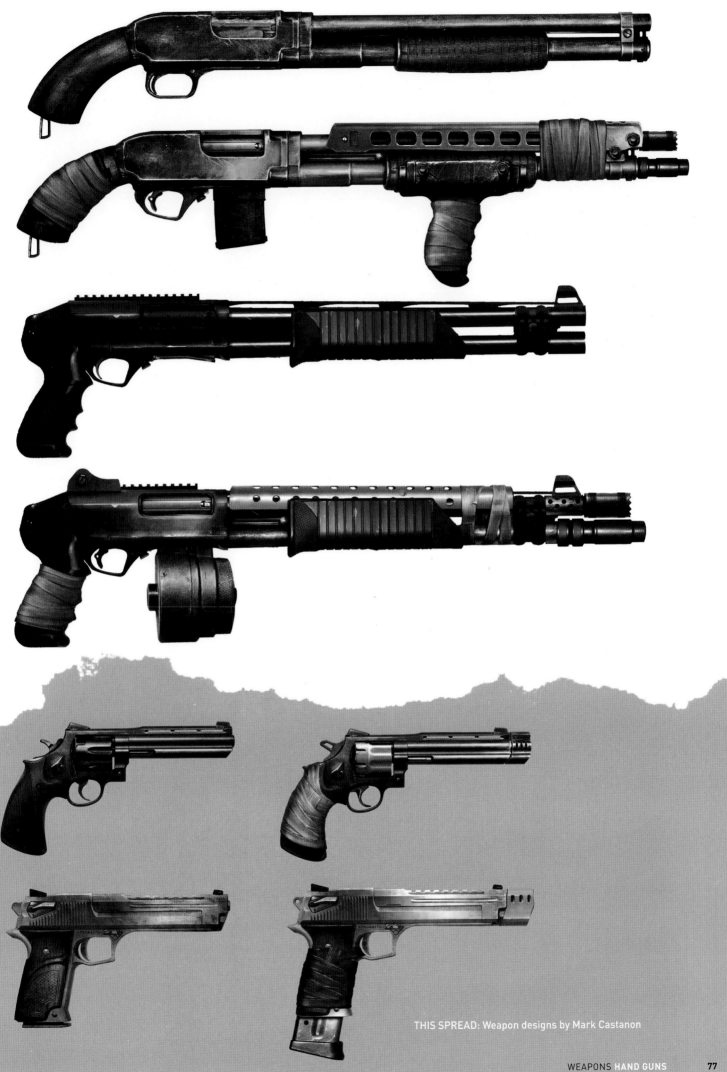

THIS SPREAD: Weapon designs by Mark Castanon

MURALS

During the prologue to *Rise of the Tomb Raider*, we learn of the myth behind the immortal Prophet, the Deathless Ones, and the lost city of Kitezh. These ancient murals tell the story of a heretical 9th century prophet who is said to have controlled the elements and held power over the very fabric of life. We see him being worshipped as a messiah, then leading his followers to a new land in order to escape oppressors. On the following spread, a faded Byzantine mural depicts a familiar ally and his holy knights from several lifetimes ago.

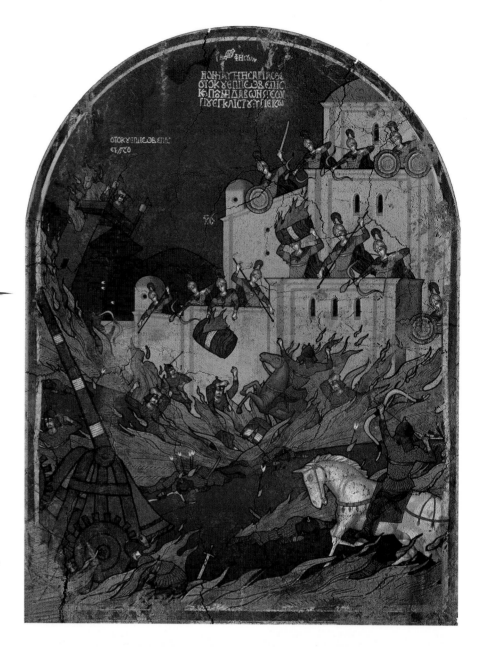

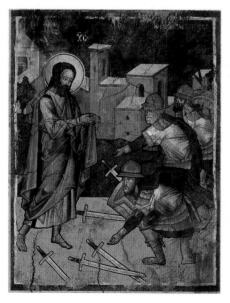
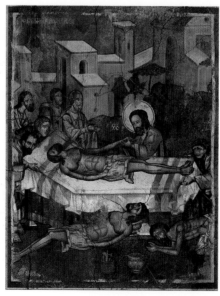
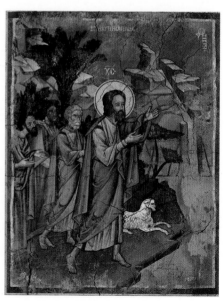

THIS SPREAD: Art by Brandon Russell
FOLLOWING SPREAD: Art by Brandon Russell

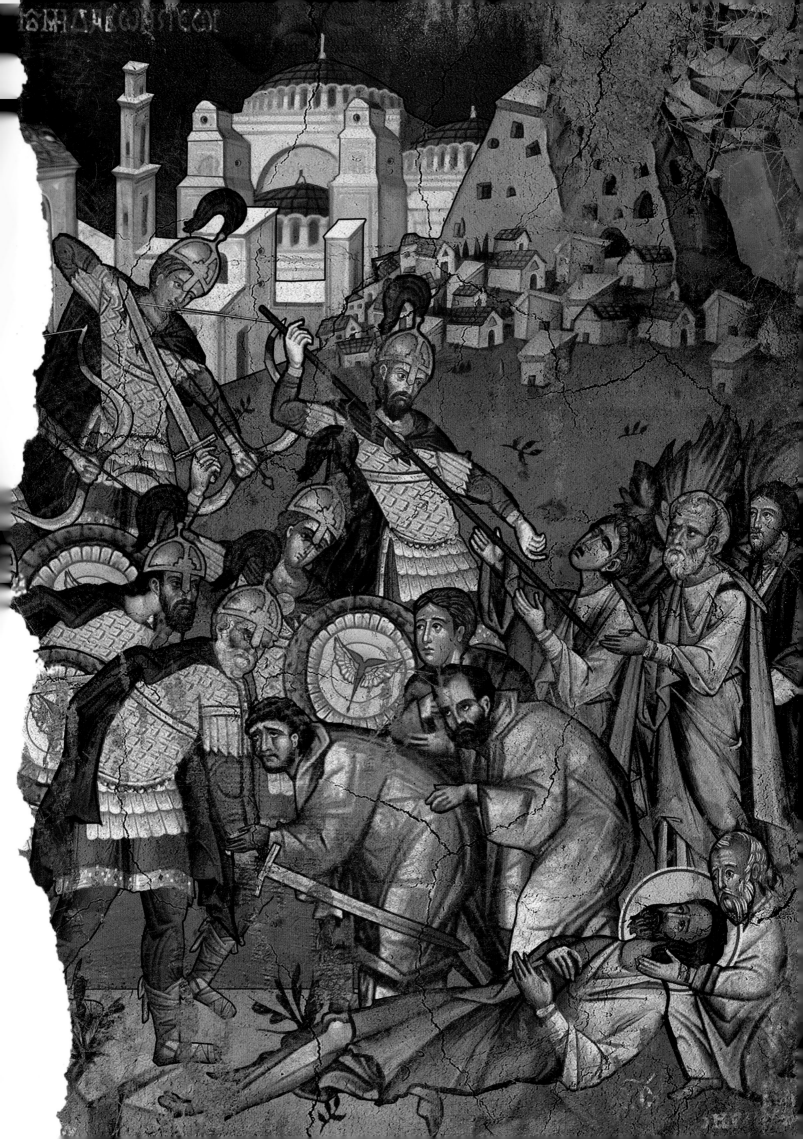

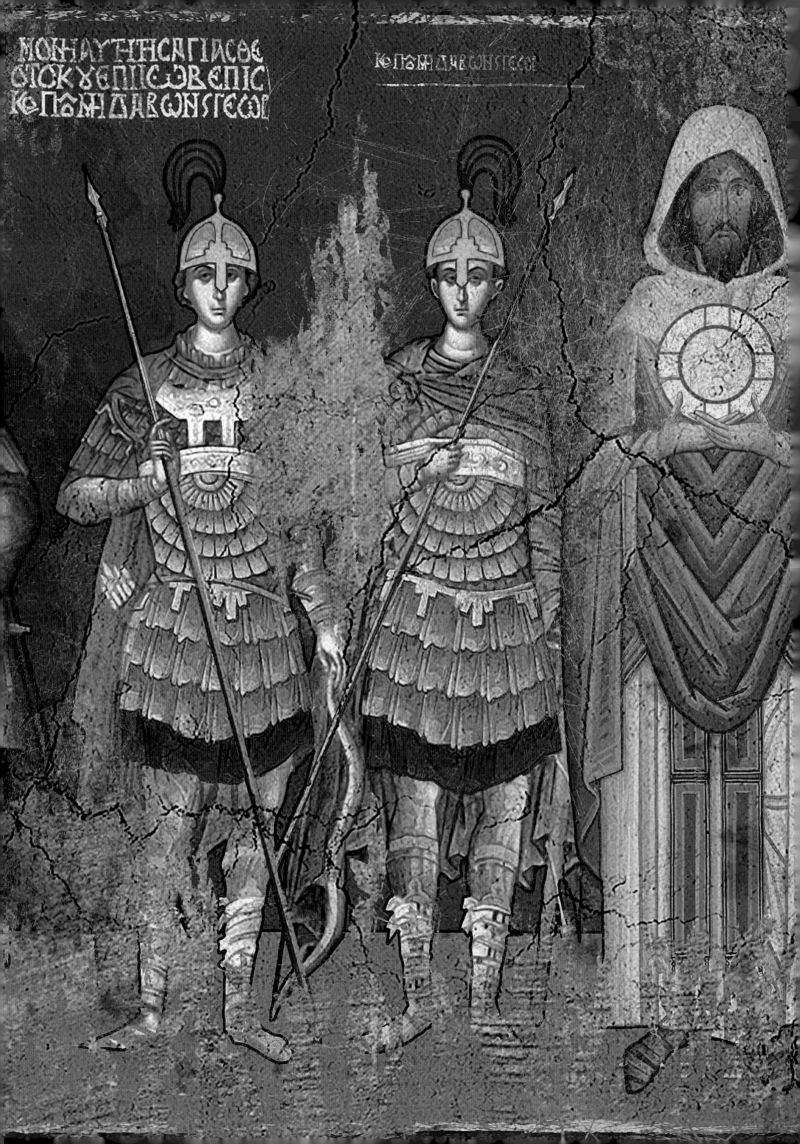

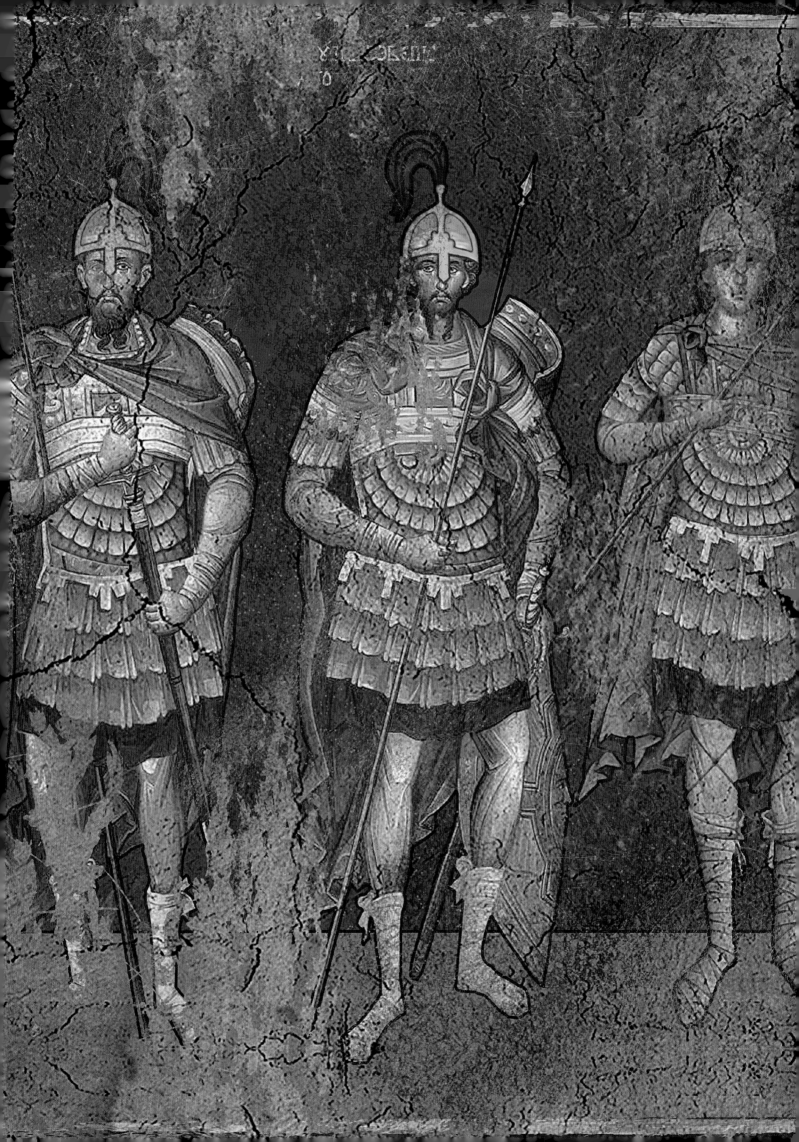

CHAPTER 3
LOCATIONS

Many of the most beautiful locations on Earth are also among the most hostile. This balance forms one of the central themes of *Rise of the Tomb Raider*, imparting a sense of ever-present danger with the majestic beauty of Syria, Siberia, and beyond. In addition to the natural world's extremes, there are also man-made structures from across centuries, filled with mysteries waiting to be discovered. Ancient subterranean temples are self-destructing under their own weight. Abandoned military establishments have lost none of their menace.

NOTE! *For fans who have not yet completed the game, this chapter includes details that could be considered plot spoilers.*

THIS SPREAD: Art by Mark Castanon

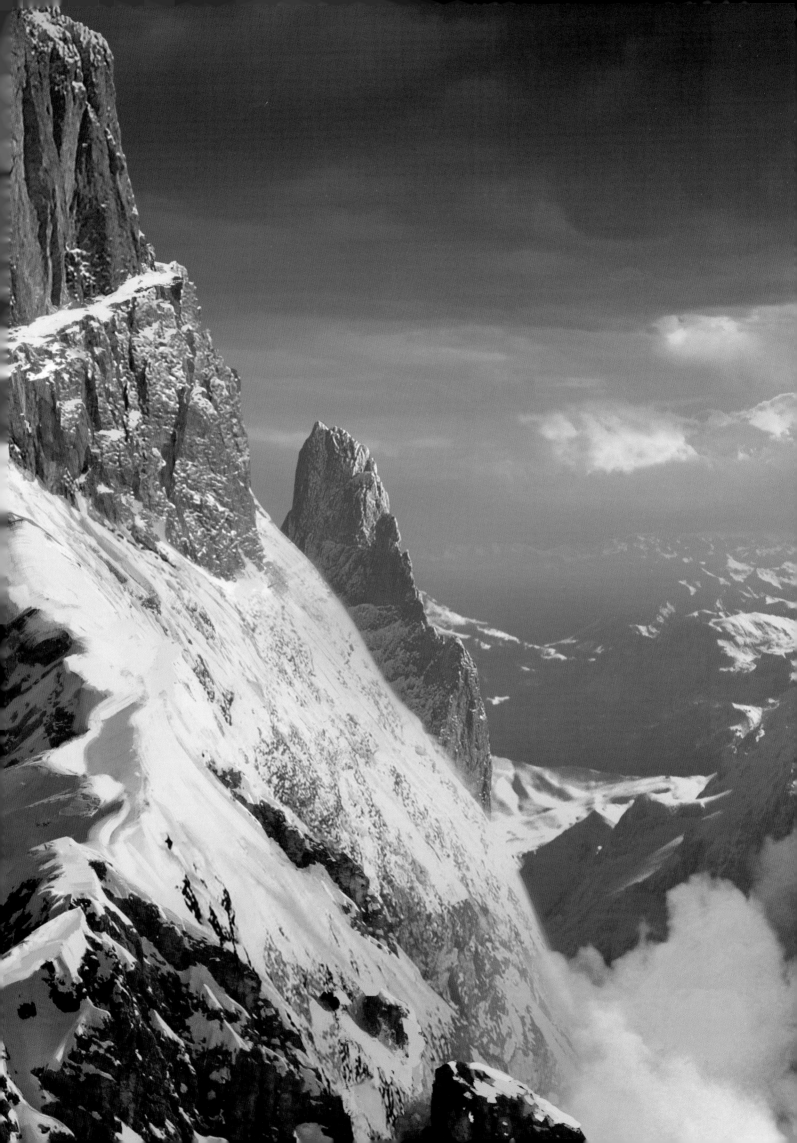

SYRIA

Syria is a country that has played home to many ancient kingdoms and empires, producing historical artifacts dating back to 10,000 BC. It is a land of diverse settings that lend themselves to stories of untold treasures in hidden tombs, and is an excellent backdrop for *Rise of the Tomb Raider*, per Brenoch Adams: "We wanted to use Syria because it has so much historical significance and is a land with a very diverse environment." Storyboards below show how concept artists imagined the chase, as Lara is almost caught in a hail of bullets and a near-fatal car crash.

RIGHT: Art by Brandon Russell
BELOW: Storyboards by Jeff Adams
OPPOSITE: Art by Michael Baytion

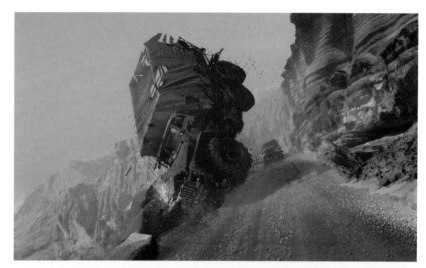

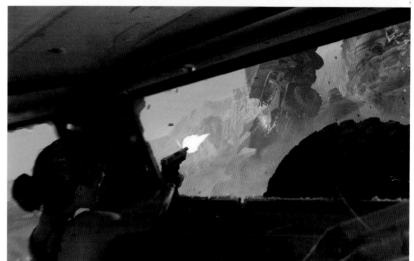

shot

LARA
Get us out of here!

shot

shot

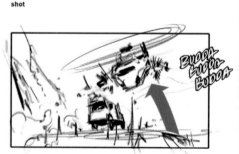

Then, out of the dust ahead, the helicopter emerges, opening fire on the jeep.

shot

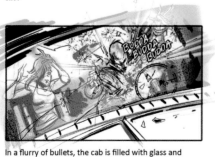

In a flurry of bullets, the cab is filled with glass and sparks.

shot
130B

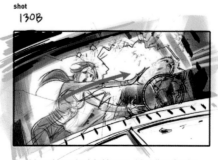

The driver slumps back in his seat. LAra dives for the wheel!

LARA (shocked)
No!

shot
140A

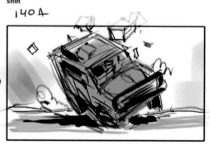

The jeep veers off the road, careening into a ravine before finally screeching to a stop upside down.

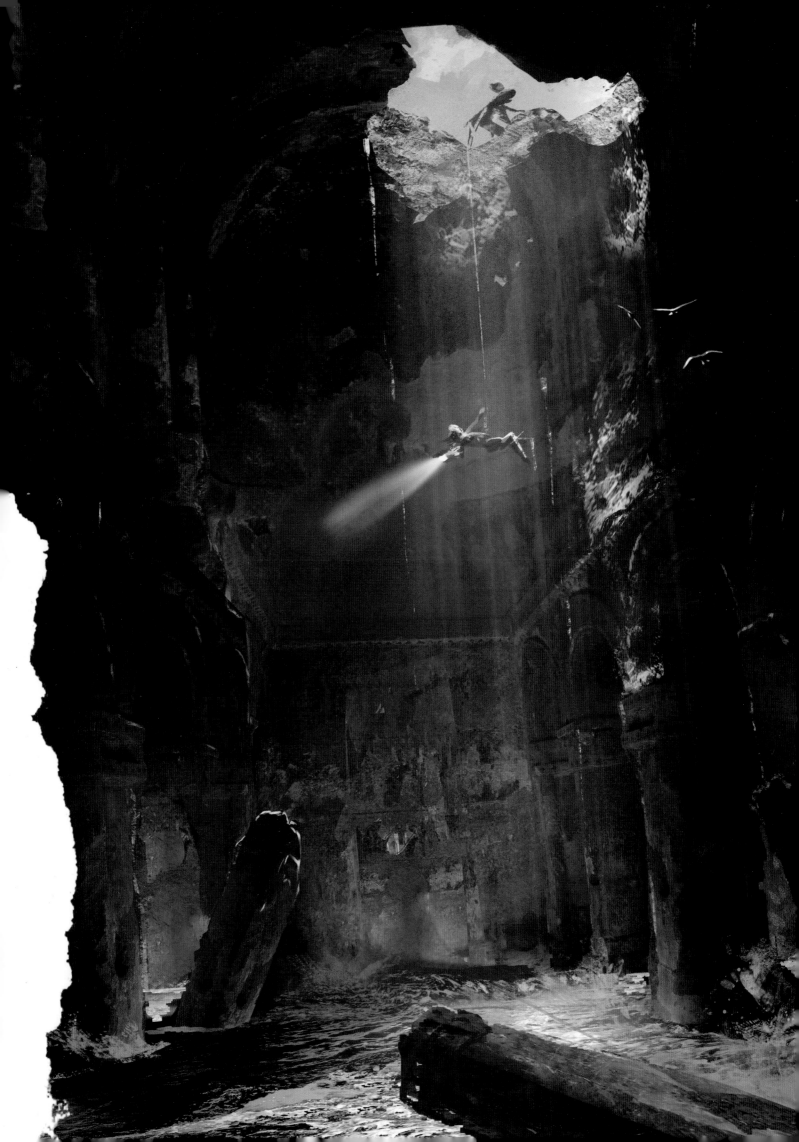

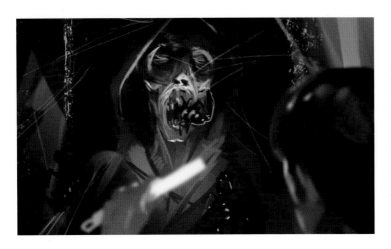
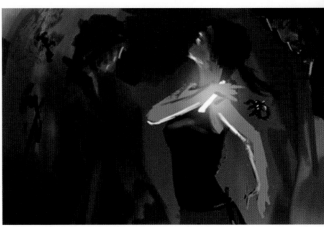

THIS SPREAD: Art by Brenoch Adams

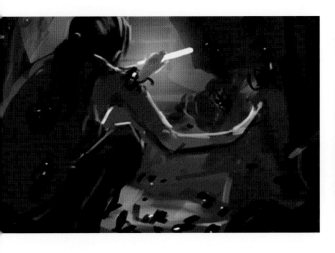

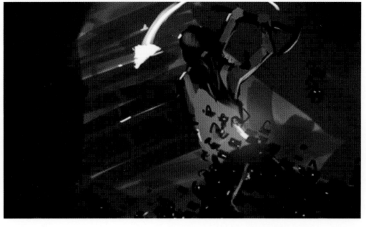

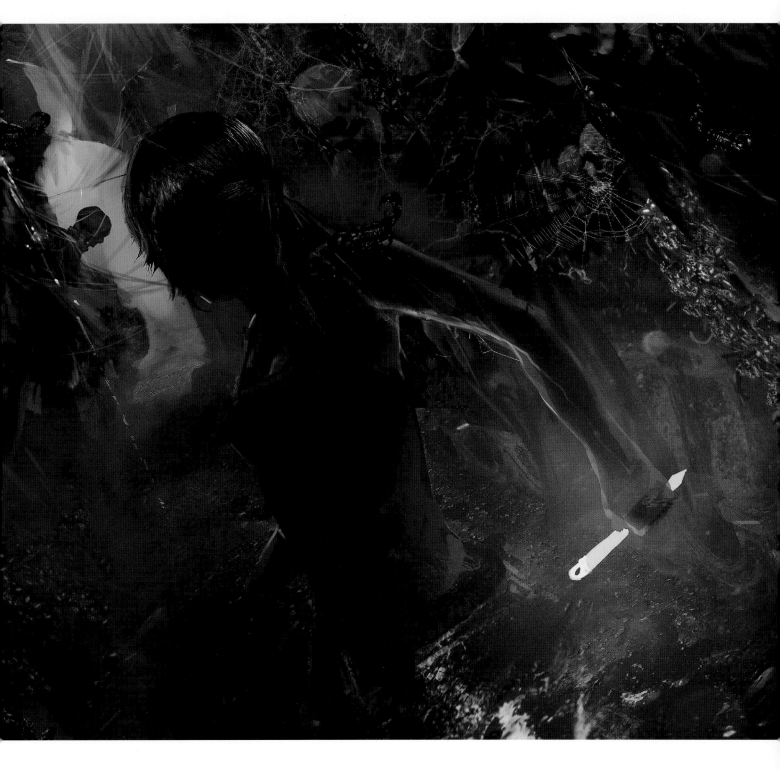

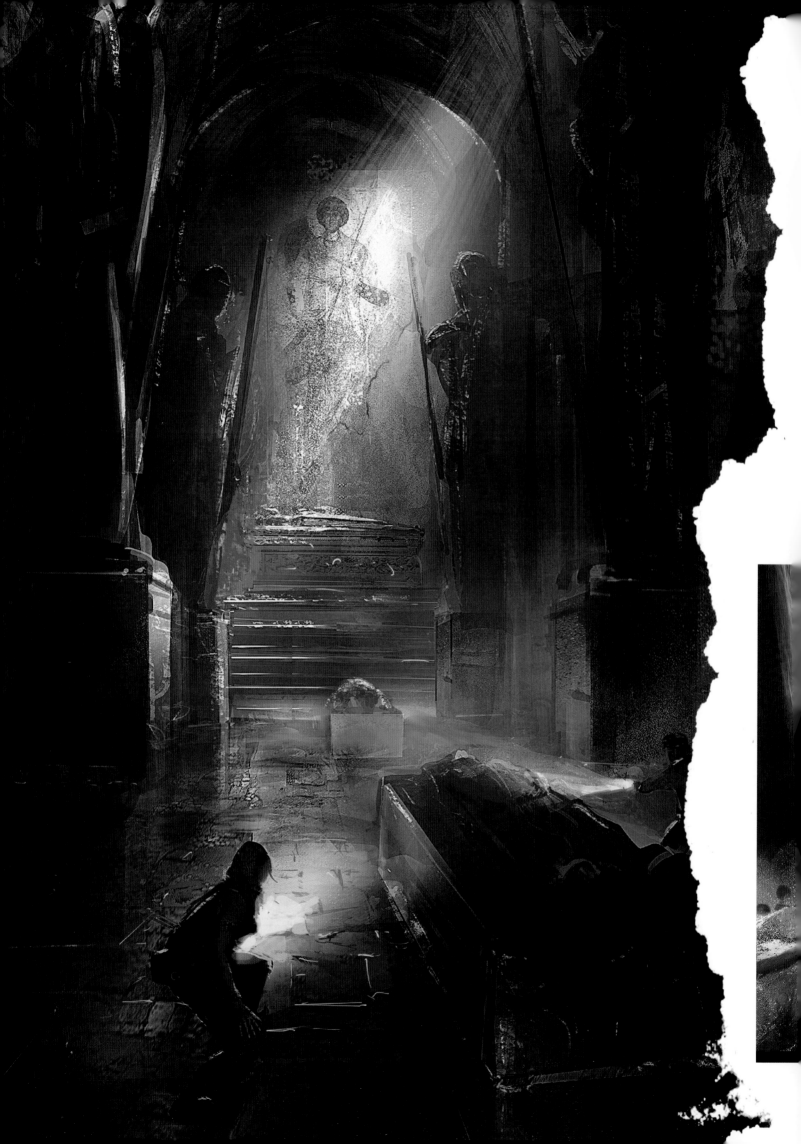

Deep in a Byzantine tomb, Lara fights through the pain and weariness. A sarcophagus is highlighted on the dais, its grand presentation of singular importance—perhaps this is a clue that will lead her to the Divine Source? There is something unsettling about this Byzantine tomb, not least owing to the human remains. Having come this far, Lara is compelled to open the hallowed casket, using all her strength to reveal what's inside.

OPPOSITE: Art by Michael Baytion
RIGHT: Art by Brandon Russell
BELOW: Sarcophagus art by Mark Castanon
BOTTOM: Art by Brenoch Adams

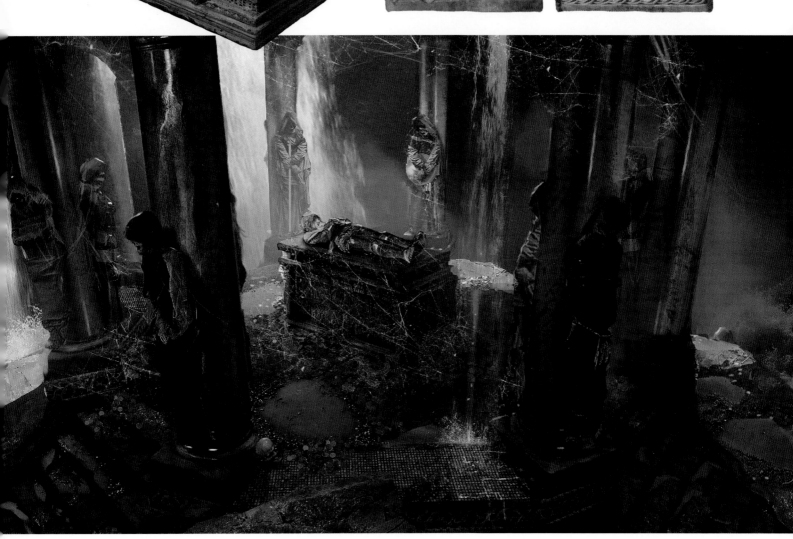

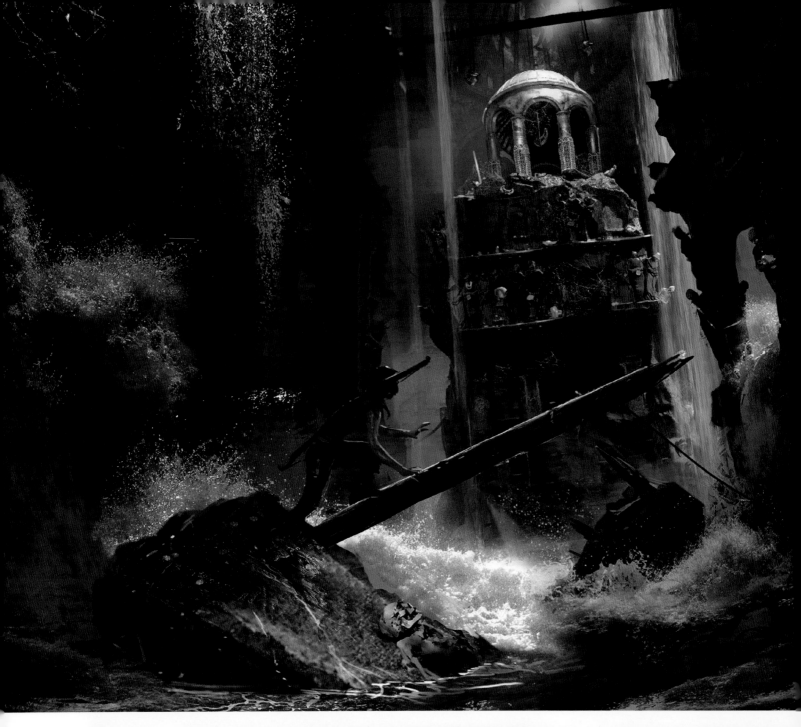

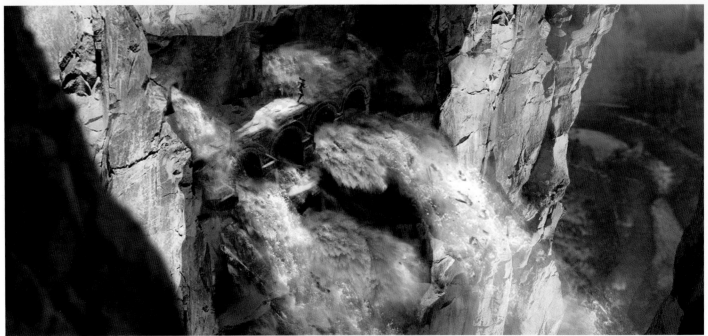

After the eerie quiet of the burial chamber, Lara is confronted by Konstantin and his Trinity soldiers who also seek the Divine Source. During the confrontation Lara triggers an explosion to escape, destroying the Tomb and the cistern holding the ground water. Desperately climbing to higher ground, Lara is forced to flee the oncoming flood, taking cover behind a precarious archway in order to avoid the raging torrent. At first she thinks her near-deadly investigation in Syria is a failure, until she uncovers a symbol that brings more questions. She returns to her apartment in London—only to soon find herself halfway across the world again: this time, on a hike through the Siberian mountains, in an effort to locate the mythological lost city of Kitezh.

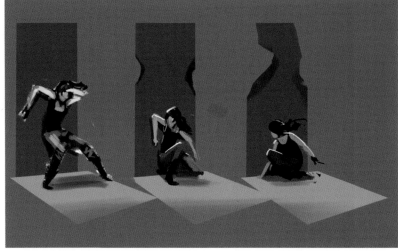

THIS SPREAD: Art by Brenoch Adams
NEXT SPREAD: Art by Mark Castanon

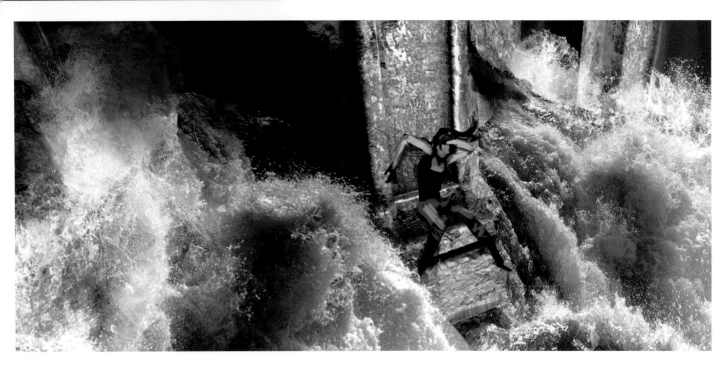

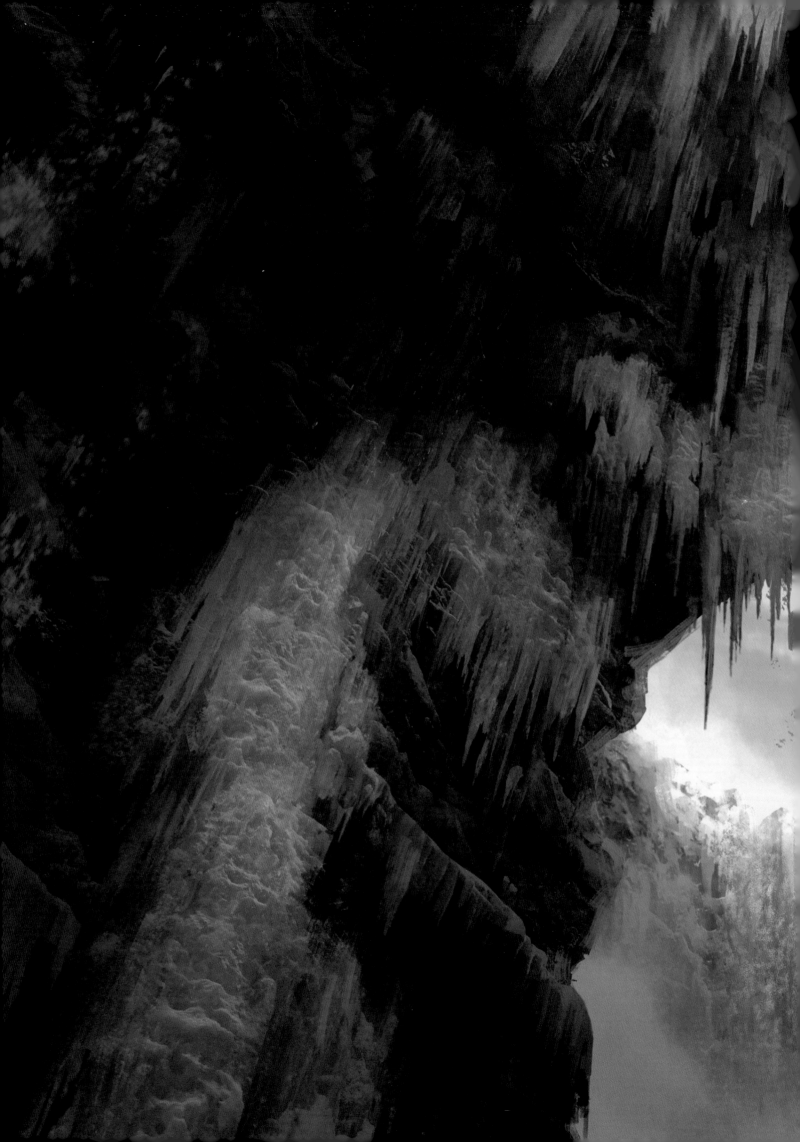

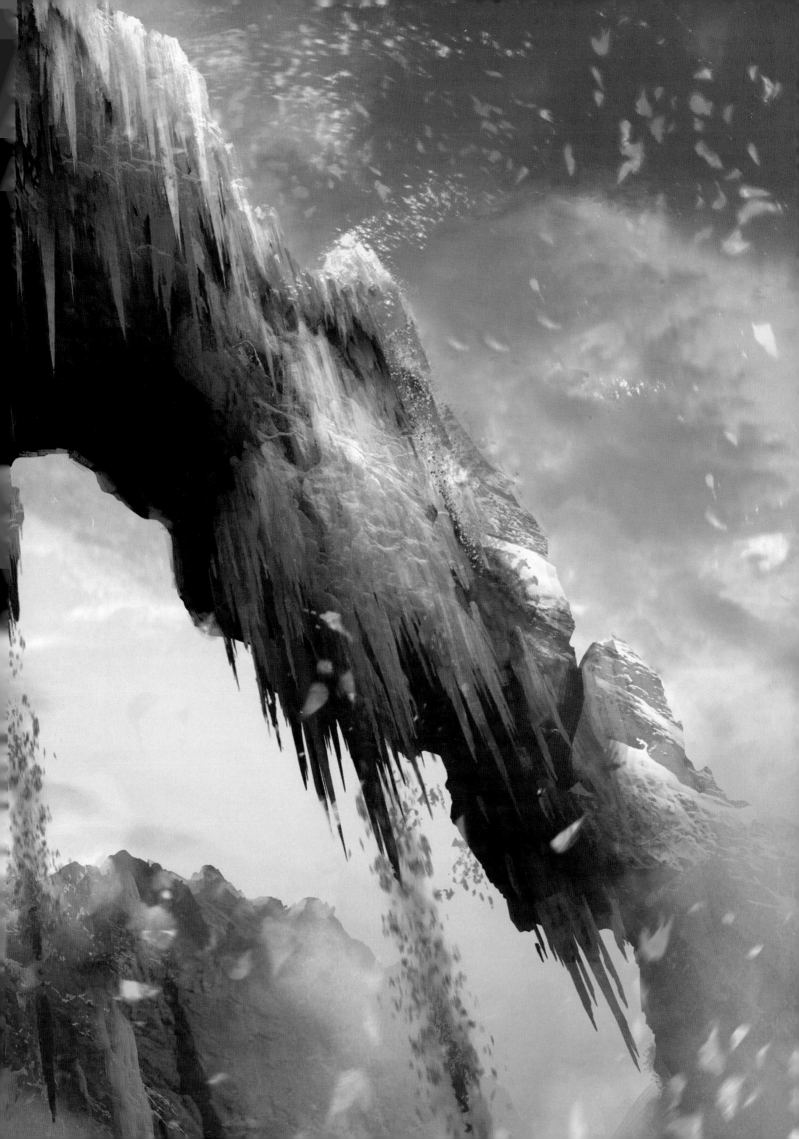

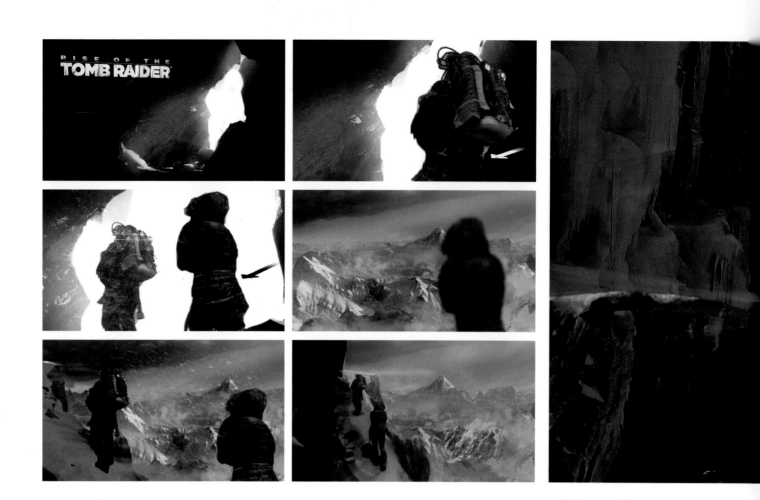

ON THE MOUNTAIN

Half a world away from Syria, Lara, Jonah, and their Sherpa guides venture into the Siberian mountains in search of the lost city of Kitezh. The snow in *Rise of the Tomb Raider* is a personality unto itself: "The snow technology is something we're very proud of" says Horton, "It reacts dynamically and you'll see animation changes depending on the snow depth and the footprints will also fill in with snow after a period of time." The approaching blizzard lends a sense of unease, whilst the mountain vistas prompt a sense of awe. These concepts illustrate how the contrast between shadow and light are used to indicate progress, drawing Lara and Jonah away from the pristine snow valley and towards the perilous cliff faces and ice walls of the Siberian mountain range.

TOP: Art by Brenoch Adams
BOTTOM: Art by Michael Baytion

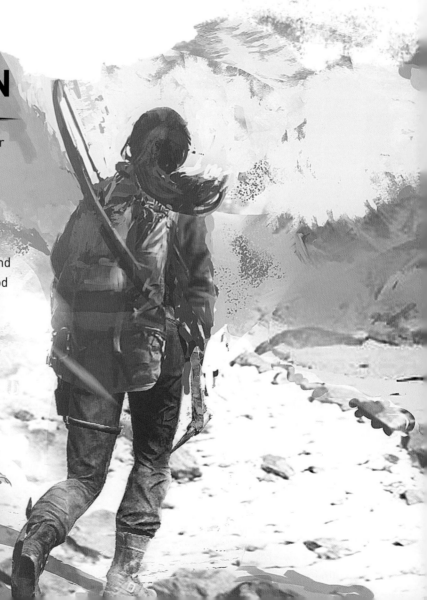

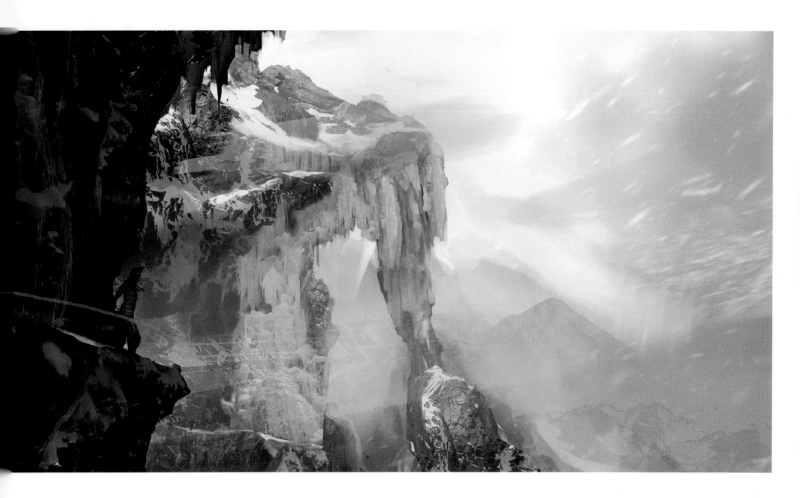

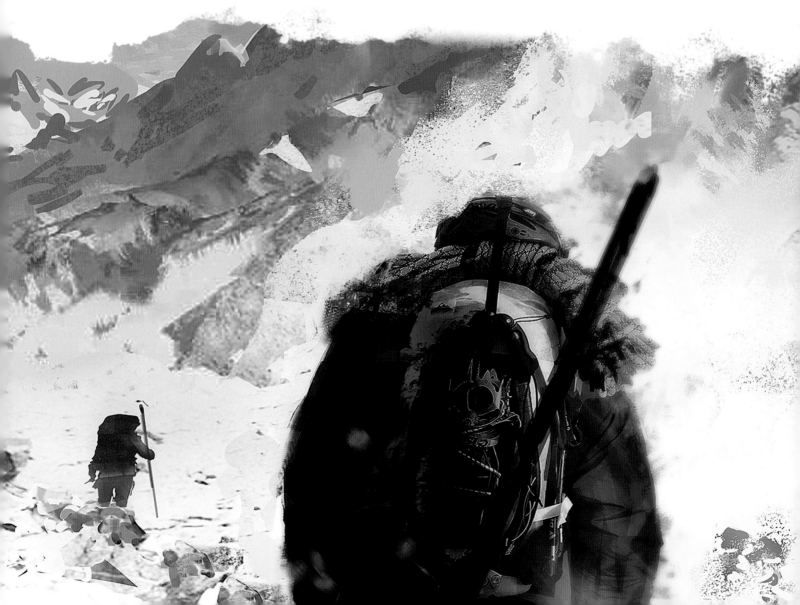

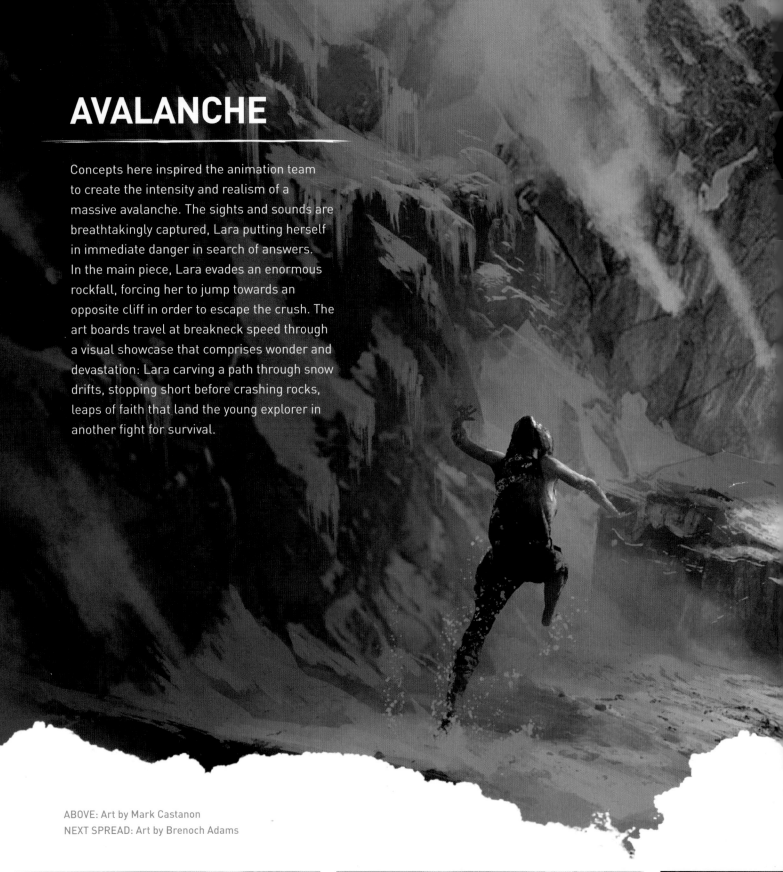

AVALANCHE

Concepts here inspired the animation team to create the intensity and realism of a massive avalanche. The sights and sounds are breathtakingly captured, Lara putting herself in immediate danger in search of answers. In the main piece, Lara evades an enormous rockfall, forcing her to jump towards an opposite cliff in order to escape the crush. The art boards travel at breakneck speed through a visual showcase that comprises wonder and devastation: Lara carving a path through snow drifts, stopping short before crashing rocks, leaps of faith that land the young explorer in another fight for survival.

ABOVE: Art by Mark Castanon
NEXT SPREAD: Art by Brenoch Adams

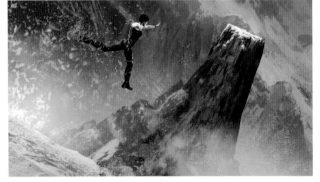
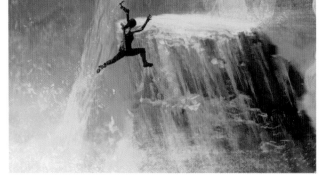

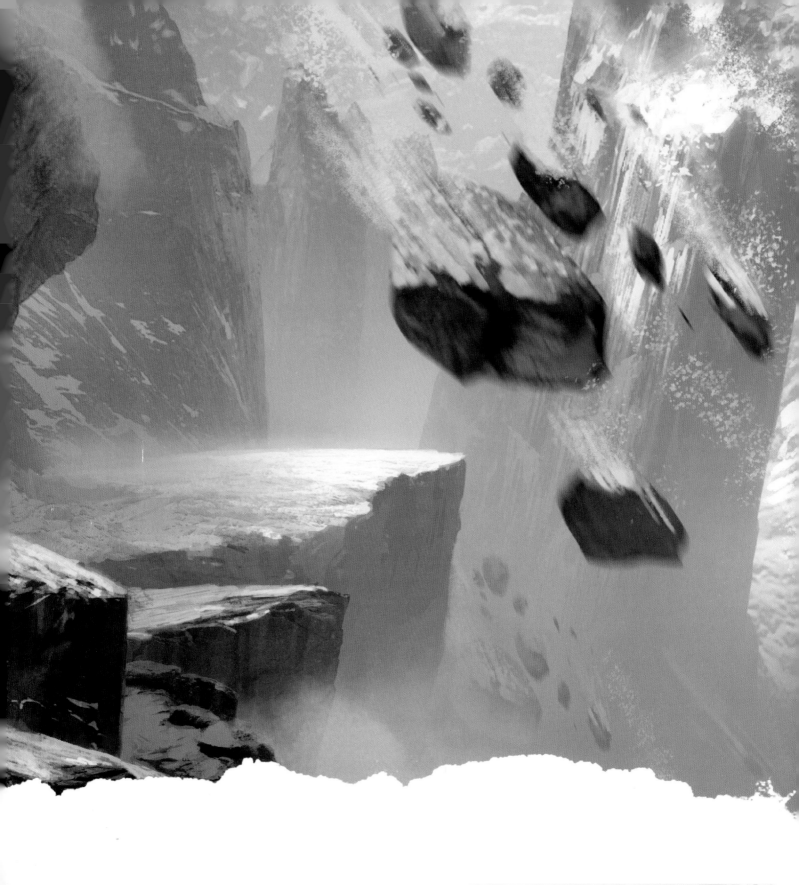

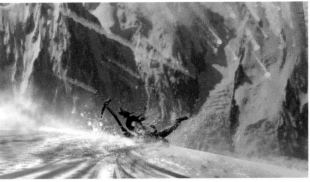
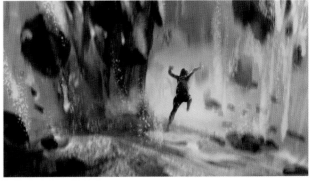

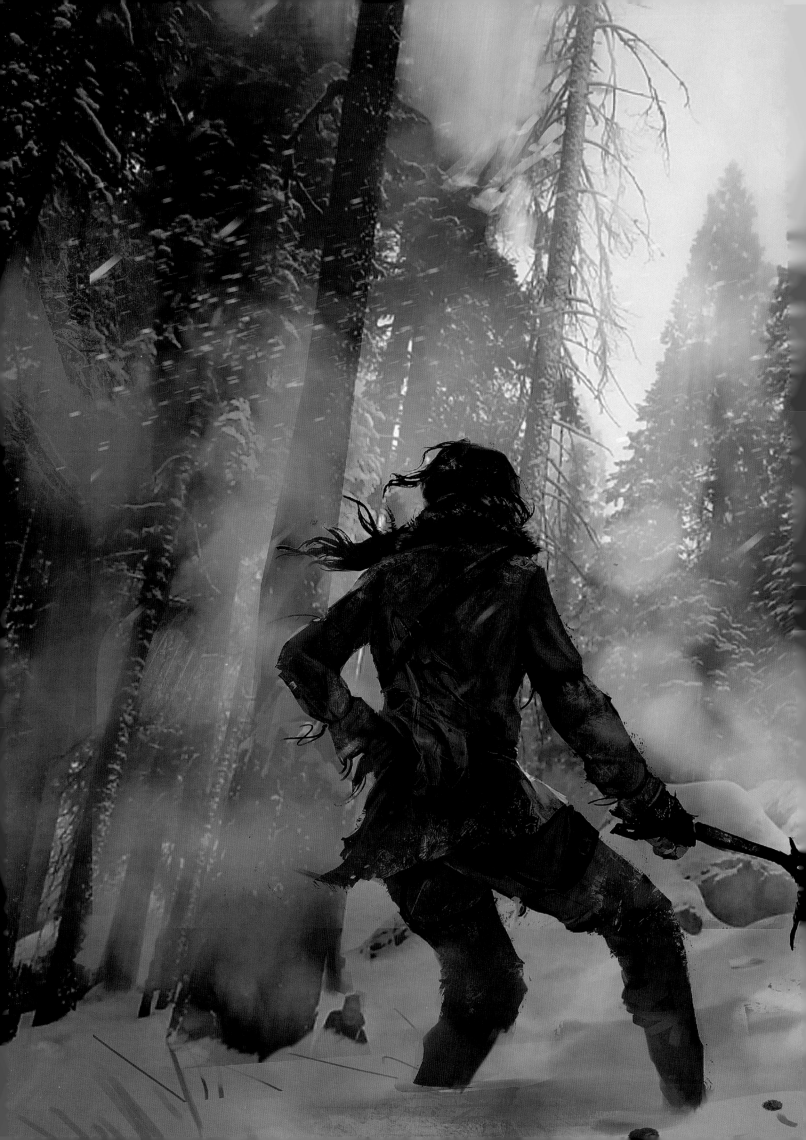

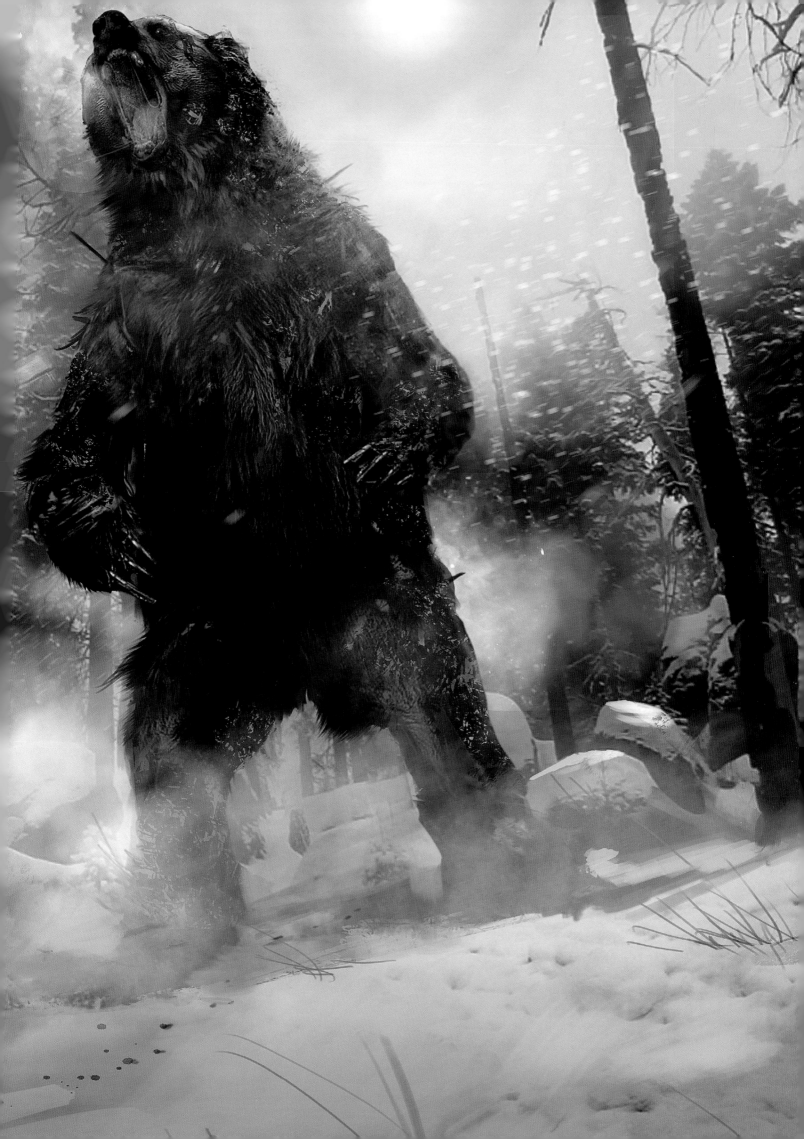

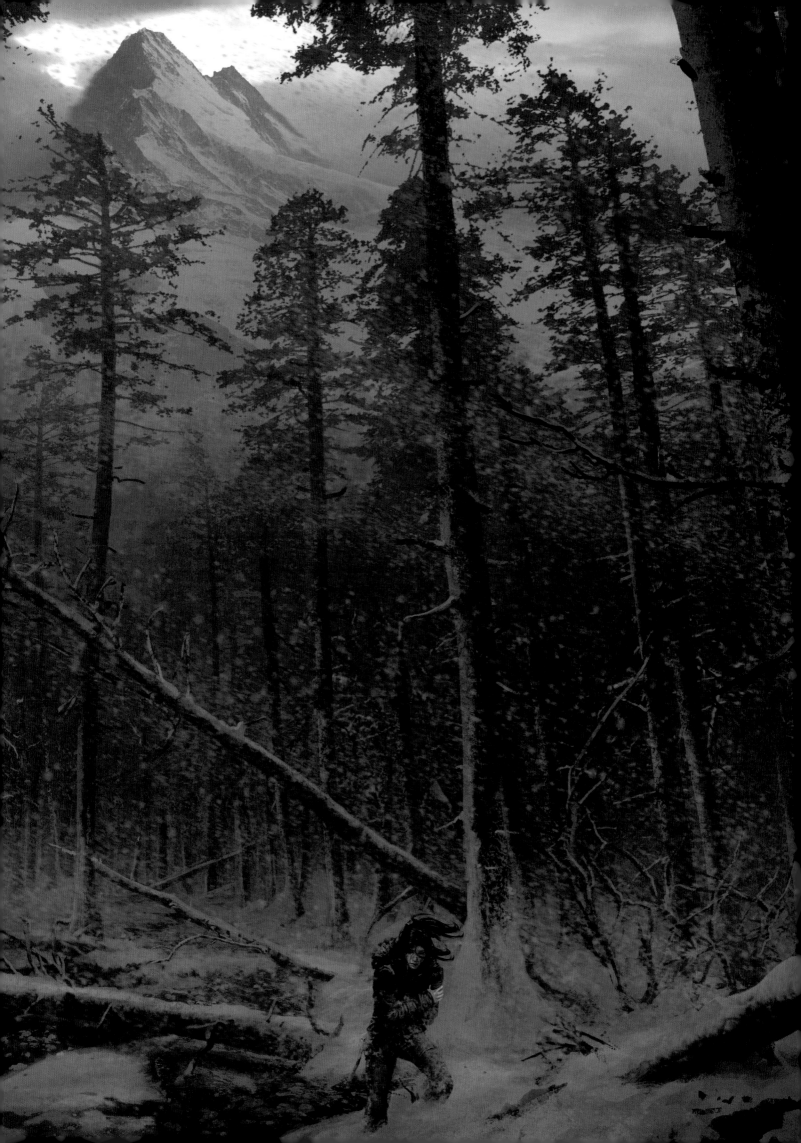

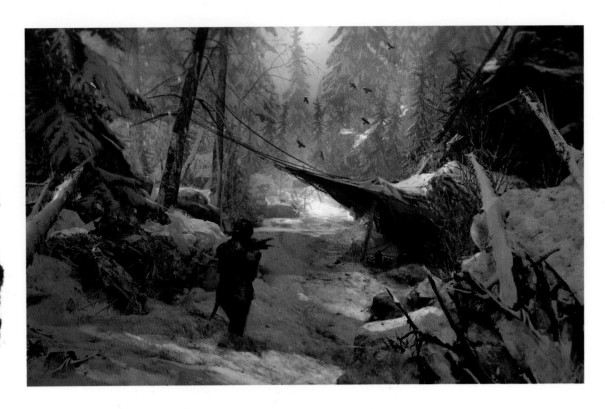

BEAR VALLEY

After the avalanche, Lara opens her eyes and finds herself buried in snow. She claws her way out to discover she has arrived in a wooded valley surrounded by high cliffs and mountains. Alone now with only the clothes on her back, her signature climbing axes and radio, Lara must now use all her skills to survive the storm sweeping into the valley. To illustrate this, the concept team began to tell the story through a series of thematic illustrations: an otherwise picturesque scene that appears natural and desolate but soon reveals itself to be inhabited by unfriendly forces amid 13th century Mongol structures.

ABOVE: Art by Brenoch Adams
OPPOSITE: Art by Mark Castanon
BELOW: Art by Mark Castanon

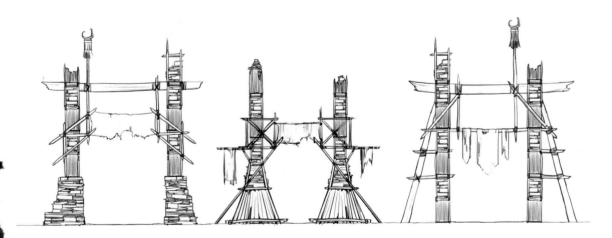

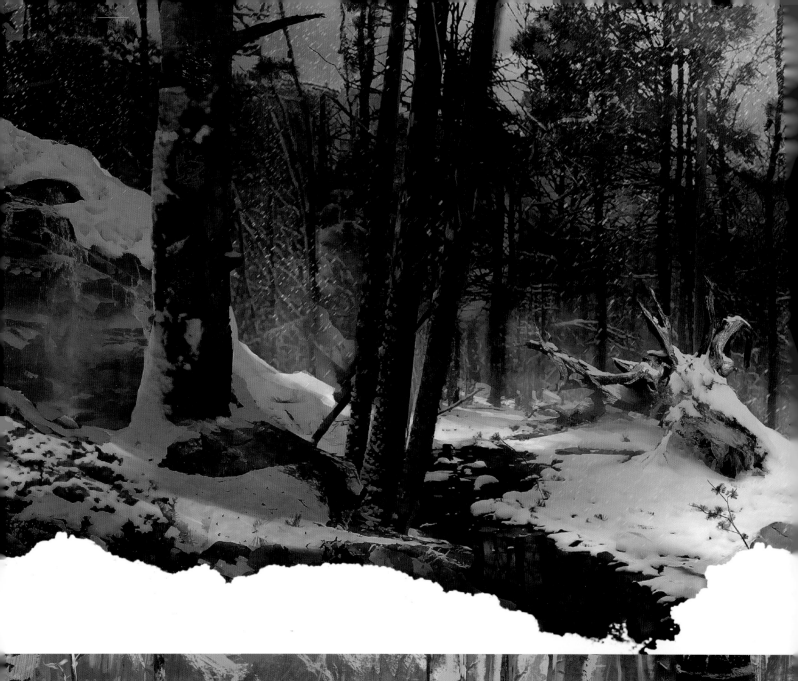

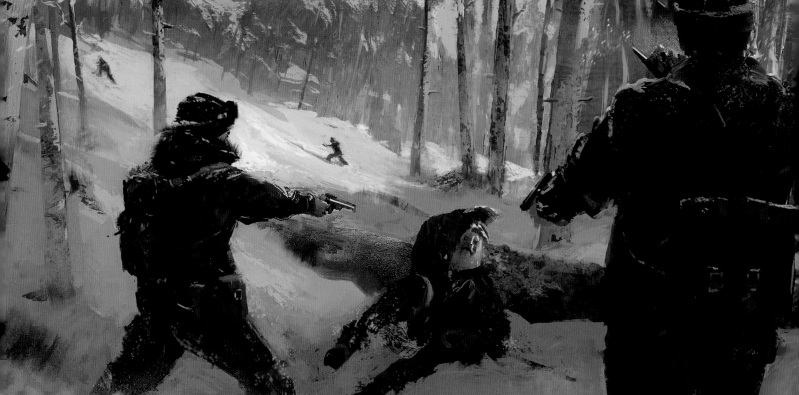

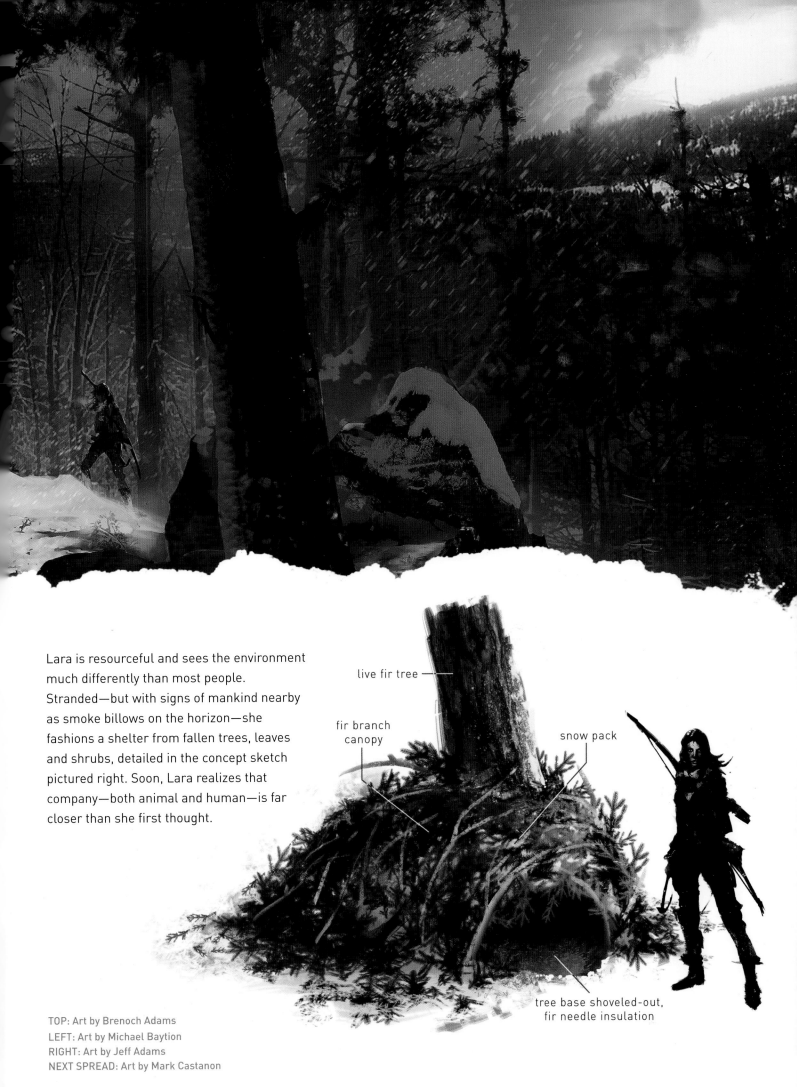

Lara is resourceful and sees the environment much differently than most people. Stranded—but with signs of mankind nearby as smoke billows on the horizon—she fashions a shelter from fallen trees, leaves and shrubs, detailed in the concept sketch pictured right. Soon, Lara realizes that company—both animal and human—is far closer than she first thought.

live fir tree

fir branch canopy

snow pack

tree base shoveled-out, fir needle insulation

TOP: Art by Brenoch Adams
LEFT: Art by Michael Baytion
RIGHT: Art by Jeff Adams
NEXT SPREAD: Art by Mark Castanon

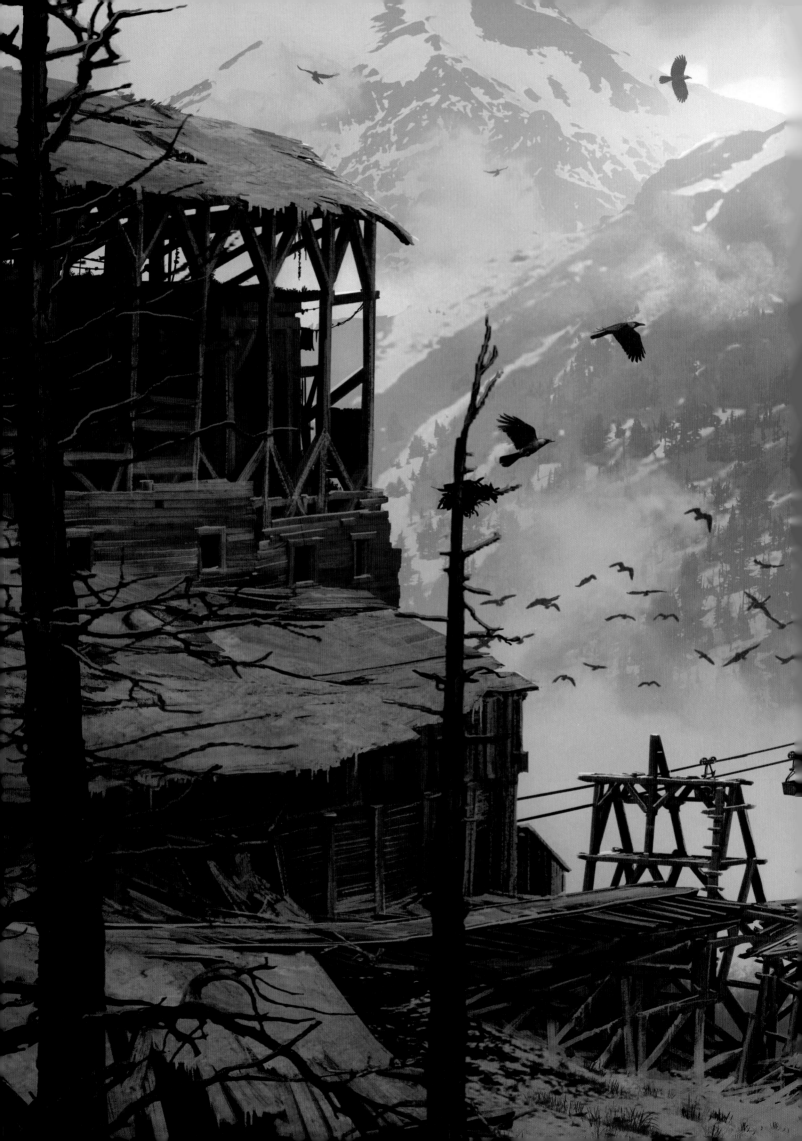

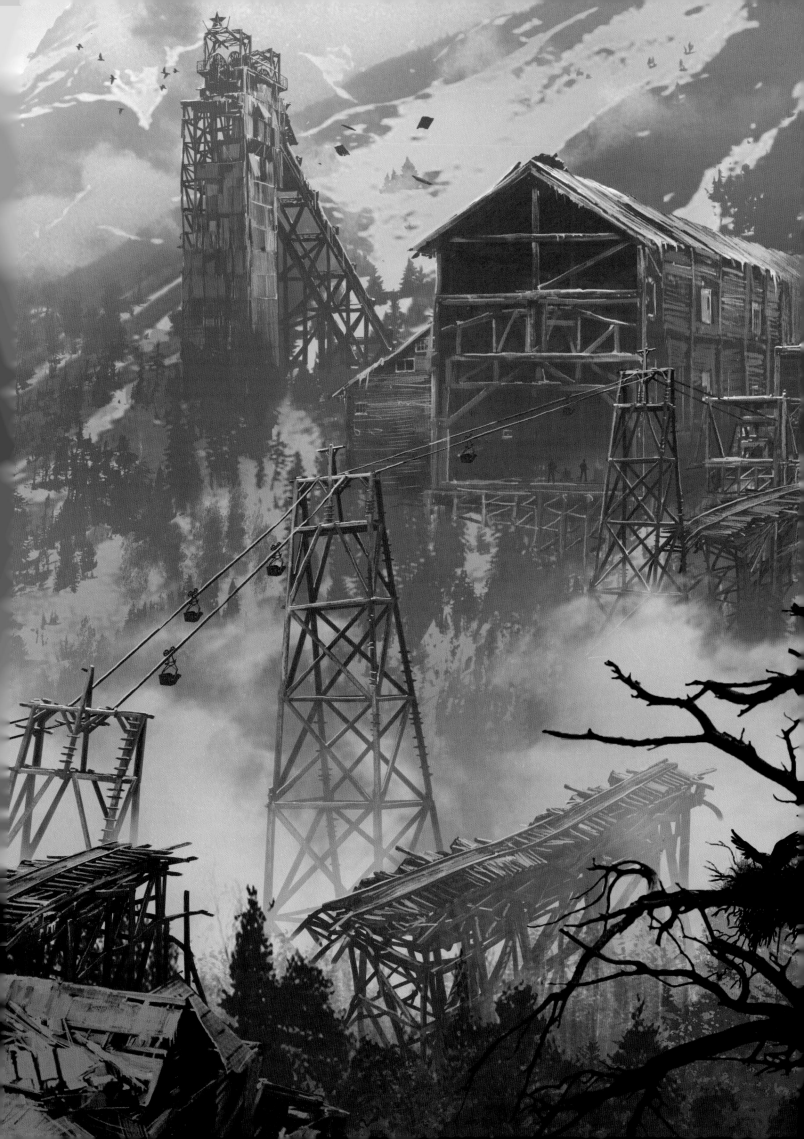

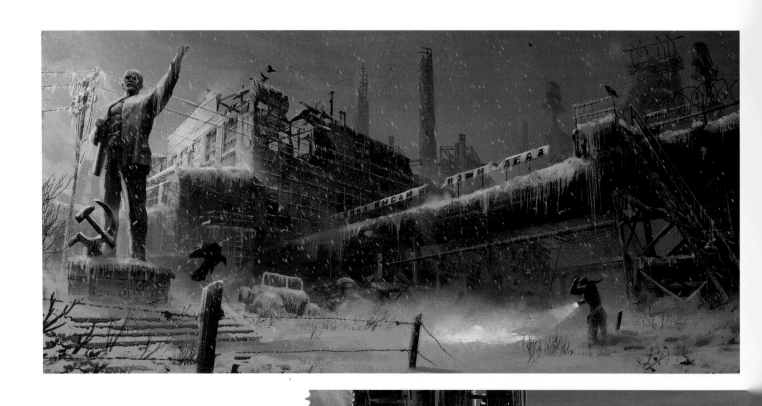

SOVIET BASE HUB

These key sketches for the Soviet base hub showcase the facility's remote location—a desolate industrial wasteland in the heart of Siberia's frozen mountains. This long abandoned Soviet gulag and mining operation was once a sub-zero prison camp. Now, it provides a base of operations for another ruthless organization: Trinity. After lying in ruins for years, the gulag is an active prison once more—housing Jacob and his band of Remnant resistance fighters.

TOP: Art by Brandon Russell
OPPOSITE TOP: Art by Mark Castanon
RIGHT: Art by Mark Castanon

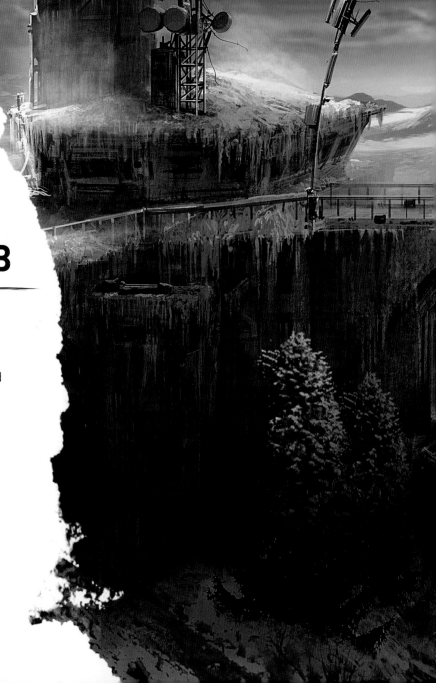

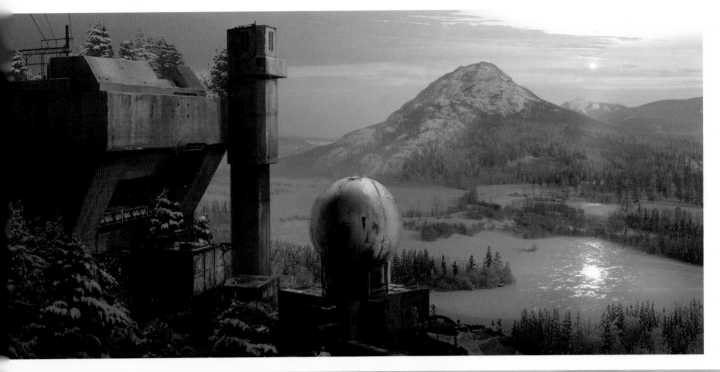

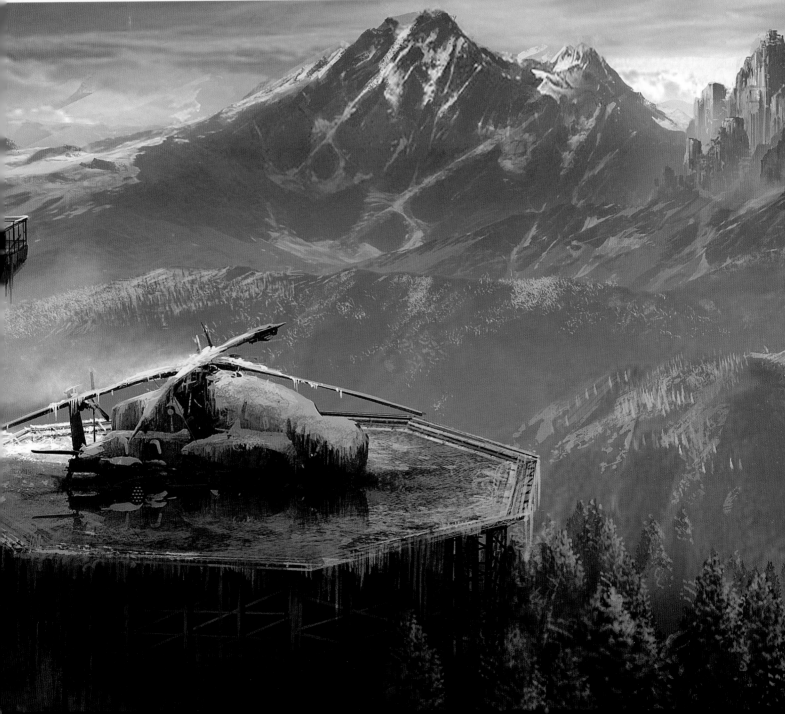

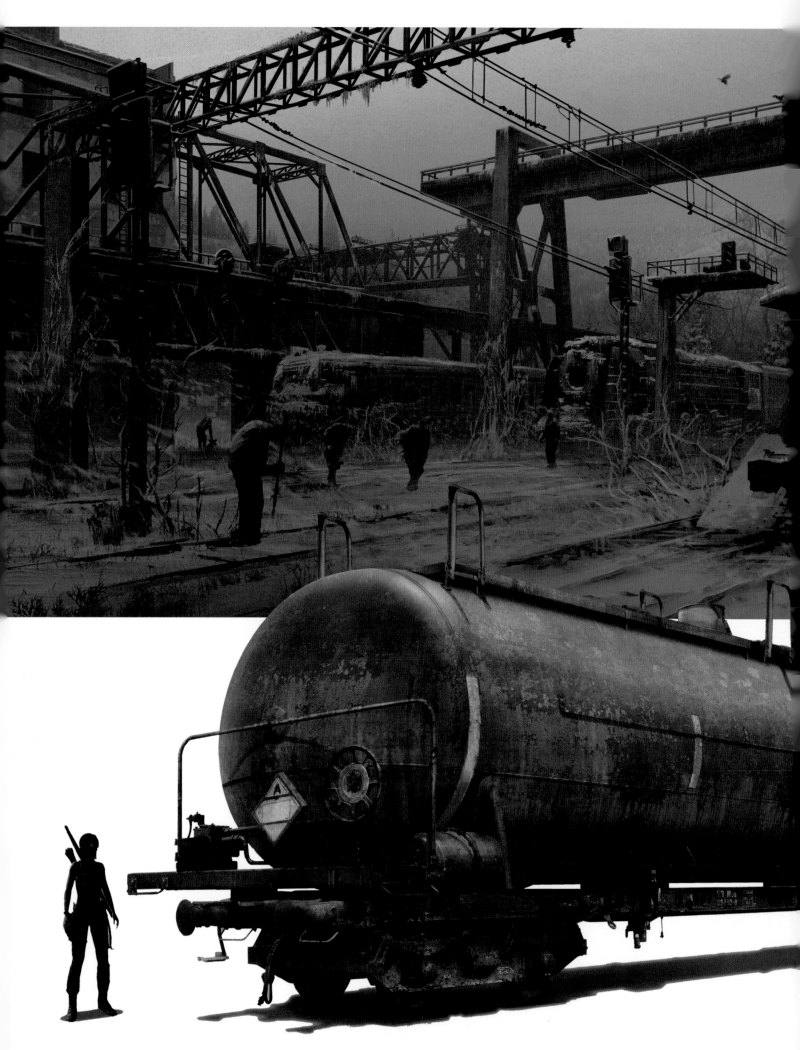

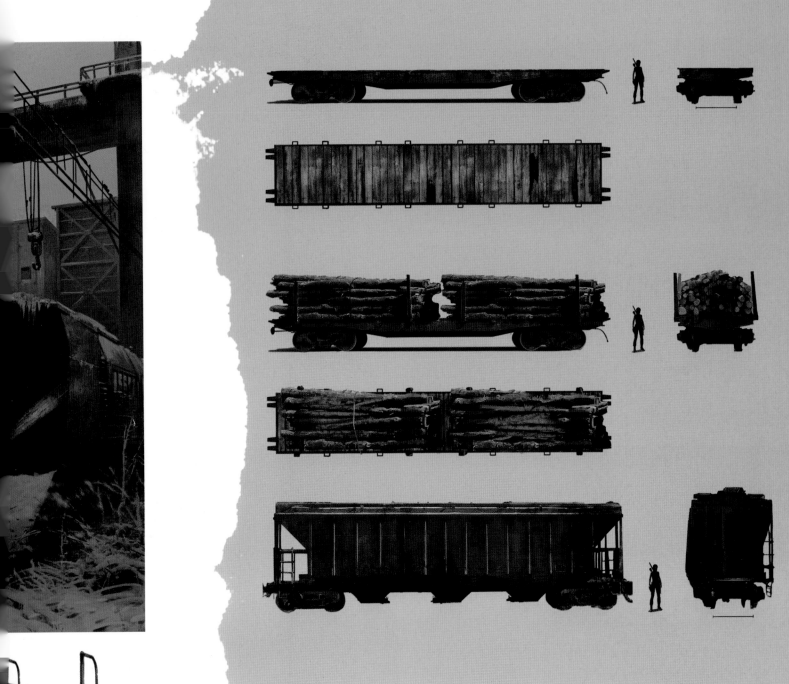

A decrepit train yard sets the stage for Lara's infiltration of the Soviet base. Attention to detail on rotting Cold War-era containers and flatbeds were designed to stand up to close scrutiny as Lara hugs their form. Nature has encroached on the old disused tracks in the form of vegetation now withered by the freezing Siberian winter. Icicles hang, birds flutter and all around snowy mist descends on Lara. It's a desolate place that anyone would wish to put behind them—but instead, Lara presses on.

THIS SPREAD: Art by Mark Castanon

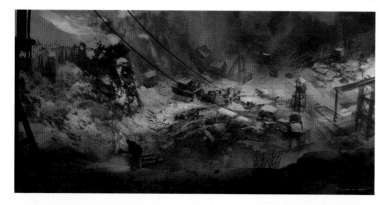

Further sketches of the Soviet trainyard, long since abandoned as a transport hub. In order for Lara to meet the dangers ahead, the combined efforts of concept artists, game designers, and animators faced their own significant obstacles in linking these hubs and environments together. The landscape concept art below provides a sense of the massive scale of hub locations in *Rise of the Tomb Raider*, shadowed by the huge strip-mine machine in the background. Lara's strength of conviction is juxtaposed with her vulnerability within these enormous environments, but where at first she may not easily succeed she may later return to conquer.

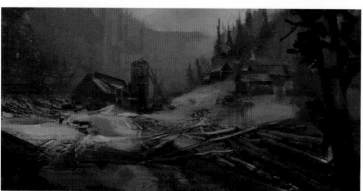

LEFT (TOP-BOTTOM): Art by Richard Healy
RIGHT: Art by Mark Castanon
BOTTOM: Art by Mark Castanon

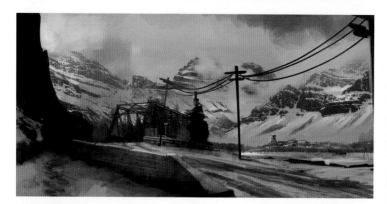

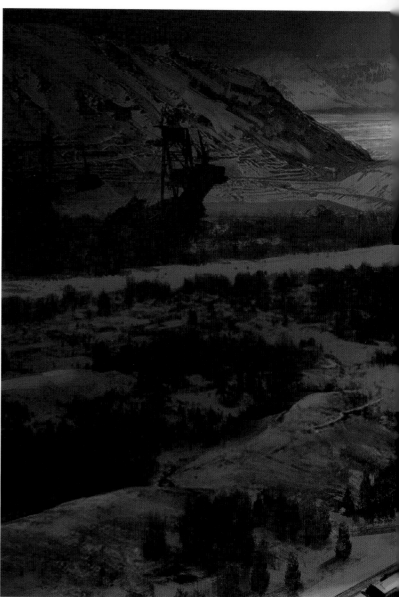

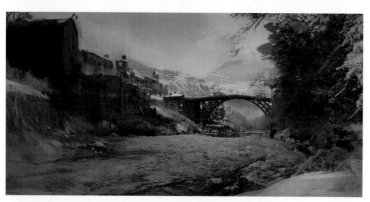

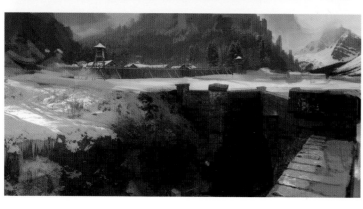

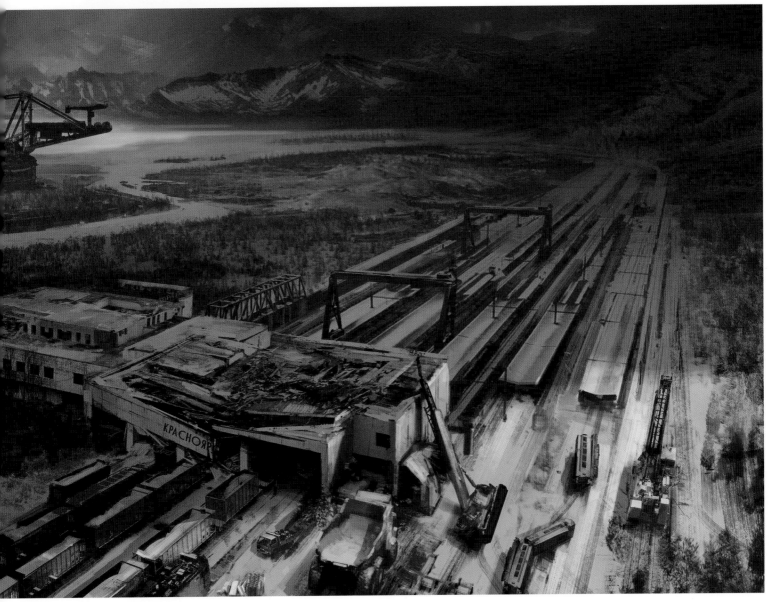

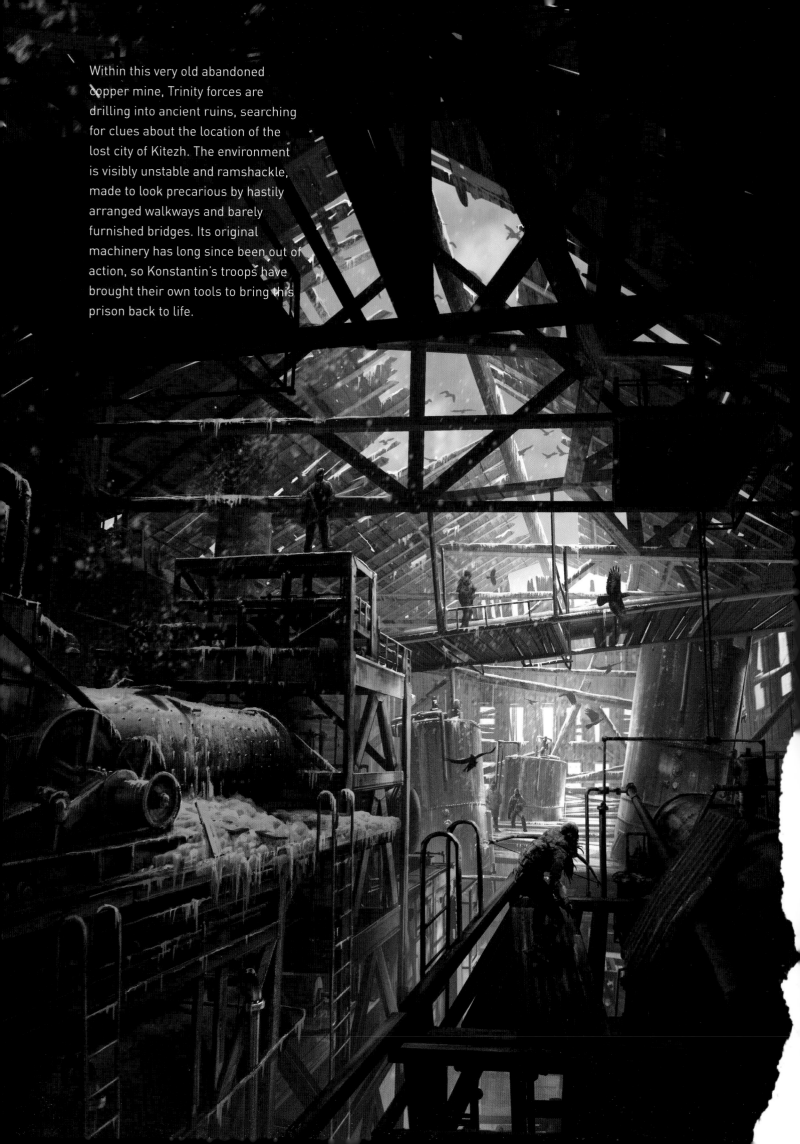

Within this very old abandoned copper mine, Trinity forces are drilling into ancient ruins, searching for clues about the location of the lost city of Kitezh. The environment is visibly unstable and ramshackle, made to look precarious by hastily arranged walkways and barely furnished bridges. Its original machinery has long since been out of action, so Konstantin's troops have brought their own tools to bring this prison back to life.

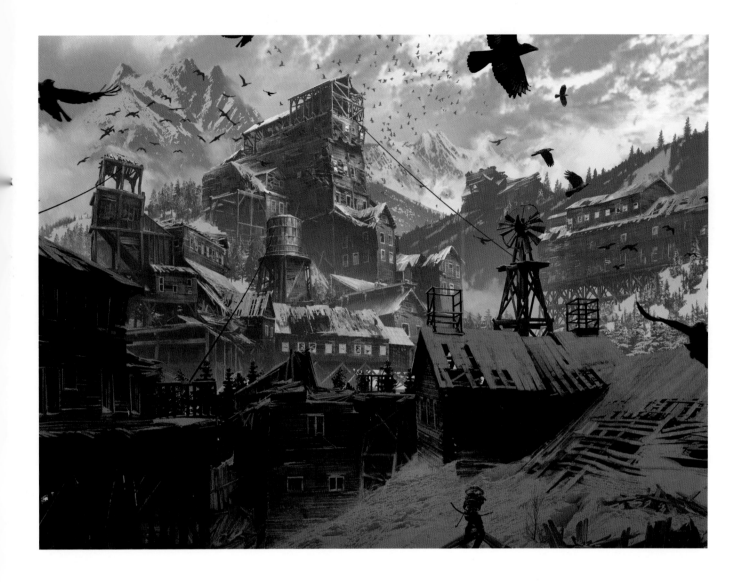

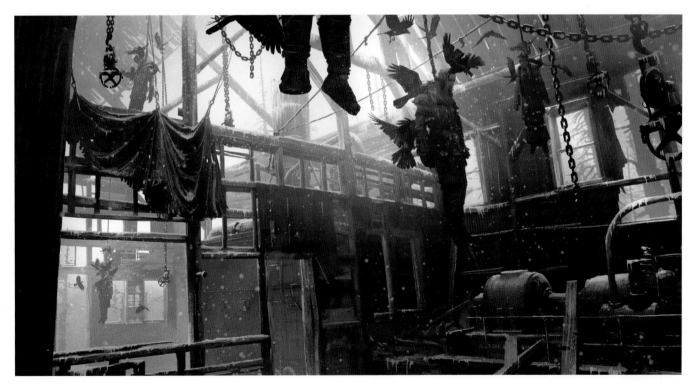

THIS SPREAD: Art by Mark Castanon
NEXT SPREAD: Art by Brenoch Adams

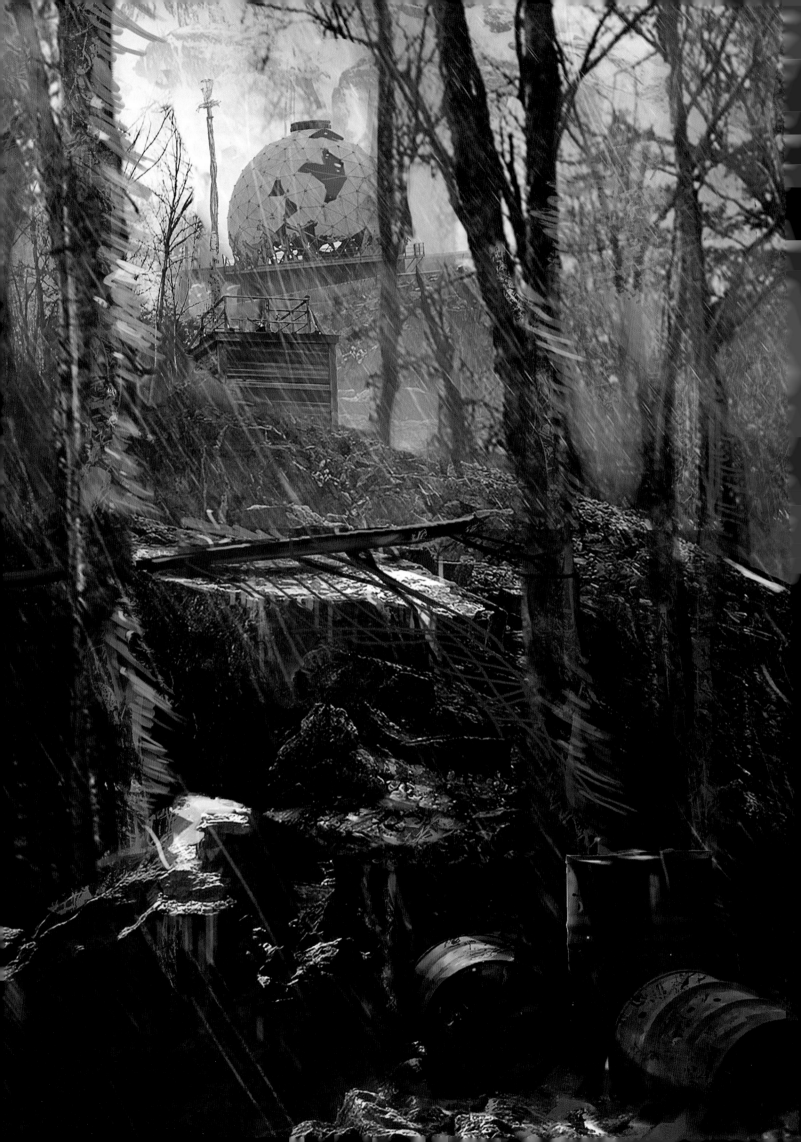

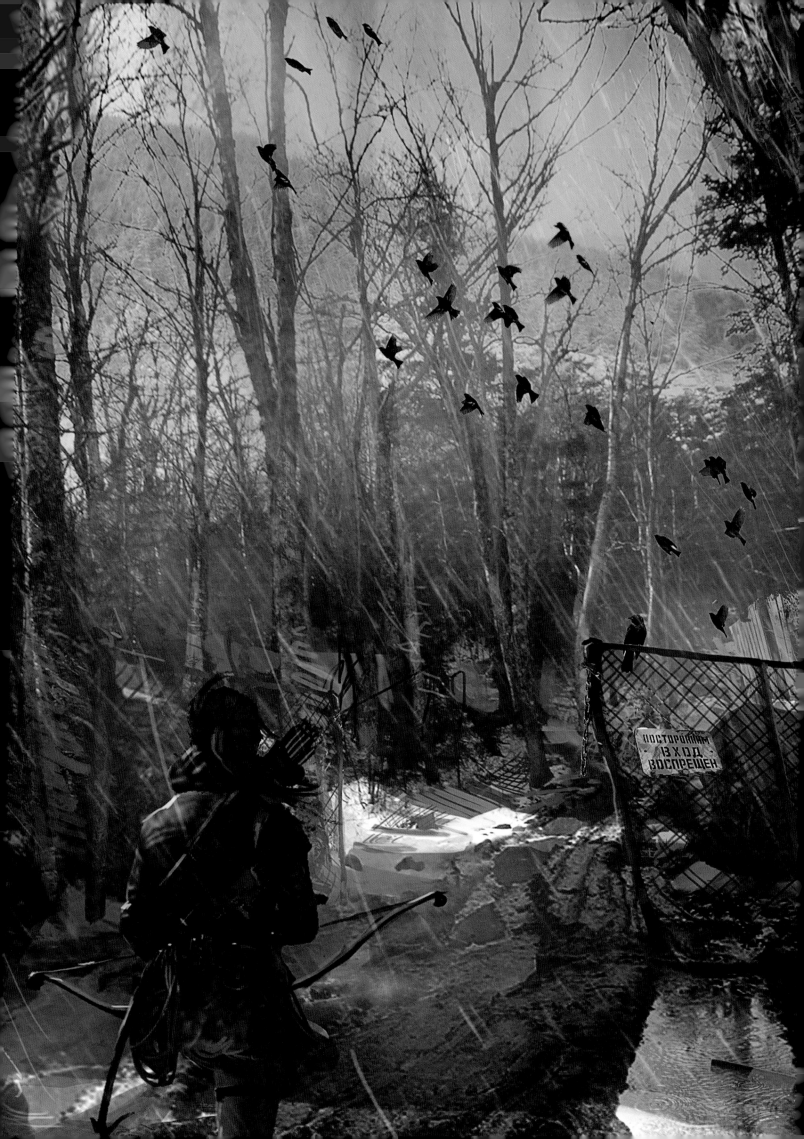

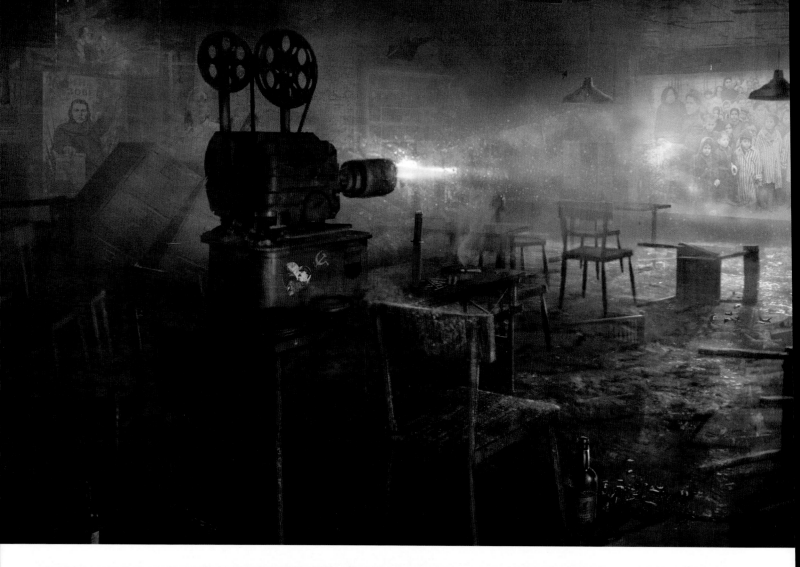

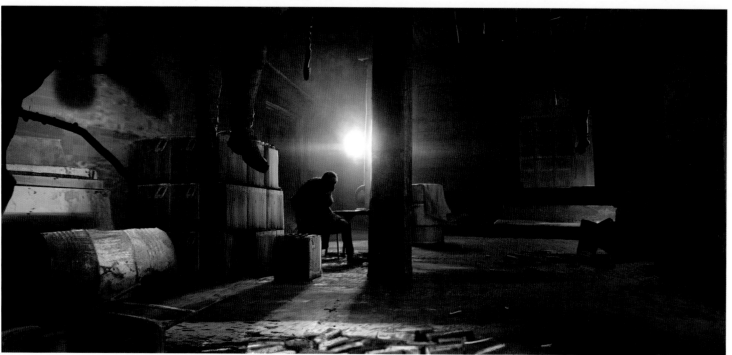

GULAG

The remains of this abandoned Soviet installation are under the control of Konstantin and Trinity, who have been capturing and interrogating the local Remnant forces for information. Deep in the bowels of the gulag, Lara briefly finds herself a prisoner and meets the Remnant leader, Jacob. By its very nature, the gulag is depicted as an oppressive place from which few escape. As Lara manages to do so, she embarks on a stealthy tour of the complex that proves to be every bit as miserable as its appearance suggests.

TOP LEFT: Art by Yohann Schepacz
RIGHT: Art by Mark Castanon and Yohann Schepacz
LEFT: Art by Mark Castanon

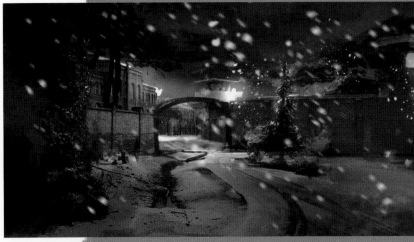

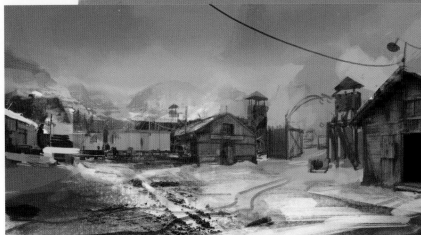

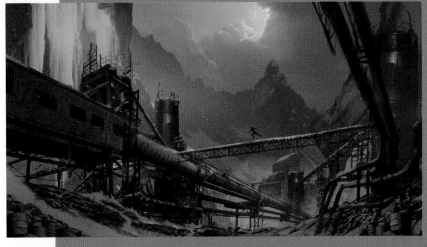

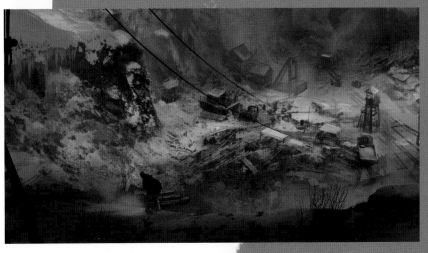

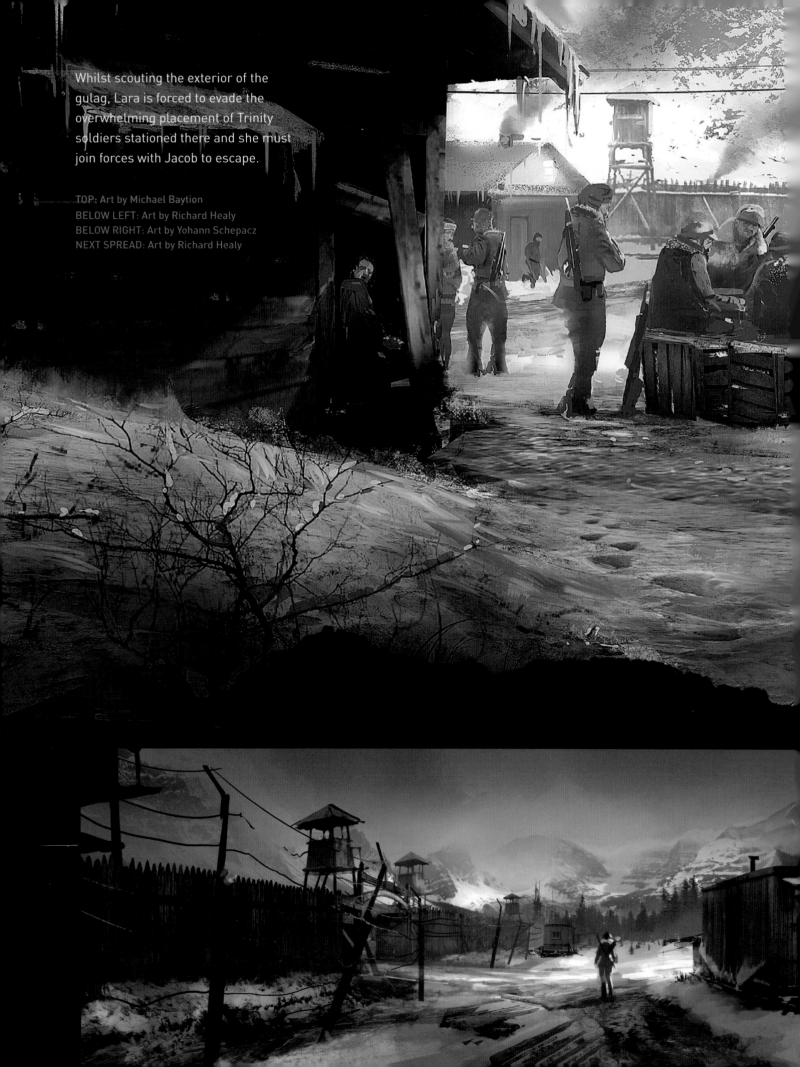

Whilst scouting the exterior of the gulag, Lara is forced to evade the overwhelming placement of Trinity soldiers stationed there and she must join forces with Jacob to escape.

TOP: Art by Michael Baytion
BELOW LEFT: Art by Richard Healy
BELOW RIGHT: Art by Yohann Schepacz
NEXT SPREAD: Art by Richard Healy

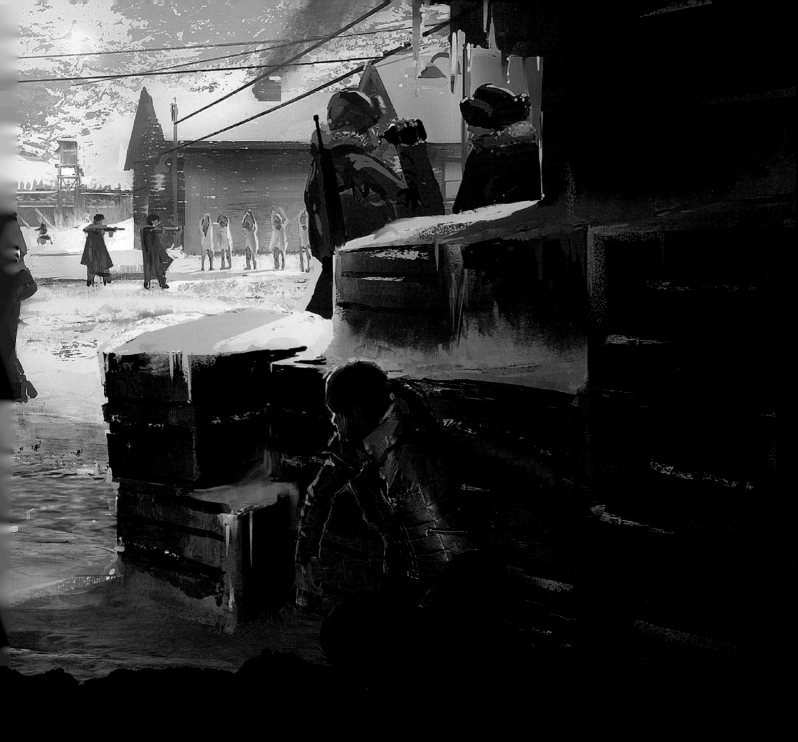

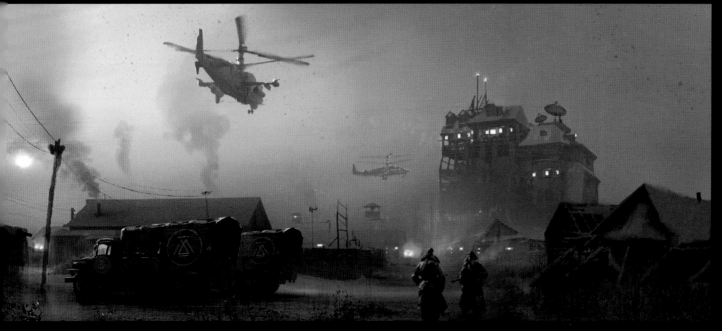

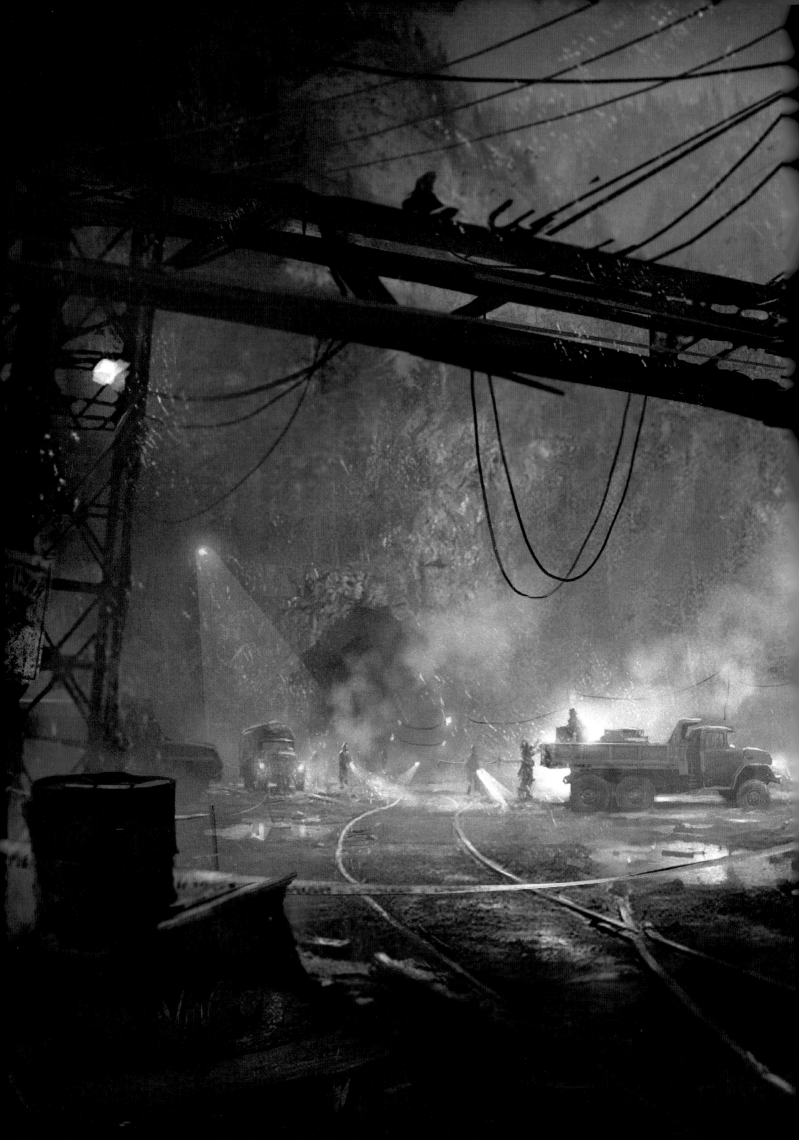

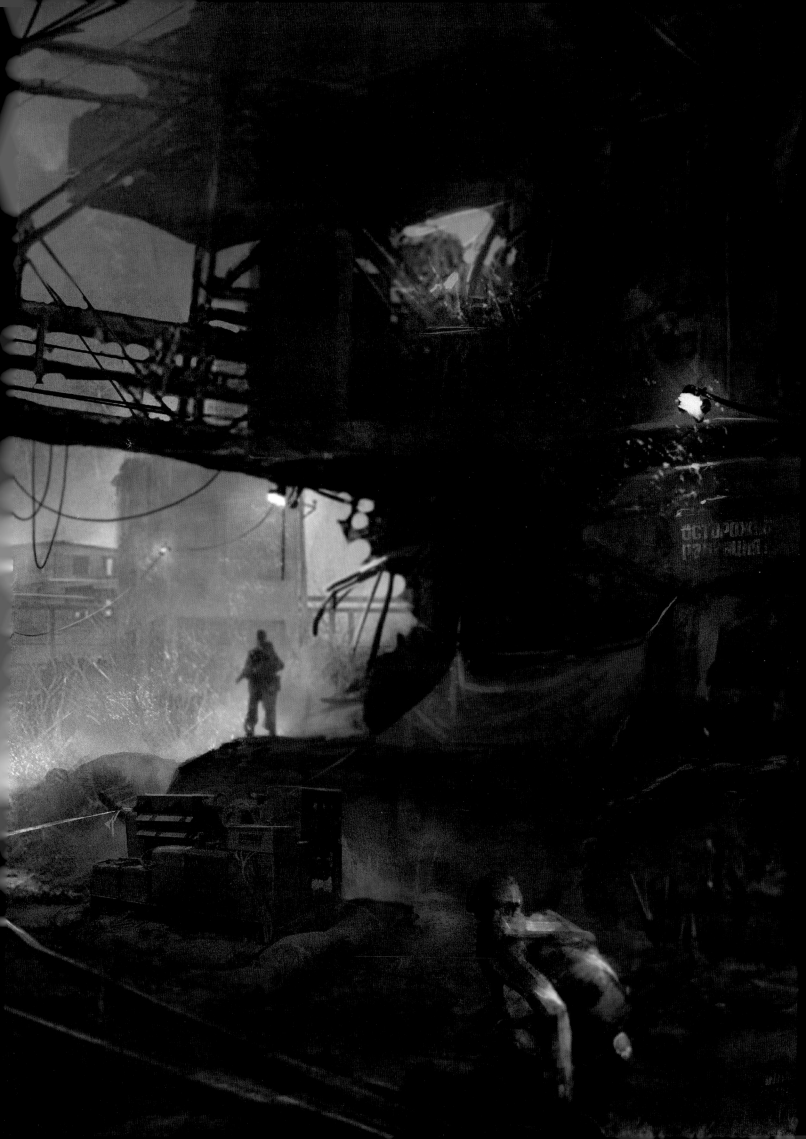

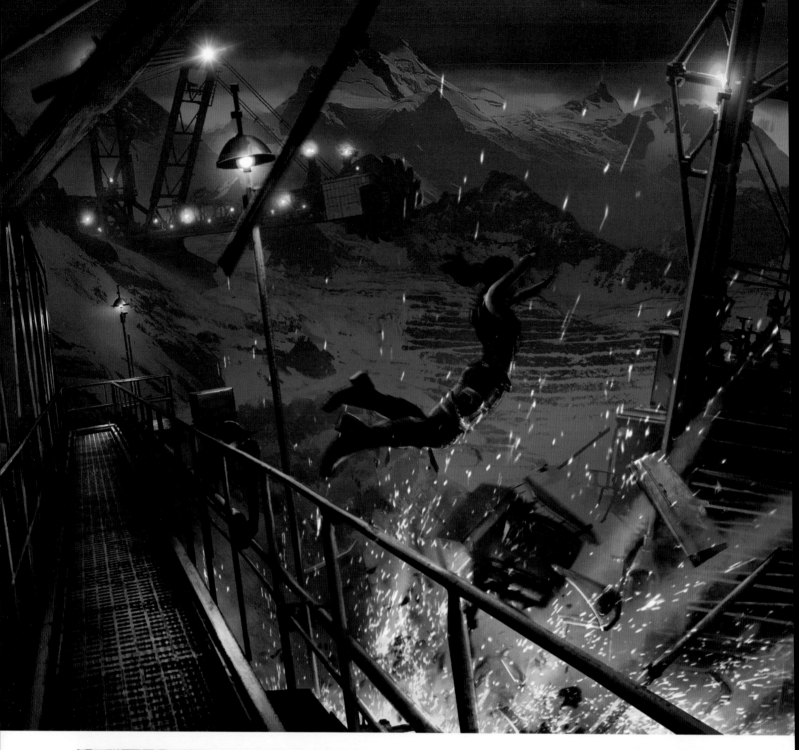

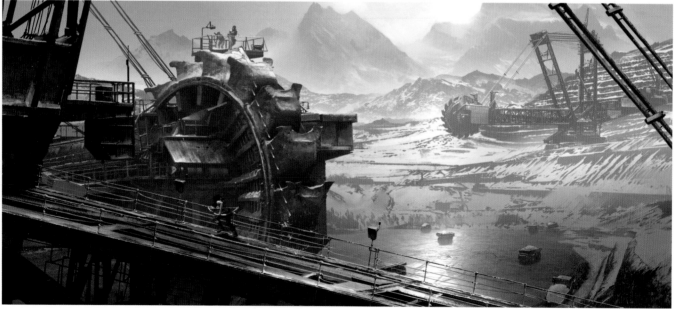

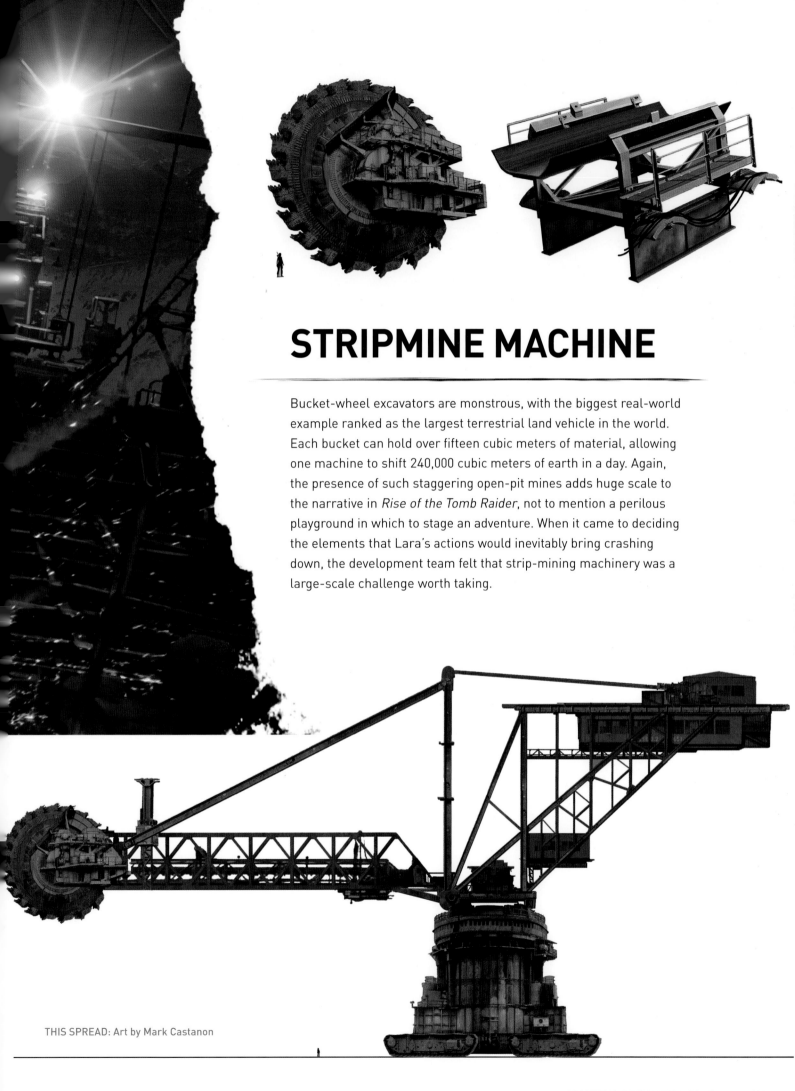

STRIPMINE MACHINE

Bucket-wheel excavators are monstrous, with the biggest real-world example ranked as the largest terrestrial land vehicle in the world. Each bucket can hold over fifteen cubic meters of material, allowing one machine to shift 240,000 cubic meters of earth in a day. Again, the presence of such staggering open-pit mines adds huge scale to the narrative in *Rise of the Tomb Raider*, not to mention a perilous playground in which to stage an adventure. When it came to deciding the elements that Lara's actions would inevitably bring crashing down, the development team felt that strip-mining machinery was a large-scale challenge worth taking.

THIS SPREAD: Art by Mark Castanon

ON THIN ICE

Fleeing from Trinity's combined forces, Lara and Jacob plunge into an icy river. This shock to her system segues to the next sequence, which continues her escape from Konstantin's attack helicopter. In spite of her terrifying circumstances, the concept art illustrates Lara's determination, her climbing axe a critical item in her inventory. However, this time the elements prove too much for Lara and she is swept away, struggling against the freezing current.

THIS SPREAD: Art by Michael Baytion

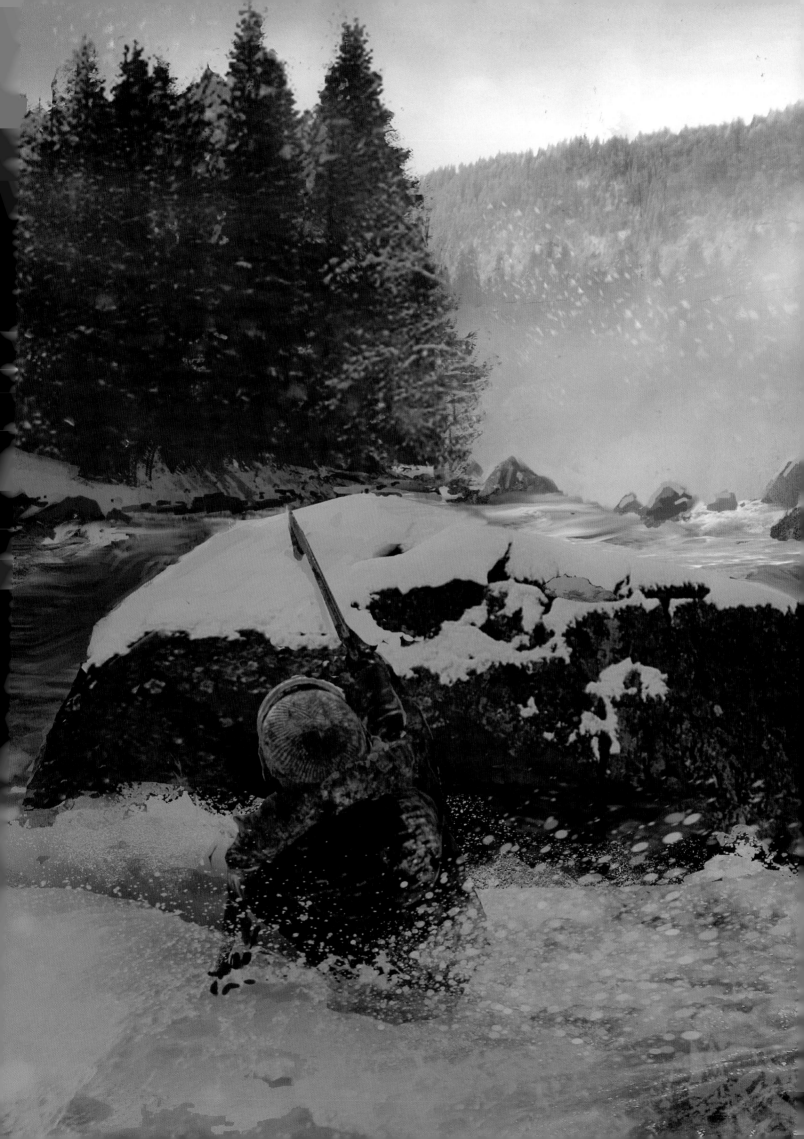

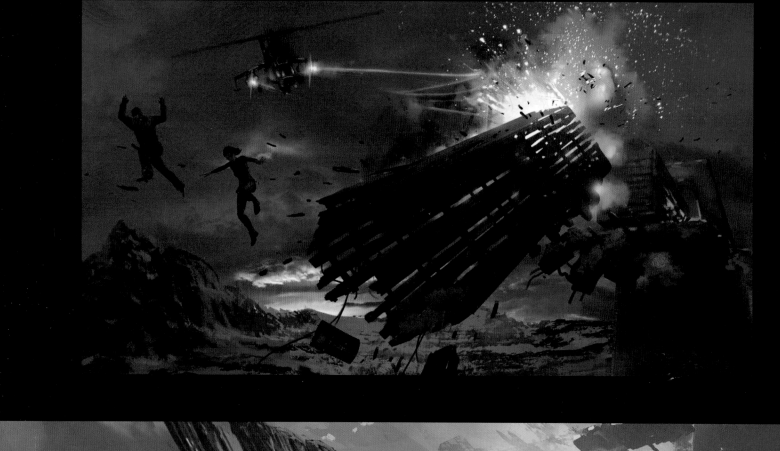

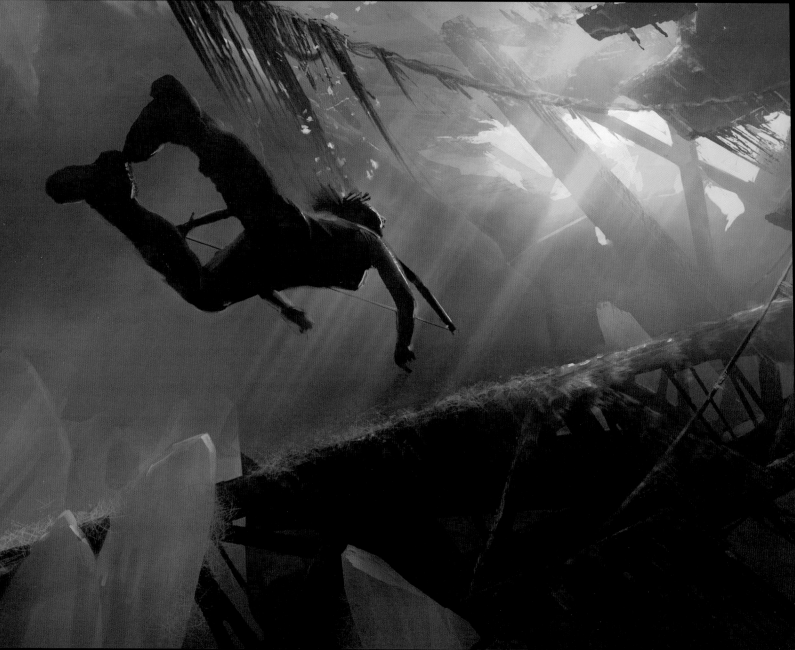

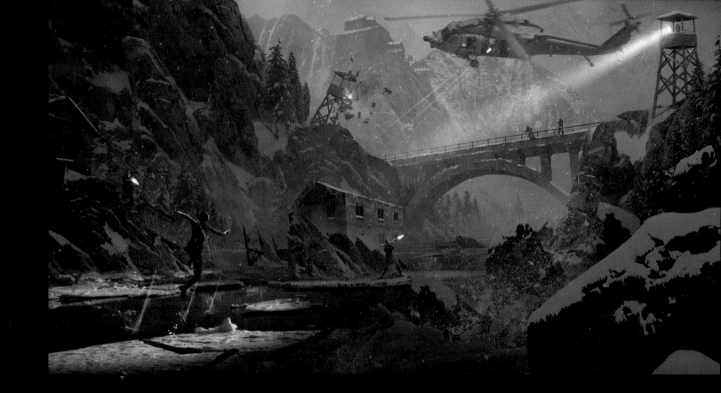

Lara and Jacob escape from the gulag, hotly pursued by a Trinity attack helicopter. Leaping into the frozen river is a risk they are both willing to take, and between them the pair eventually survive the incident. In these concepts the effects of lighting on a scene are explored, from the explosions on the bridge to filtered searchlights viewed from underwater. Such visual effects can all be dramatically recreated using modern rendering technology, employed both to create dynamic visuals and guide players toward their next goals. Instinctively, Lara swims toward the glimmer, though her progress is made with caution owing to its origins being less than friendly.

TOP LEFT: Art by Yohann Schepacz
TOP RIGHT: Art by Brandon Russell
LEFT: Art by Michael Baytion
BELOW: Art by Michael Baytion

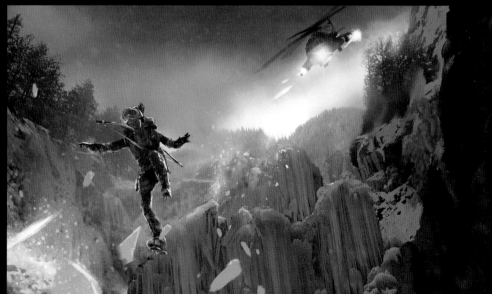

BYZANTINE ICE CAVES

After barely surviving her plunge into the icy river, Lara discovers a vast crack in the ice, leading deeper into the glacier. She climbs down to the bottom and discovers an enormous central cavern, where undisturbed Byzantine ruins still stand, shielded beneath a roof of blue ice. Instinctively, she knows she's close to Kitezh—and whatever secrets it holds. Amidst the ice and rubble lays troubling evidence—Trinity have found it first, constructing a mining operation to excavate the ruins' mysteries.

OPPOSITE: Art by Mark Castanon
BELOW: Art by Mark Castanon
BOTTOM: Art by Michael Baytion

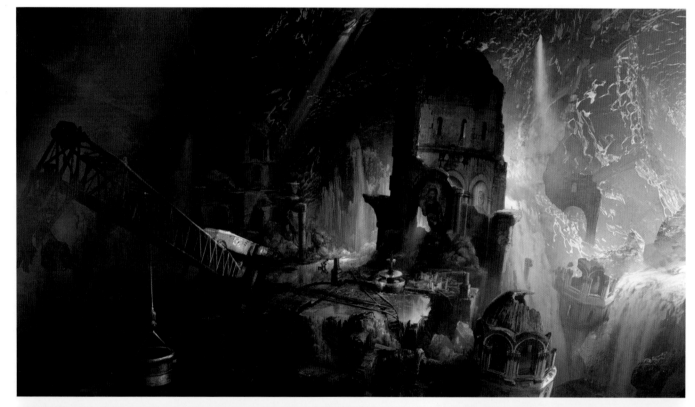

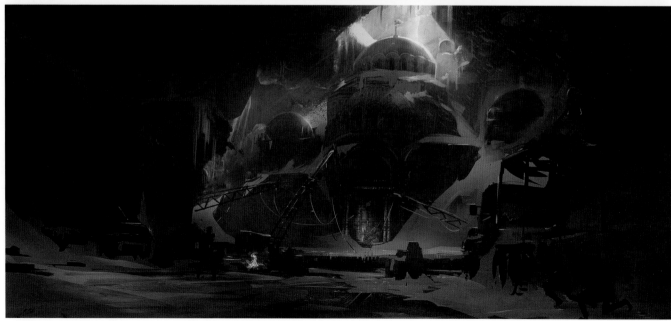

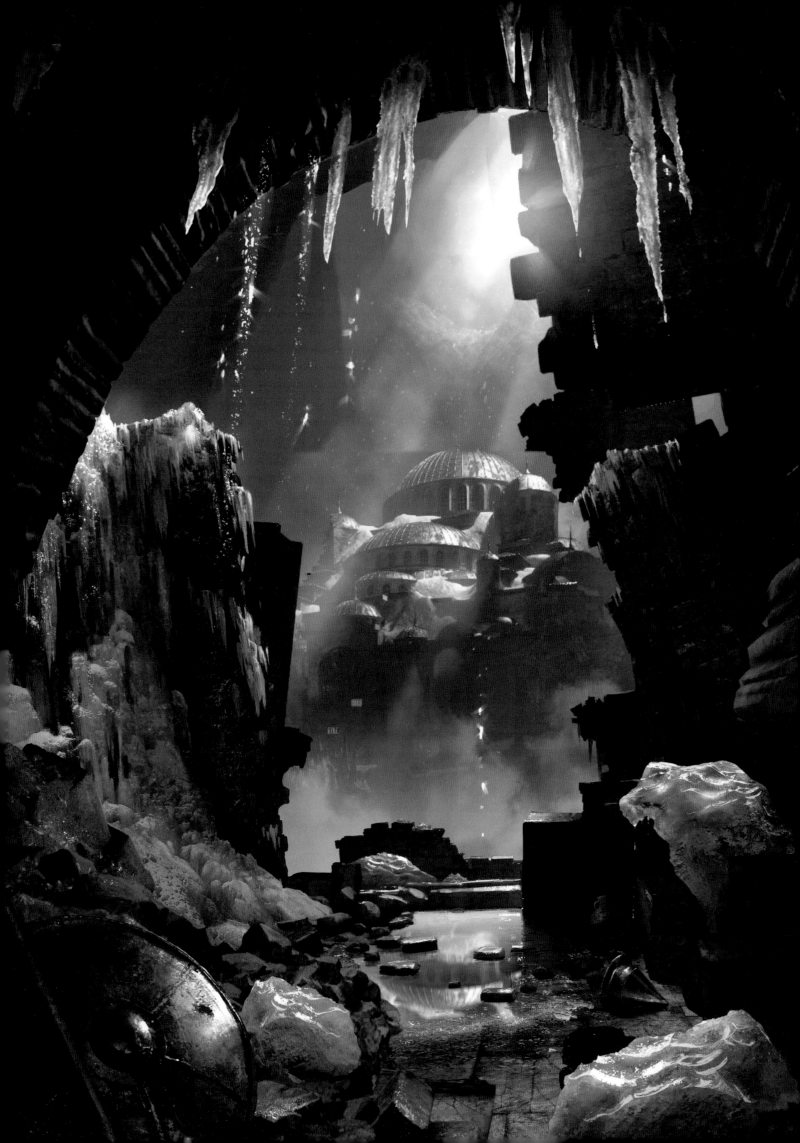

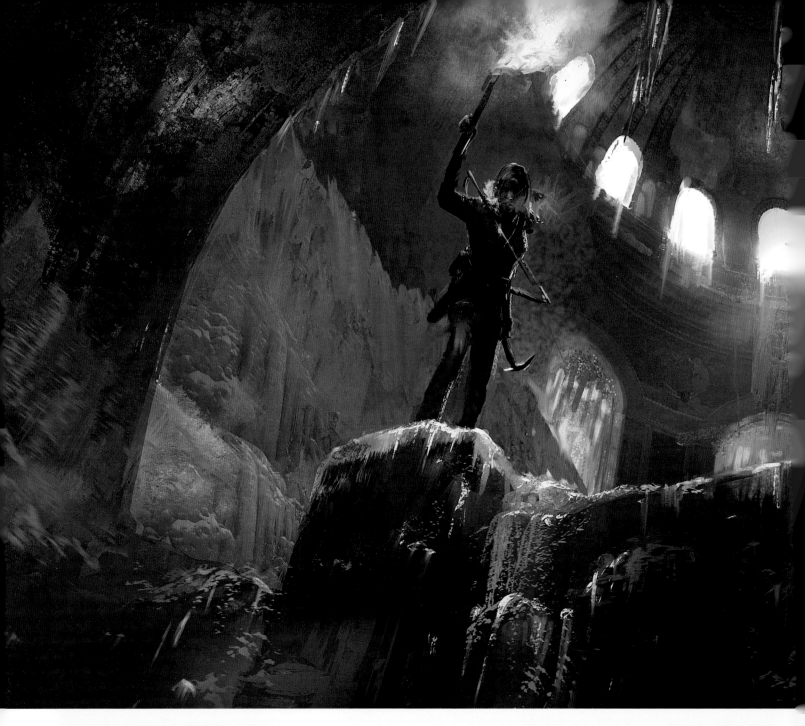

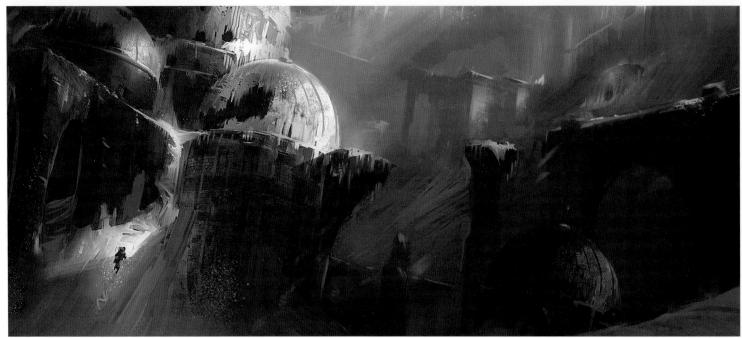

Byzantine architecture was amongst the most influential of the medieval era, spreading from the Middle East outwards. Though Roman in origin, the style grew in complexity to incorporate sophisticated mosaics beneath equally elaborate domed exteriors. Subtle interior lighting was achieved via windows that filtered through thin alabaster. There would be no doubt in Lara's mind that she had found her prize, or at least its most likely resting place. For Crystal Dynamics' art team, this presented the opportunity to showcase a diverse array of surface textures that bounce light sources around caves, providing eerie illumination, from the frozen city itself to its snow laden burial place. Its presentation is reminiscent of an Escher painting, hinting at the puzzles and tombs that await Lara in Kitezh.

LEFT: Art by Michael Baytion
BOTTOM (L-R): Art by Michael Baytion
RIGHT: Statue design by Brenoch Adams

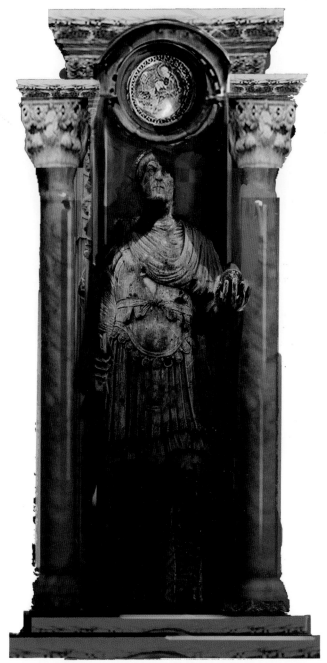

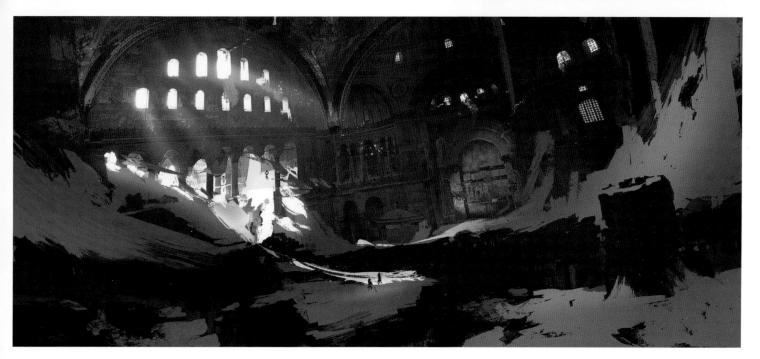

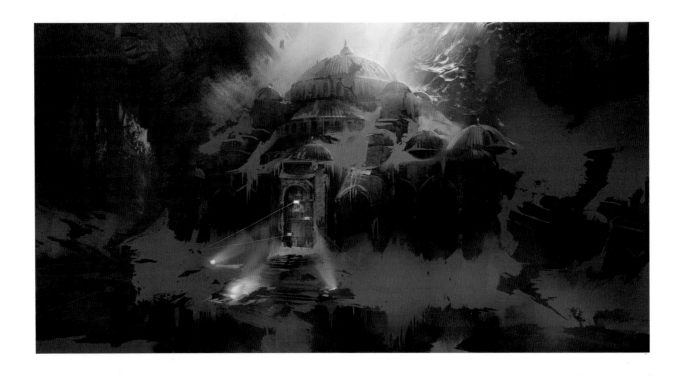

Below are examples of work that may have been created by Byzantine gold- and silver-smiths, among them an ornate prayer room fountain. They are simply referred to as set dressing in the design documents, which speaks to the great care taken with all objects found within this fictional world to assume realism. The colossal gilded doors look set to be prized open by the attached ropes, another potential puzzle for Lara to solve.

ABOVE: Art by Michael Baytion
OPPOSITE: Art by Mark Castanon
LEFT/BELOW: Vase designs by Natasha Tan

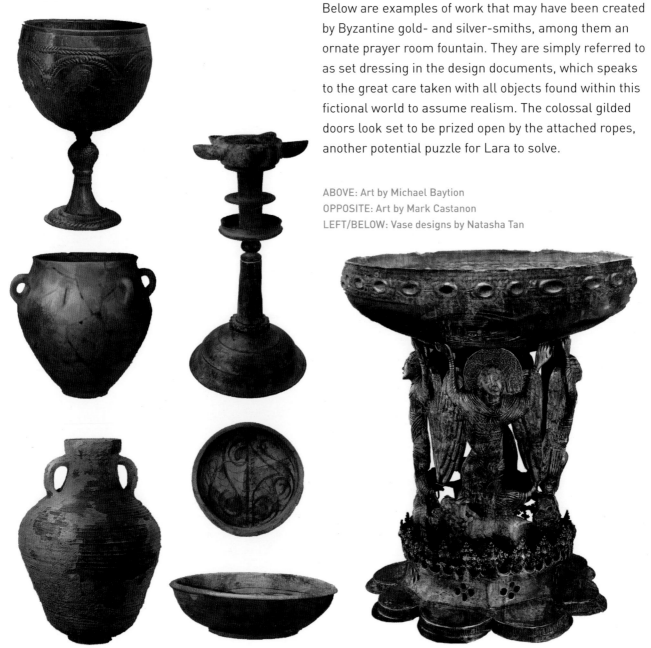

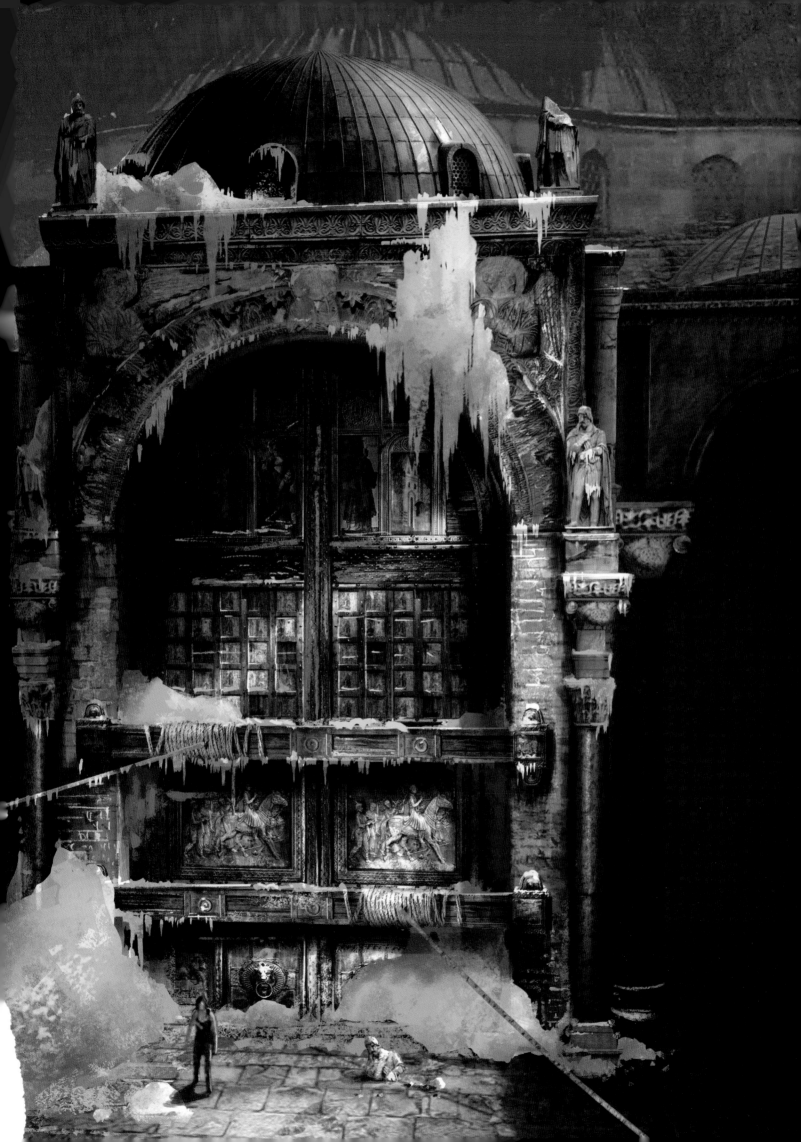

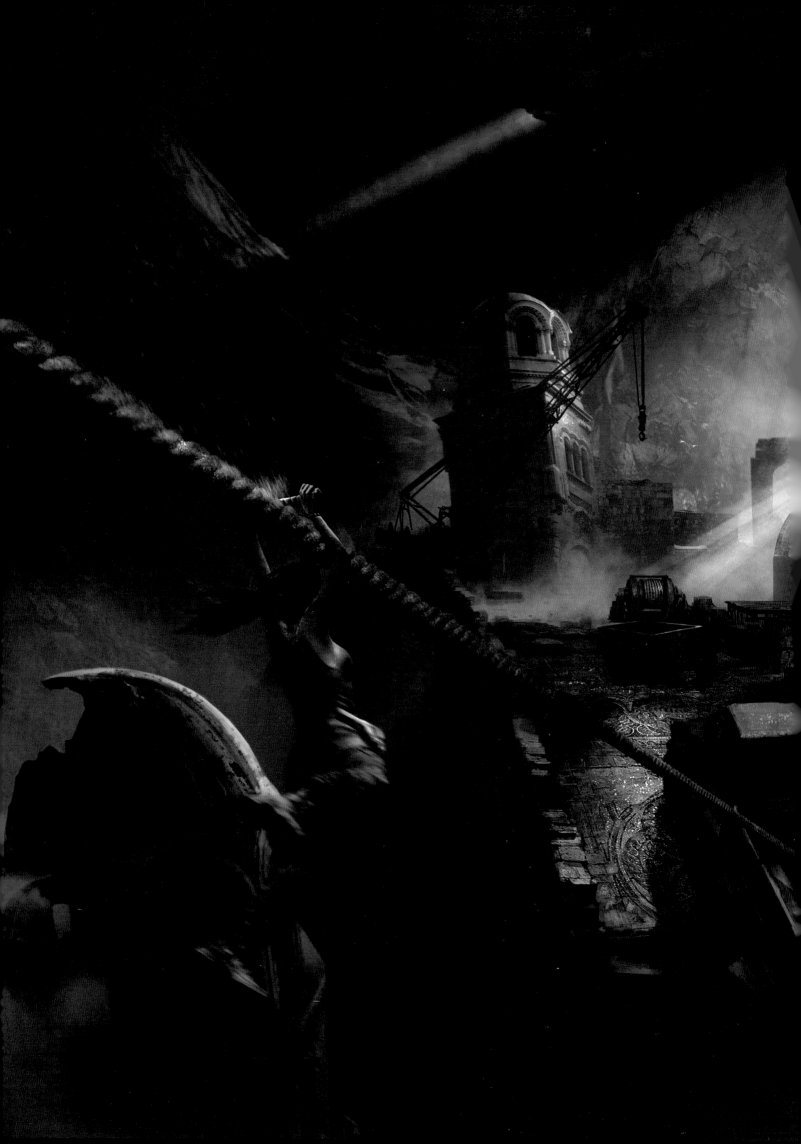

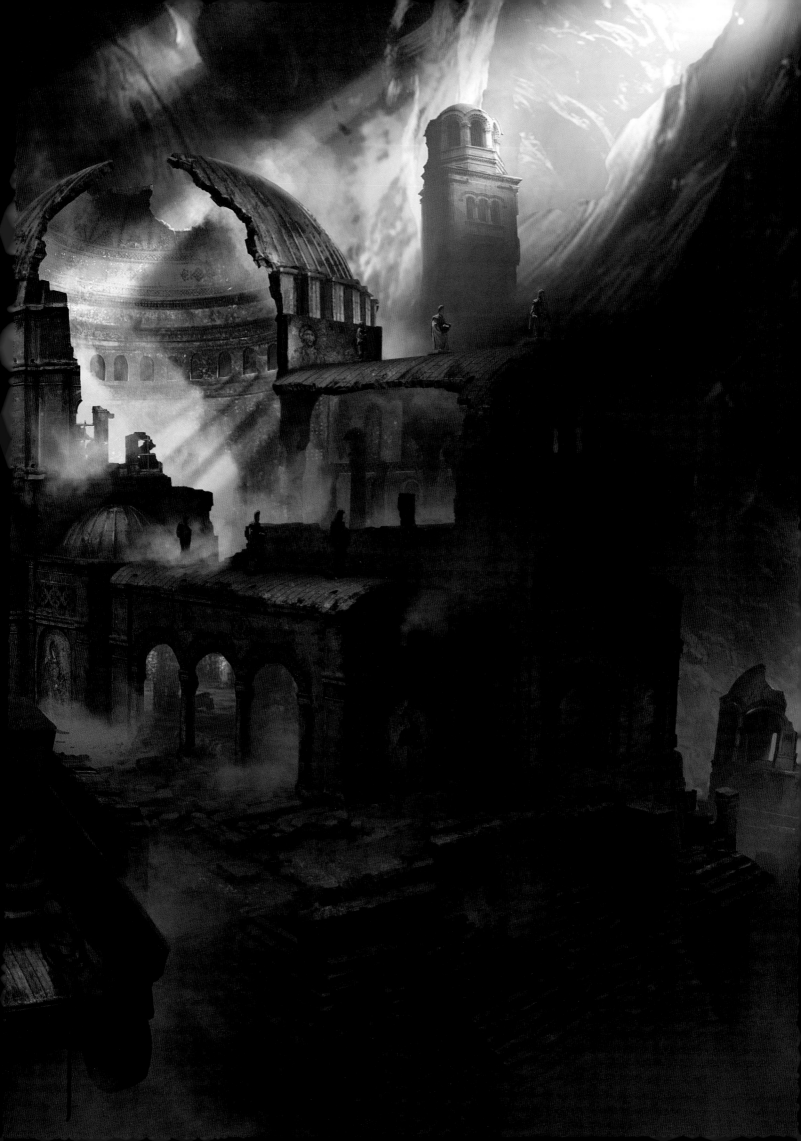

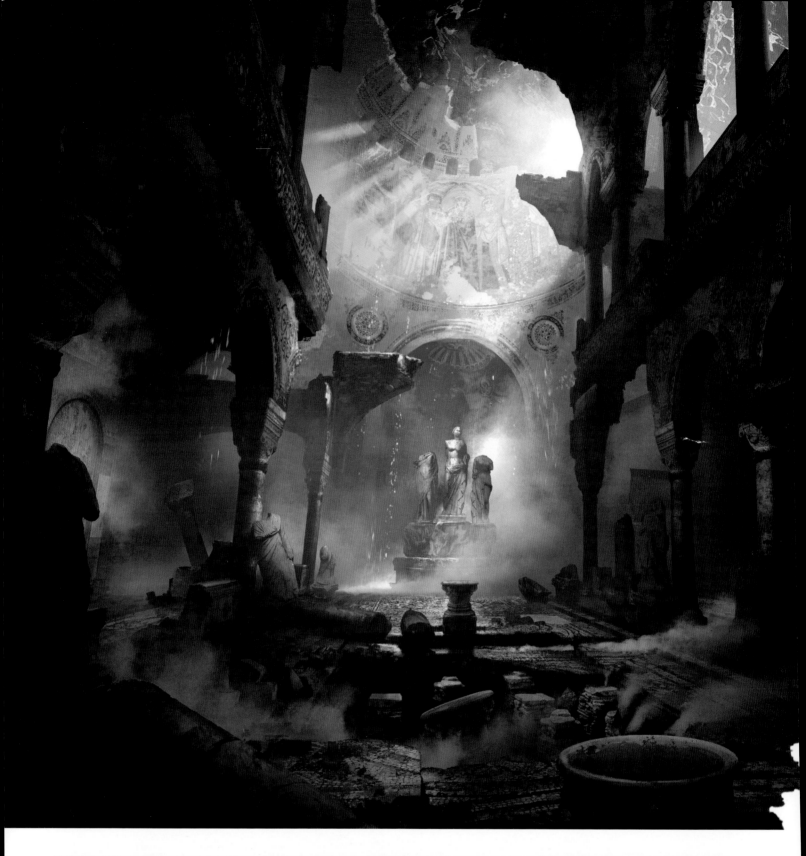

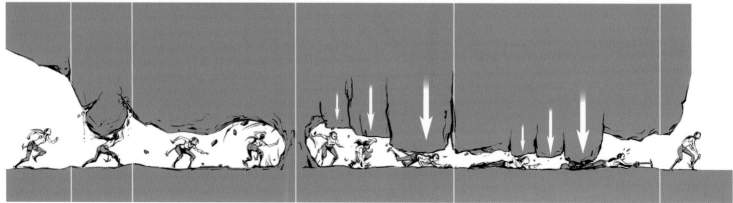

RISE OF THE TOMB RAIDER THE OFFICIAL ART BOOK

Light from the ice canopy above filters down through this sauna ruin's windows, the structure reclaimed by nature. "Shape and scale were big influences here. We looked at ancient cathedrals and used those as an inspiration," says Adams. "The geothermal activity is causing this area to be incredibly unstable. You can see things being chewed away; we wanted to look like it's starting to corrode and being swallowed back into the world."

LEFT: Art by Mark Castanon
BOTTOM LEFT: Art by Jeff Adams
BELOW: Art by Michael Baytion

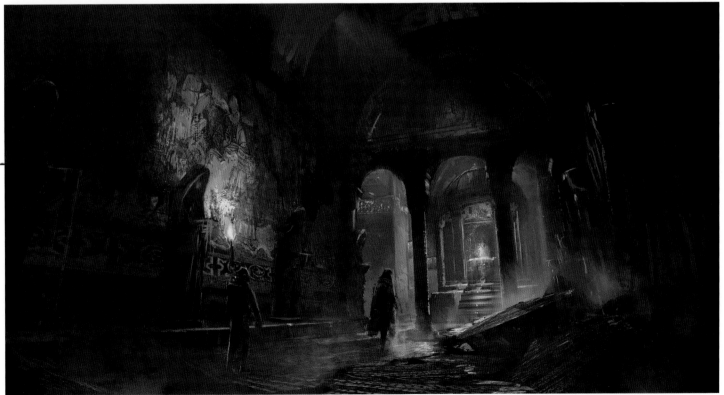

Lara's first sighting of the lost city of
Kitezh sparks immediate recognition.
At the center of the city is the
Chamber of Souls, the final resting
place of the Deathless Prophet.
Together we are stopped in our
tracks to absorb the moment. Trinity
forces have attempted to use brute
mechanical to pry open the gates to
no avail. To reach them herself Lara
must solve one last set of puzzles,
her mountaineering skills zipping
her undauntedly across the chasms.

TOP: Art by Brandon Russell
OPPOSITE: Art by Mark Castonon
BELOW SKETCHES: Art by Richard Healey
BOTTOM: Art by Brandon Russell
NEXT SPREAD: Art by Richard Healey

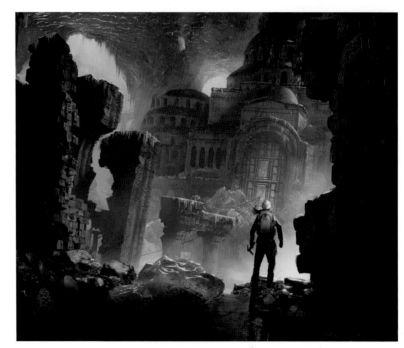

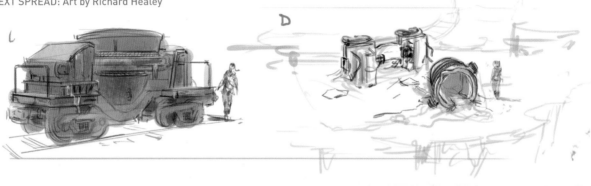

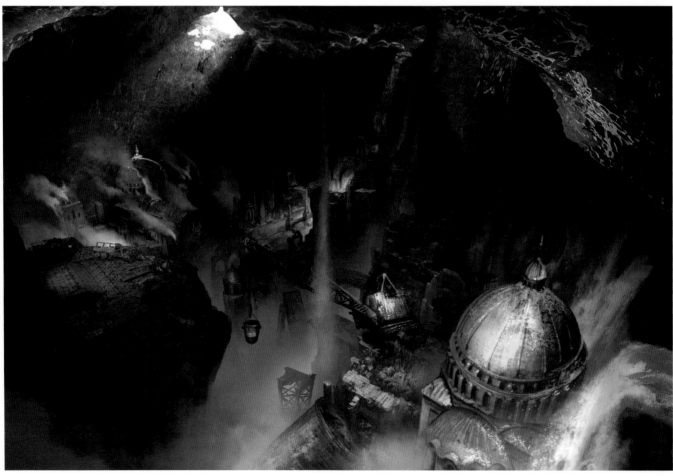

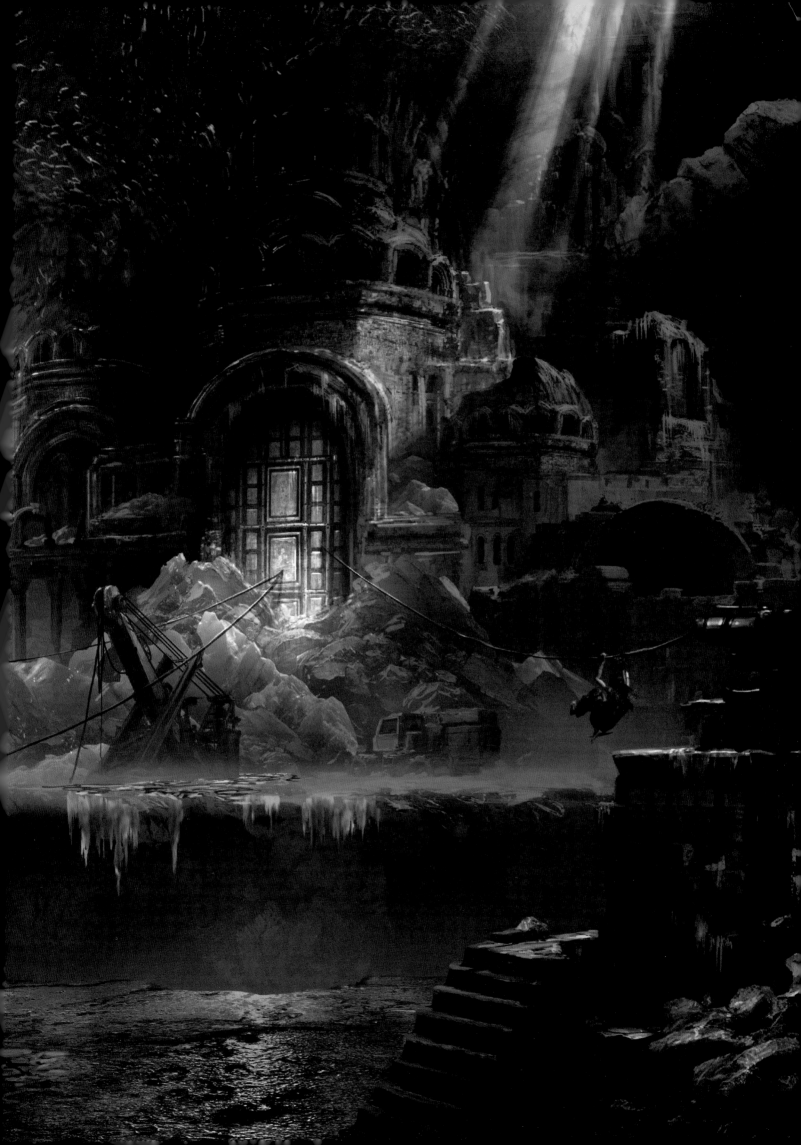

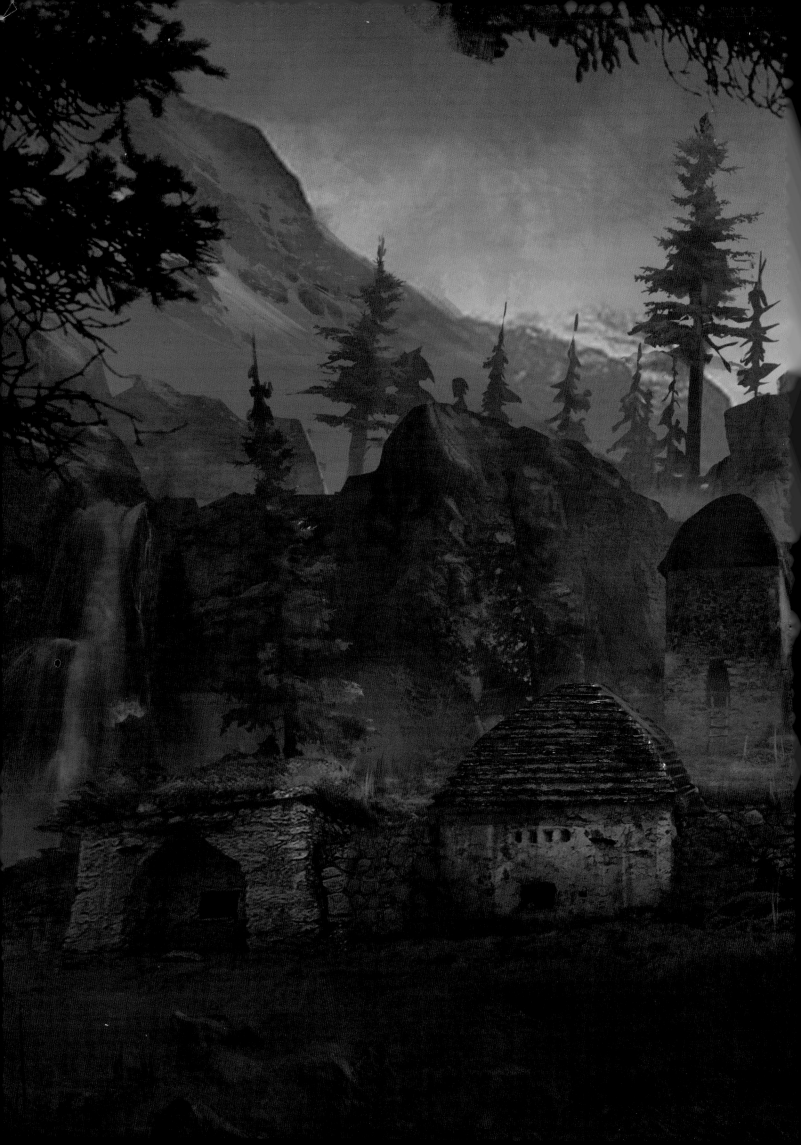

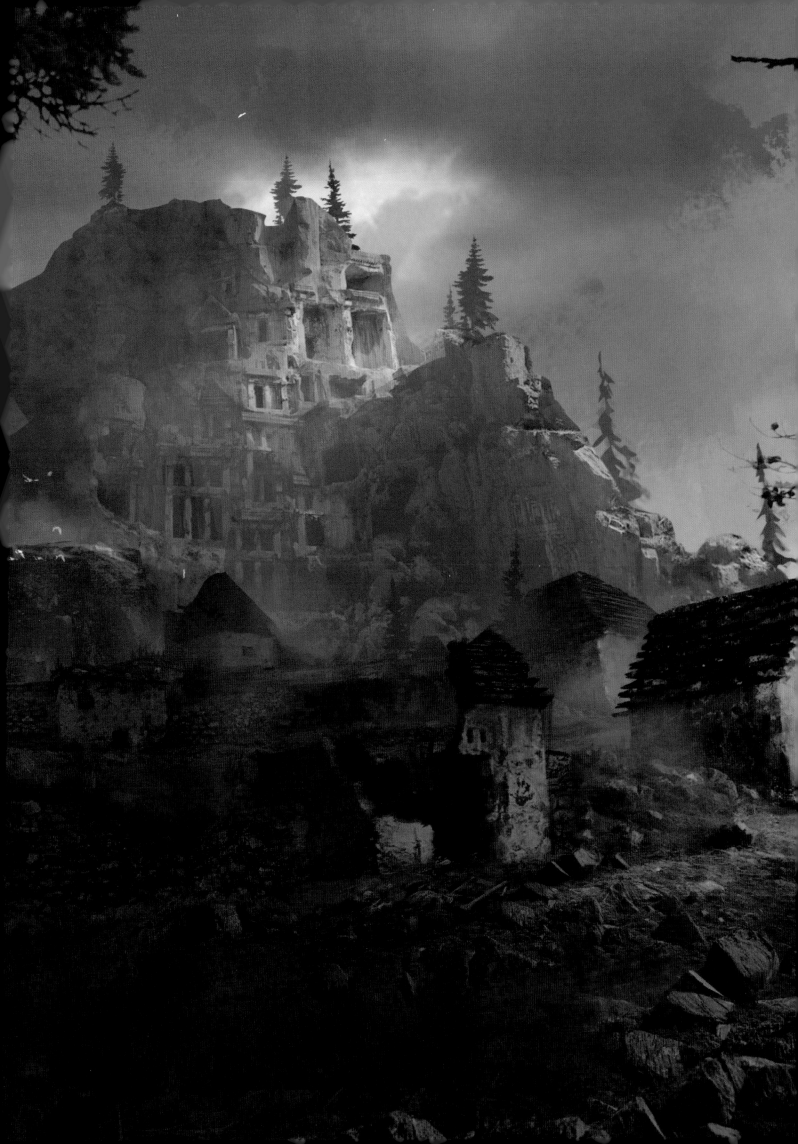

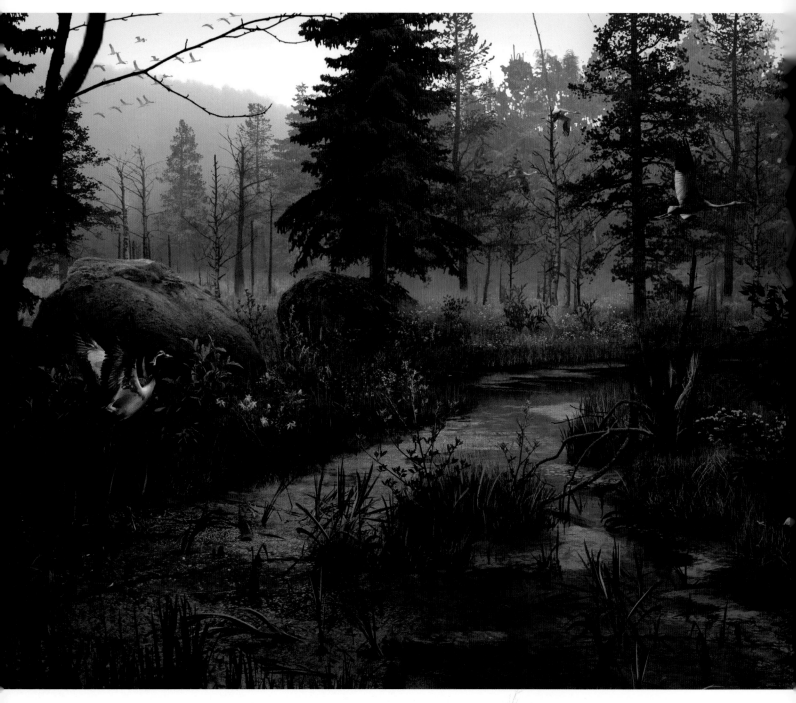

REMNANT VALLEY

The Remnant (The People of the Prophet) are a self-sustaining isolated population hidden in this particular Siberian valley. The majority of them are descendants of the original followers of the Prophet, but, over the years, others have come to the valley, lost and alone, seeking salvation. Their existence is fundamentally linked to the protection of the valley, the Divine Source within the ruins of the old city, and of the power of the Prophet.

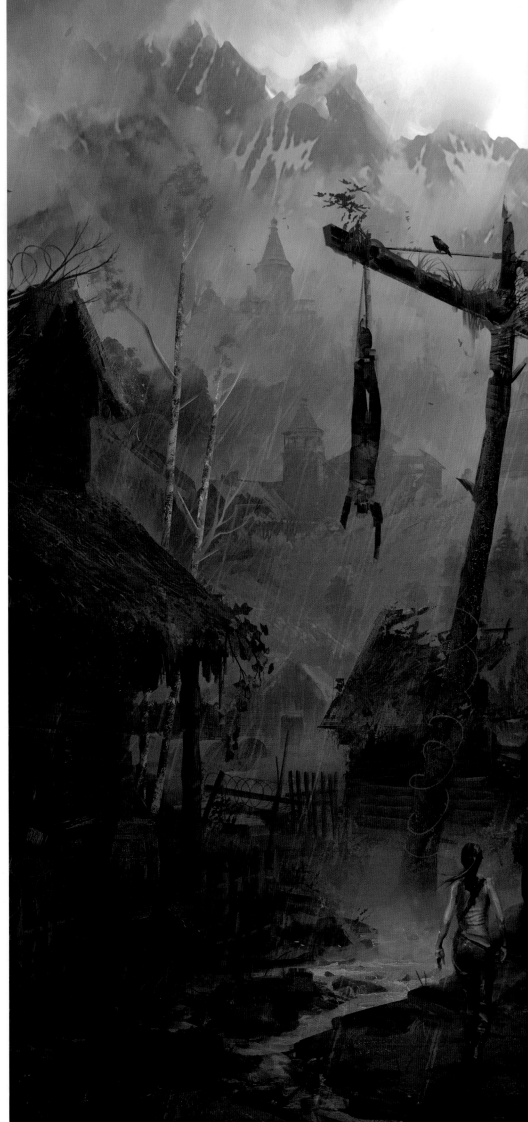

ABOVE: Art by Mark Castanon
LEFT: Art by Brandon Russell
RIGHT: Art by Brandon Russell

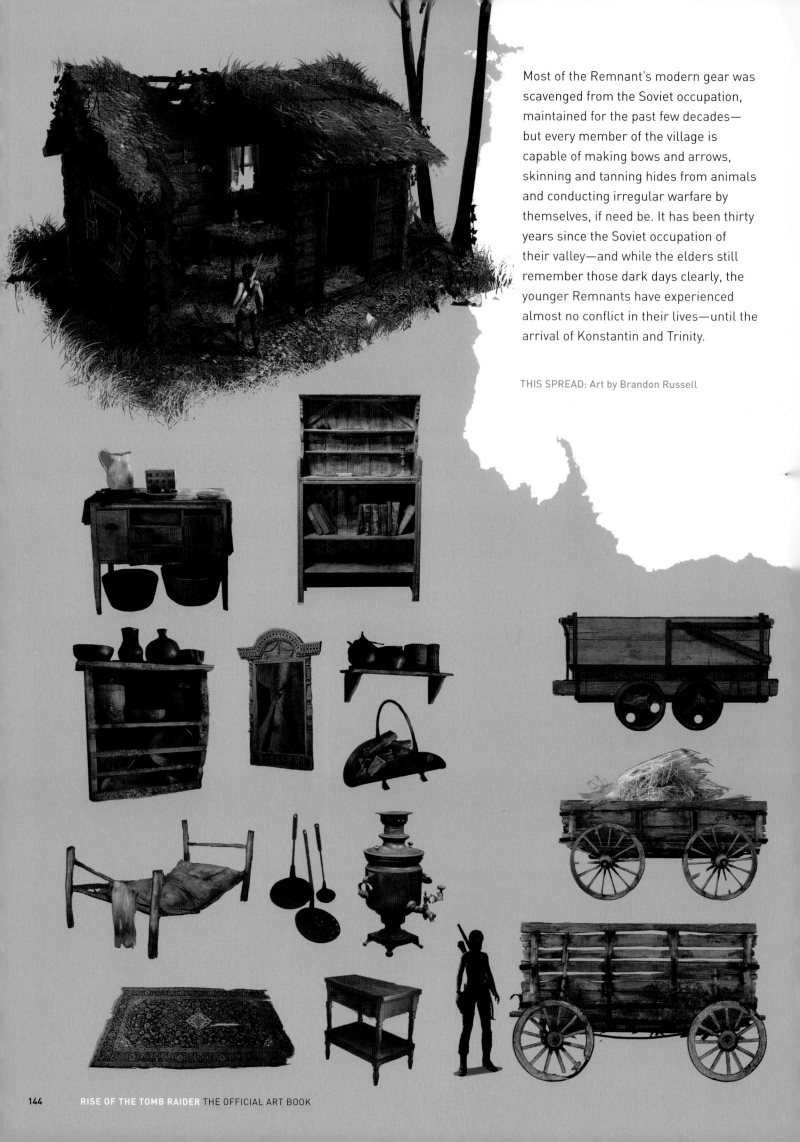

Most of the Remnant's modern gear was scavenged from the Soviet occupation, maintained for the past few decades—but every member of the village is capable of making bows and arrows, skinning and tanning hides from animals and conducting irregular warfare by themselves, if need be. It has been thirty years since the Soviet occupation of their valley—and while the elders still remember those dark days clearly, the younger Remnants have experienced almost no conflict in their lives—until the arrival of Konstantin and Trinity.

THIS SPREAD: Art by Brandon Russell

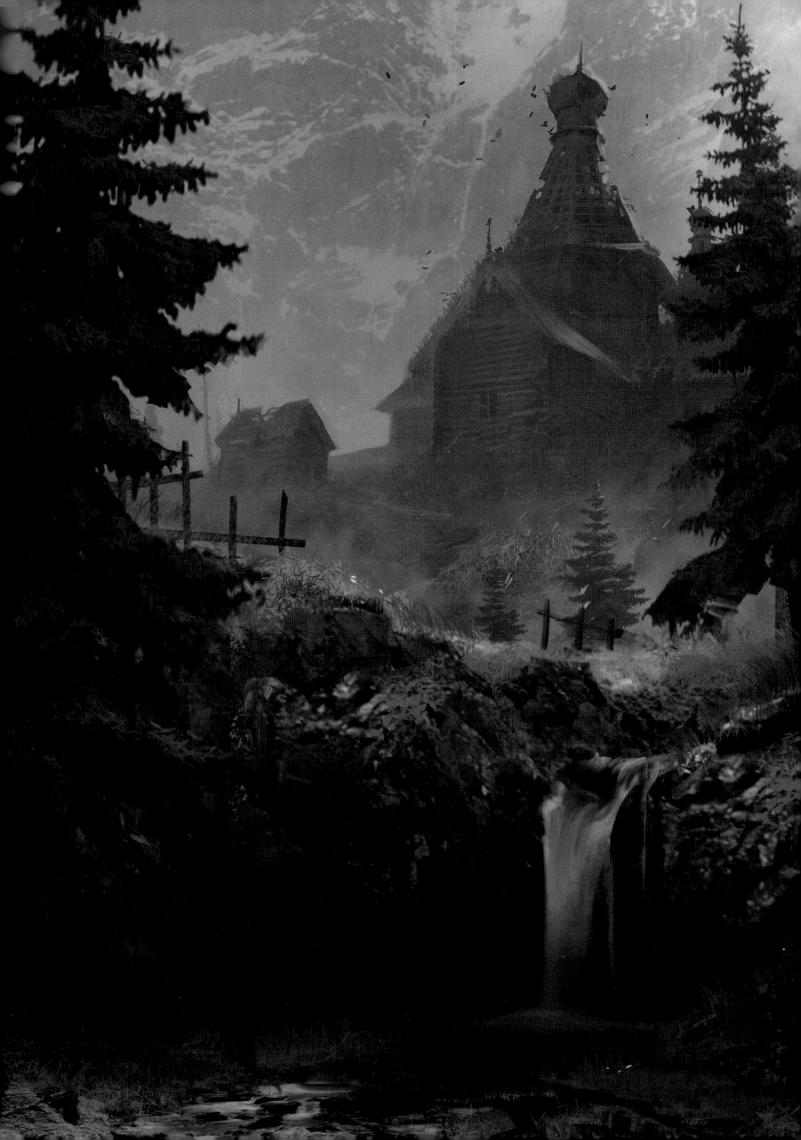

THE TOWER

These ruins of a Byzantine tower are the hiding place of the Atlas—an important artifact crucial to finding a way into Kitezh. Outside, storm clouds gather and rain begins to fall. The natural surroundings around the tower are far lusher and greener than the Siberian wastes nearby—a mysterious, and potentially supernatural, occurrence.

THIS SPREAD: Art by Brandon Russell

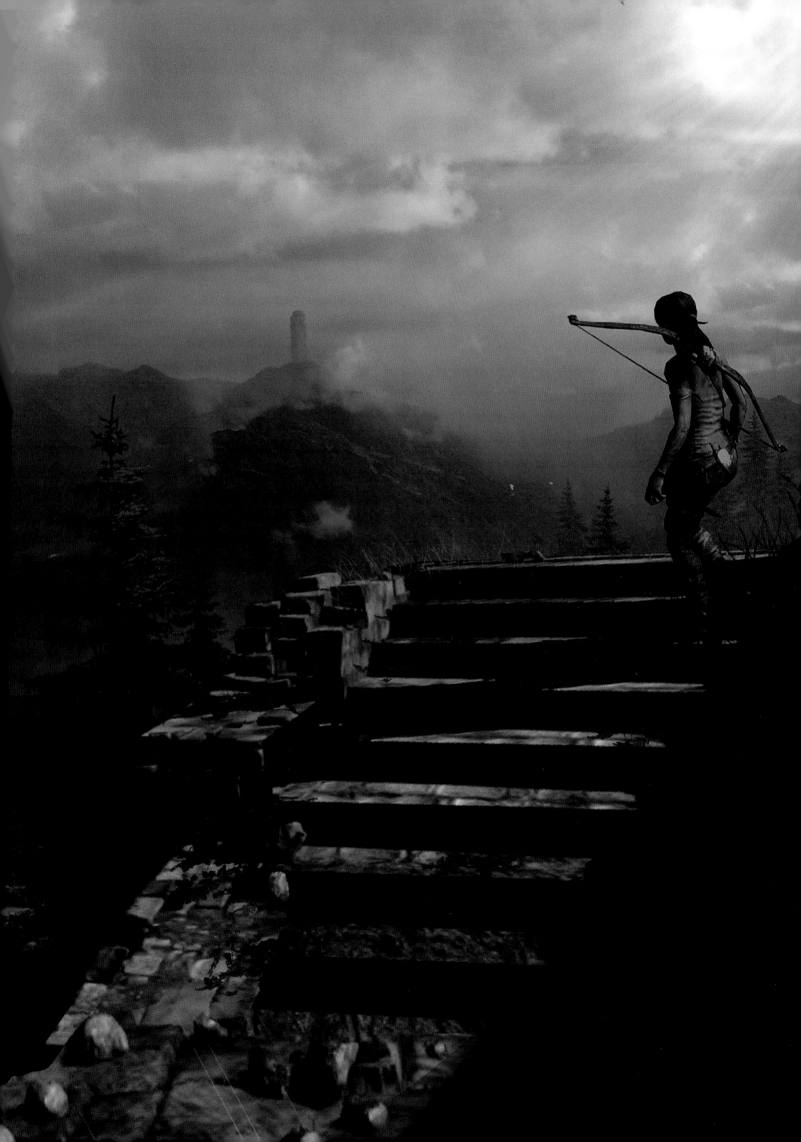

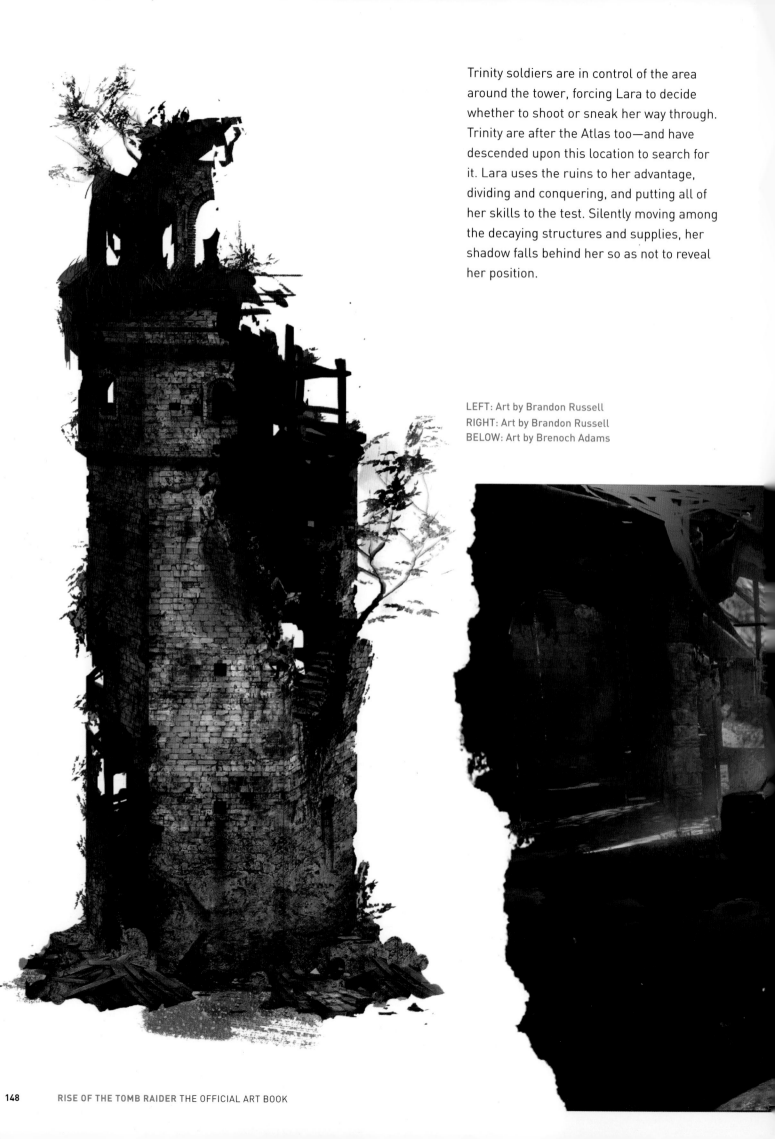

Trinity soldiers are in control of the area around the tower, forcing Lara to decide whether to shoot or sneak her way through. Trinity are after the Atlas too—and have descended upon this location to search for it. Lara uses the ruins to her advantage, dividing and conquering, and putting all of her skills to the test. Silently moving among the decaying structures and supplies, her shadow falls behind her so as not to reveal her position.

LEFT: Art by Brandon Russell
RIGHT: Art by Brandon Russell
BELOW: Art by Brenoch Adams

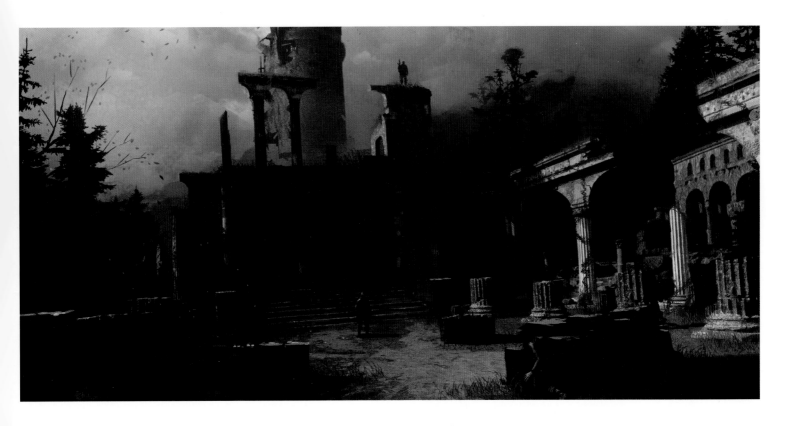

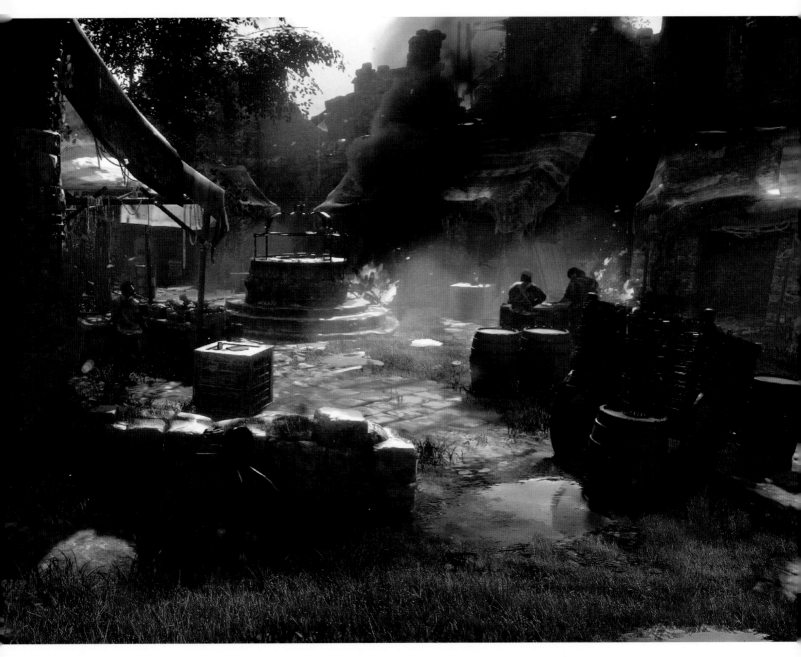

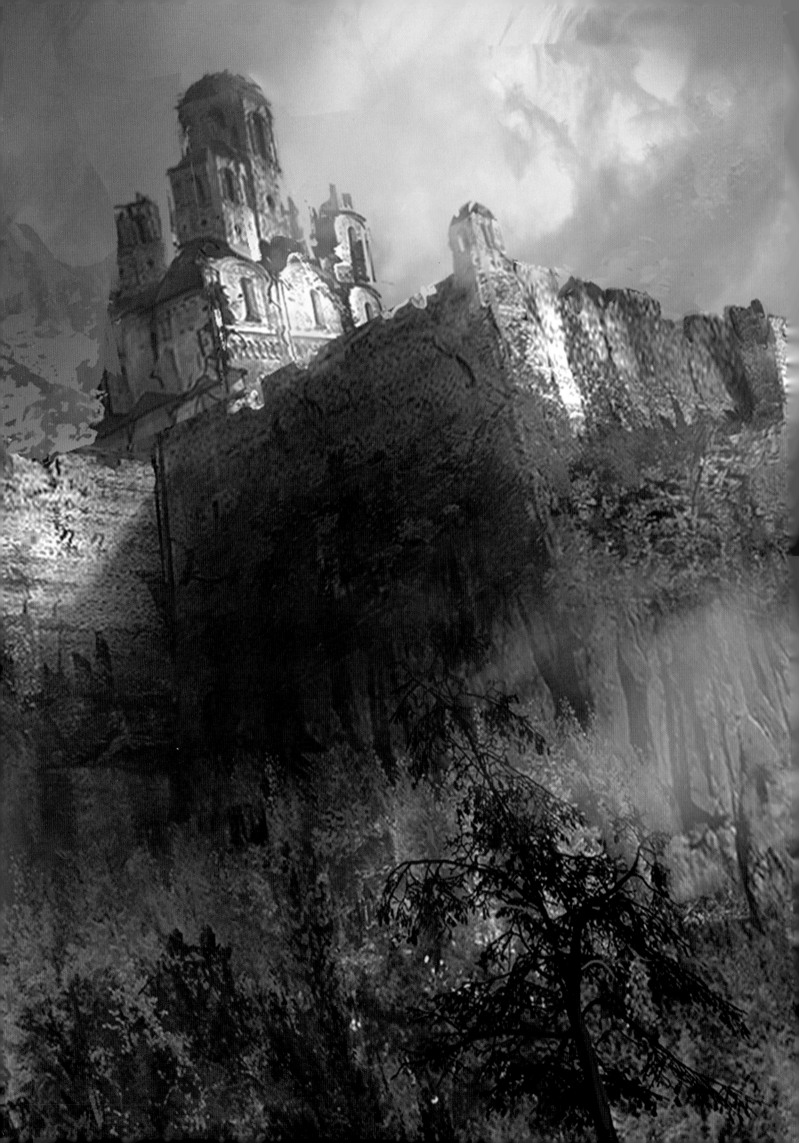

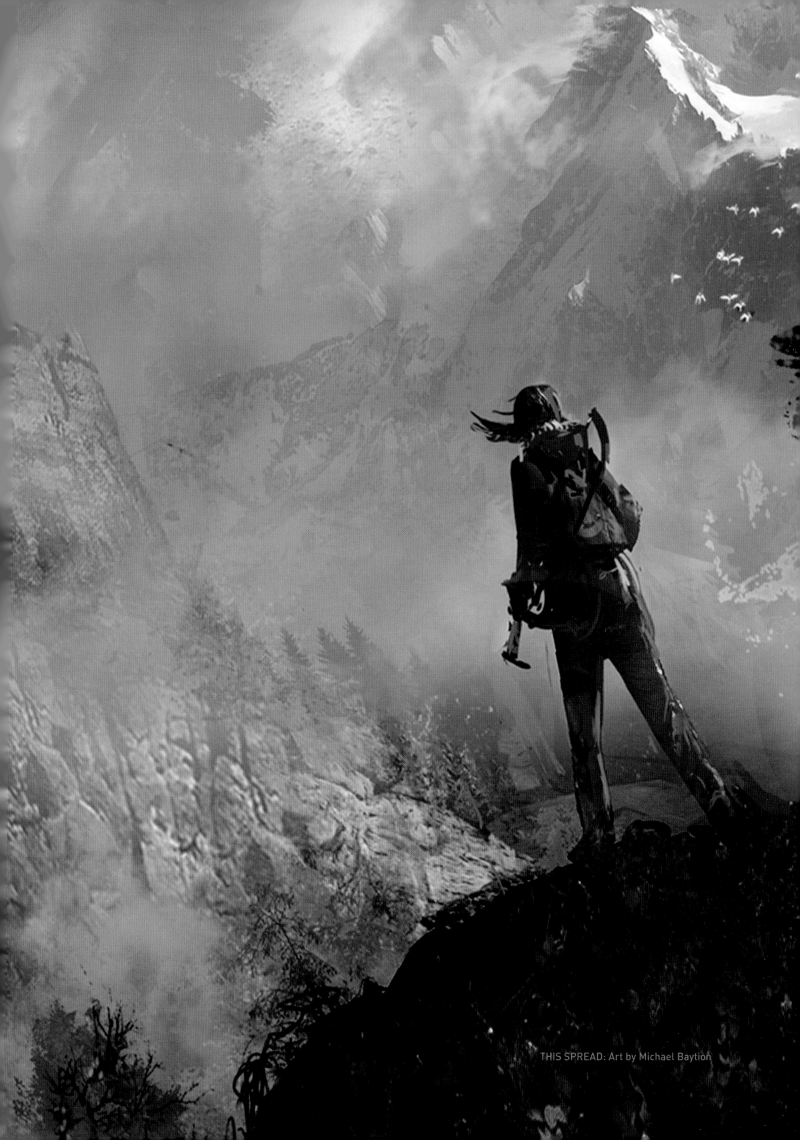

THIS SPREAD: Art by Michael Baytion

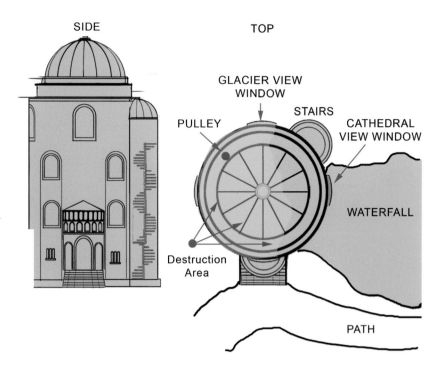

SIDE

TOP

GLACIER VIEW
WINDOW

PULLEY

STAIRS

CATHEDRAL
VIEW WINDOW

WATERFALL

Destruction
Area

PATH

The Atlas is a small, intricately carved tablet that depicts an ancient map of the lost city of Kitezh. Lara uses clues from a mosaic at the ruined cathedral to interpret the Atlas, realizing it points to a secret entrance. In the storyboards shown right, the sequence is mapped out by the concept artists for the animators to follow, showing the desired viewing positions and how dialogue should be timed to coincide. During the planning stages for this puzzle, the concept team had the cathedral tower drawn up in simple plan and elevated views to describe how this might all theoretically work together.

LEFT: Diagram by Jeff Adams
RIGHT: Storyboards by Jeff Adams
BELOW: Art by Michael Baytion

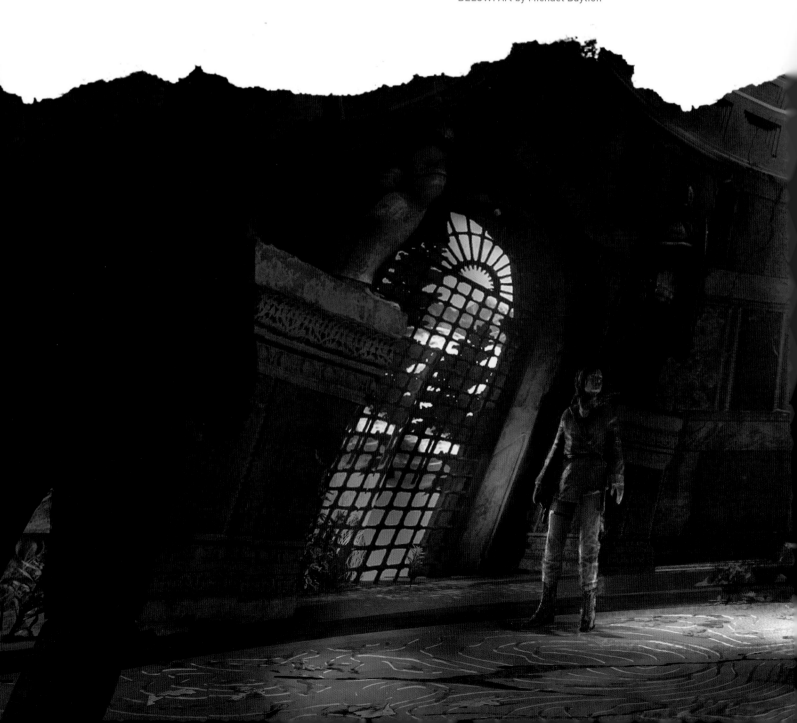

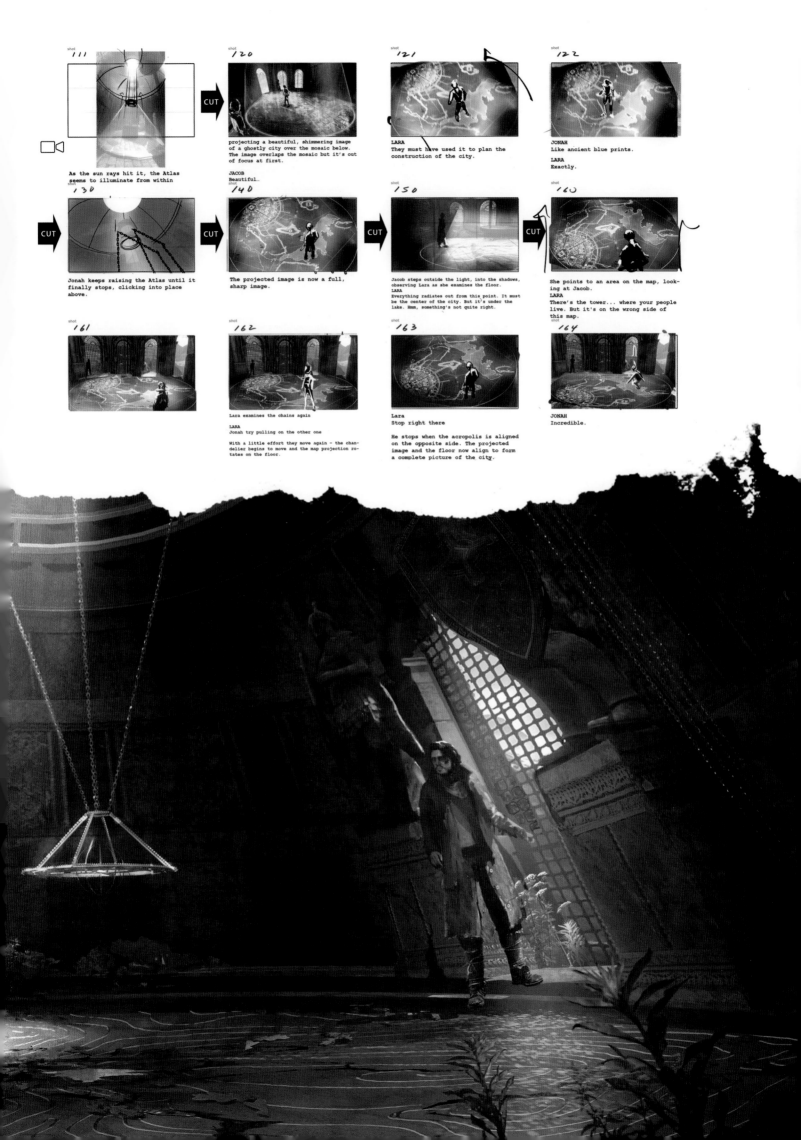

shot **111**

As the sun rays hit it, the Atlas
seems to illuminate from within

CUT

shot **120**

projecting a beautiful, shimmering image
of a ghostly city over the mosaic below.
The image overlaps the mosaic but it's out
of focus at first.

JACOB
Beautiful...

shot **121**

LARA
They must have used it to plan the
construction of the city.

shot **122**

JONAH
Like ancient blue prints.

LARA
Exactly.

shot **130**

CUT

Jonah keeps raising the Atlas until it
finally stops, clicking into place
above.

shot **140**

CUT

The projected image is now a full,
sharp image.

shot **150**

CUT

Jacob steps outside the light, into the shadows,
observing Lara as she examines the floor.
LARA
Everything radiates out from this point. It must
be the center of the city. But it's under the
lake. Hmm, something's not quite right.

shot **160**

CUT

She points to an area on the map, look-
ing at Jacob.
LARA
There's the tower... where your people
live. But it's on the wrong side of
this map.

shot **161**

shot **162**

Lara examines the chains again

LARA
Jonah try pulling on the other one

With a little effort they move again - the chan-
delier begins to move and the map projection ro-
tates on the floor.

shot **163**

Lara
Stop right there

He stops when the acropolis is aligned
on the opposite side. The projected
image and the floor now align to form
a complete picture of the city.

shot **164**

JONAH
Incredible.

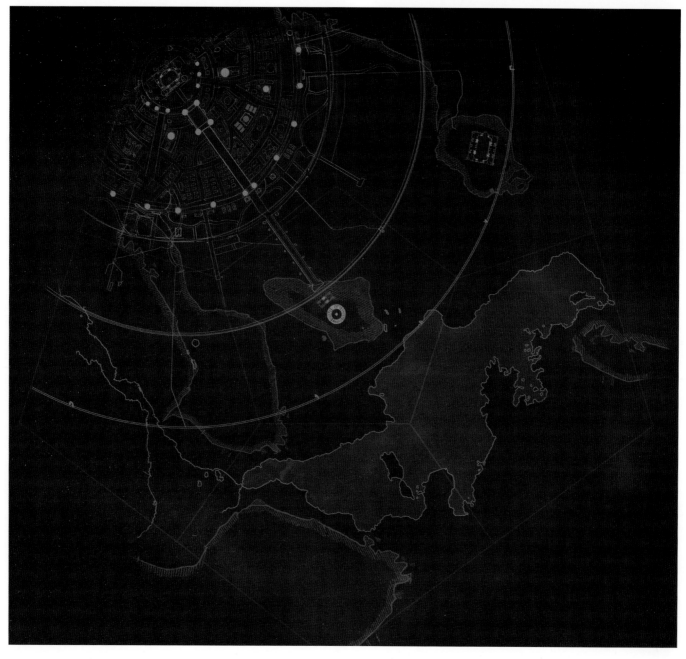

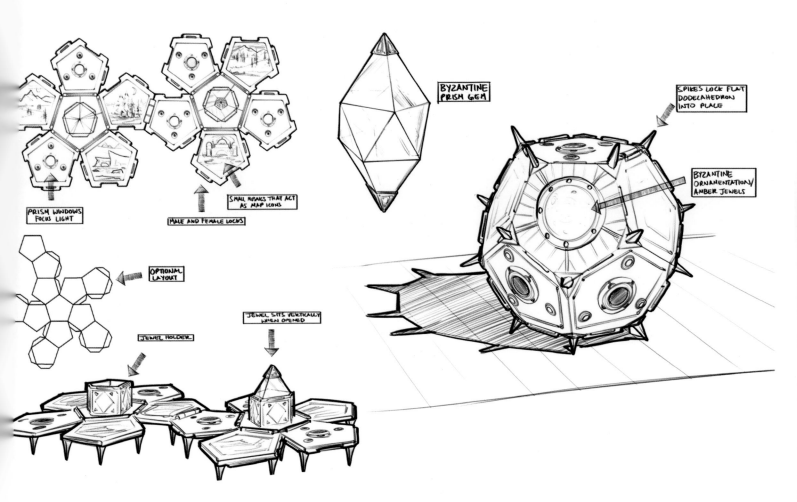

PRISM WINDOWS FOCUS LIGHT

SMALL MOSAICS THAT ACT AS MAP ICONS

MALE AND FEMALE LOCKS

BYZANTINE PRISM GEM

SPIKES LOCK FLAT DODECAHEDRON INTO PLACE

BYZANTINE ORNAMENTATION/ AMBER JEWELS

OPTIONAL LAYOUT

JEWEL HOLDER

JEWEL SITS VERTICALLY WHEN OPENED

These pages show an early concept for the Atlas, designed to incorporate a Byzantine prism gem within a folded-out dodecahedron that snaps into place. Light beaming down from the cathedral ceiling passes through an amber jewel to illuminate the Atlas. It then displays a sophisticated map of the lost city's whereabouts on the floor. Hinged jewelry was popular during Byzantine times, a theme explored by the concept artists to make the Atlas a believable historical object. The Byzantines also tended to filter light through windows, influencing the addition of the porthole. Ultimately, the Atlas serves its purpose as a curio of unseen power.

OPPOSITE: Art by Brenoch Adams
TOP: Art by Mark Castanon
ABOVE: Art by Brenoch Adams

KITEZH HUB

Deep in the ice caverns, Lara sees the central pristine acropolis of Kitezh spread out before her. Light filters through the ice above to create an eerie, pervasive blue-white hue. Centuries ago, the city of Kitezh rested in a magnificent valley sheltered from the storms. Then, as now, it was heated by geothermal activity deep within the earth. Incredible monuments and immense, elaborate structures were built in honor of its people's beloved Prophet. Though unseen for centuries, not all that lurks inside remains buried.

THIS SPREAD: Art by Michael Baytion

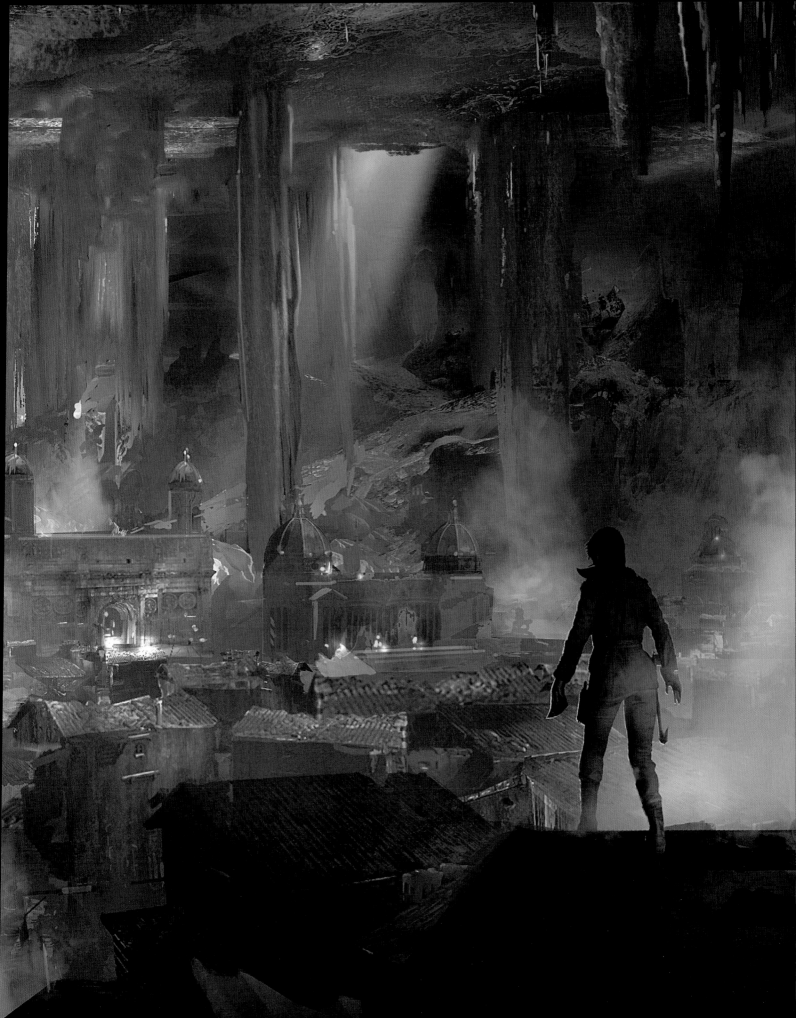

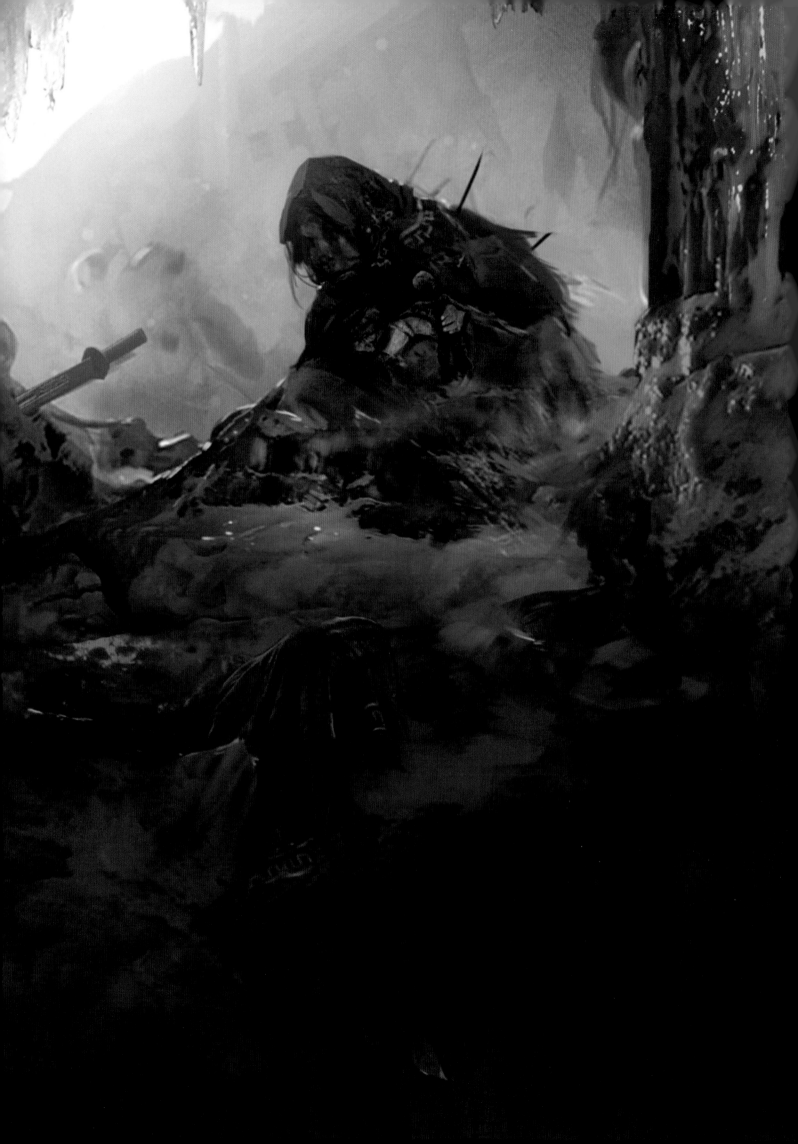

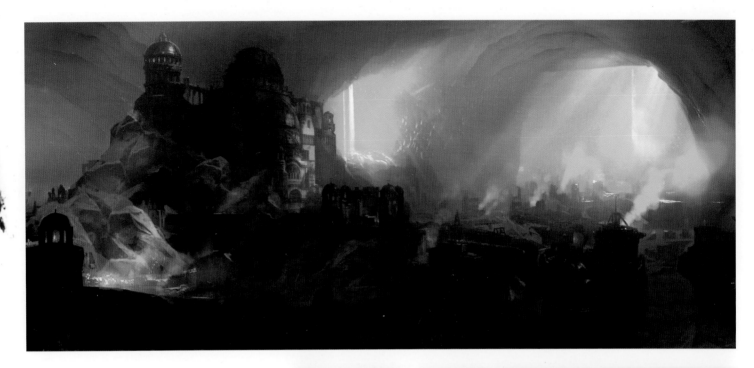

THIS SPREAD: Art by Michael Baytion

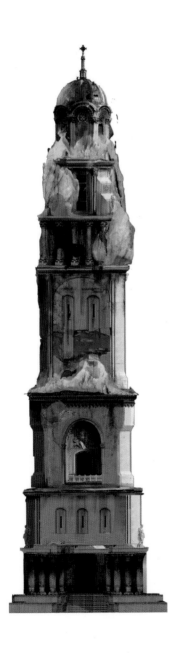

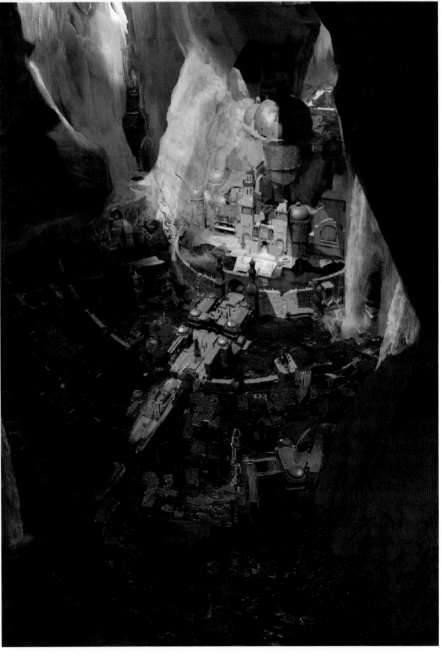

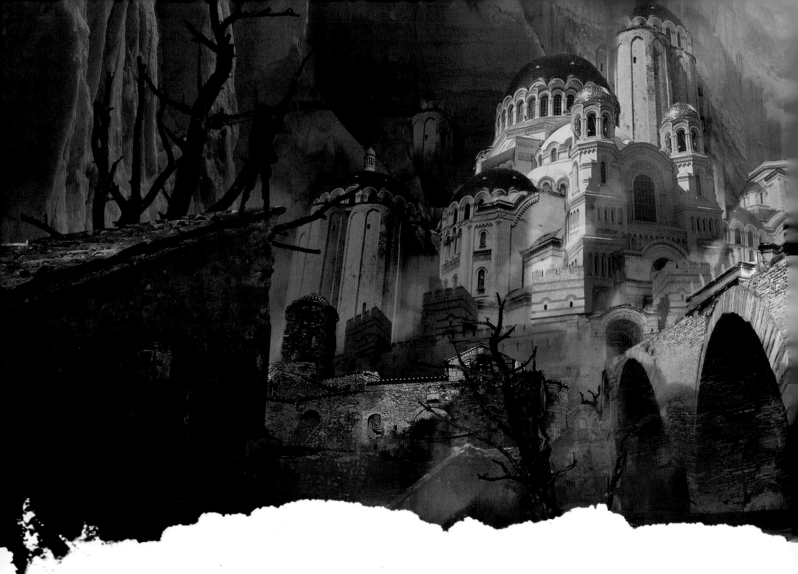

Lara stands silhouetted against the reflected light of the Byzantine structures, geothermal mists rising up below. Various concepts for the frozen city are depicted below and right, detailing intricate dome work for the variety of buildings that make up the Kitezh, as well as the ornate architecture found throughout the lost city.

ABOVE: Art by Brenoch Adams
BELOW: Art by Michael Baytion
RIGHT: Art by Brenoch Adams

Top of Mountain Plateau **Valley** **Crater / Sinkhole / Lake** **Shaft**

 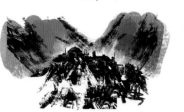 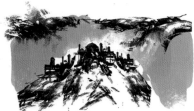 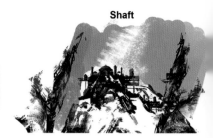

Symmetrical Towers **Asymmetrical Tower** **Cluster** **Fortress-like Pitched Sides**

Oversized Main Tomb **Oversized Main with Supporting Towers** **Bridges and Aqueducts** **Slender Towers**

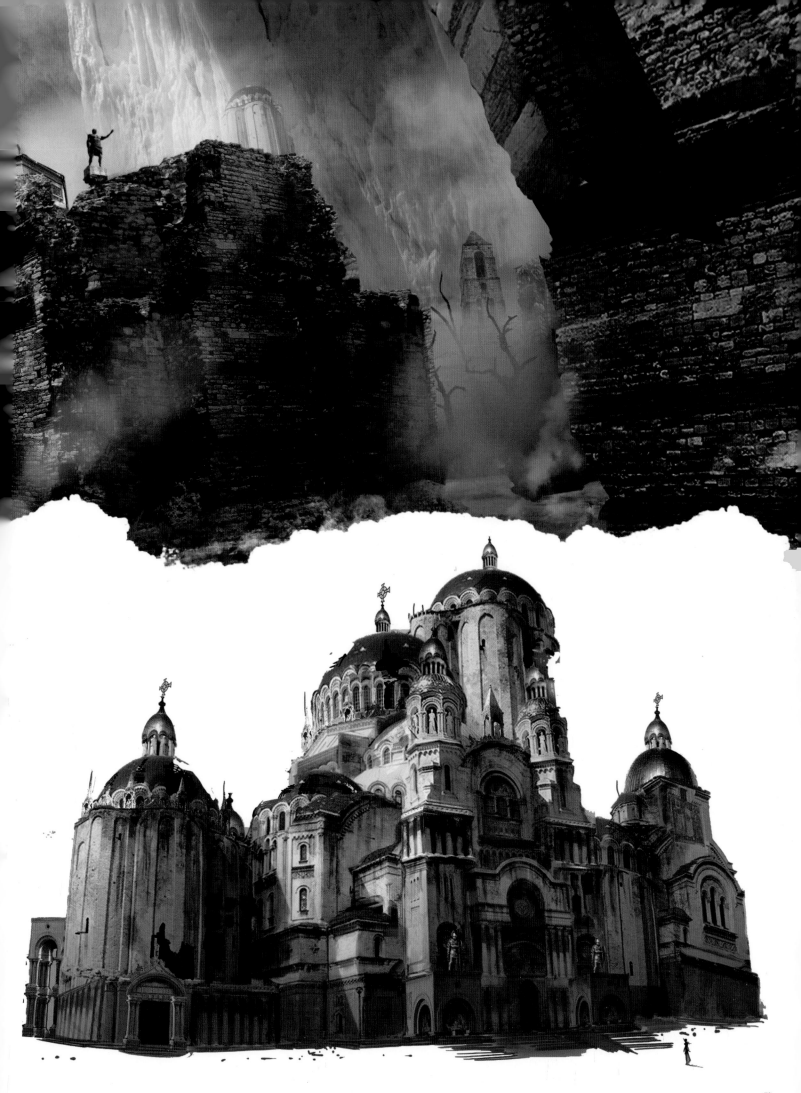

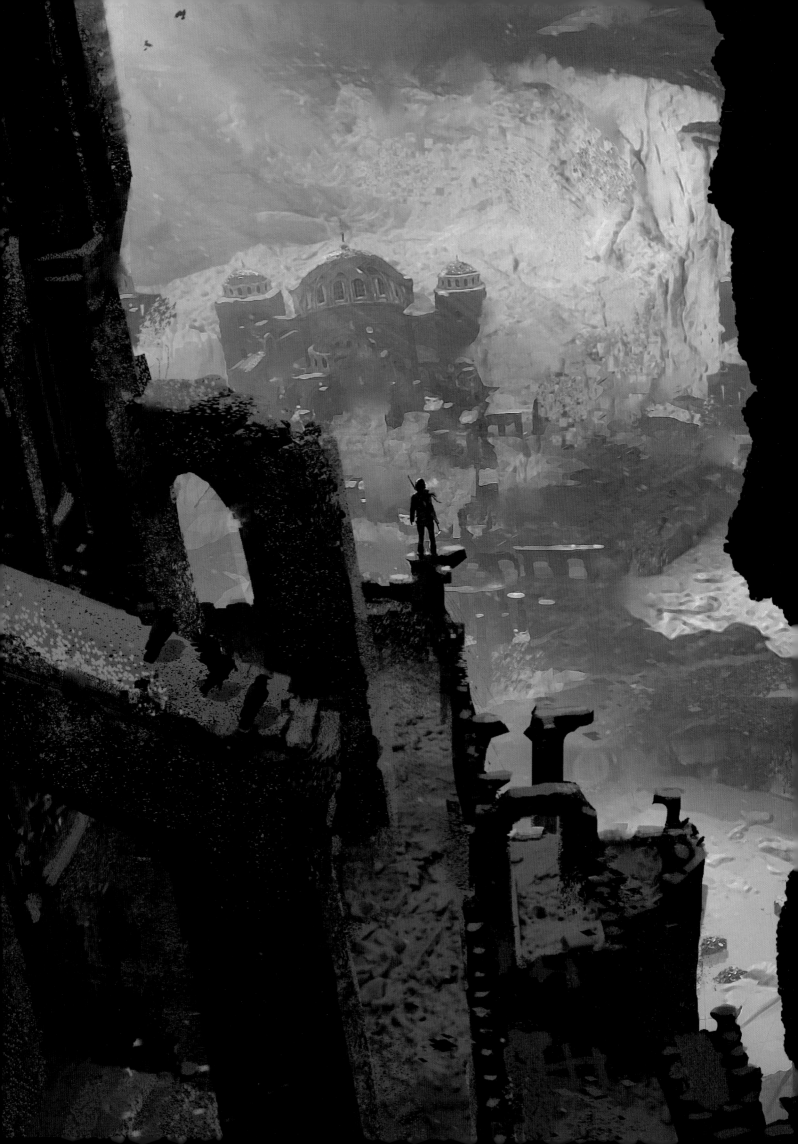

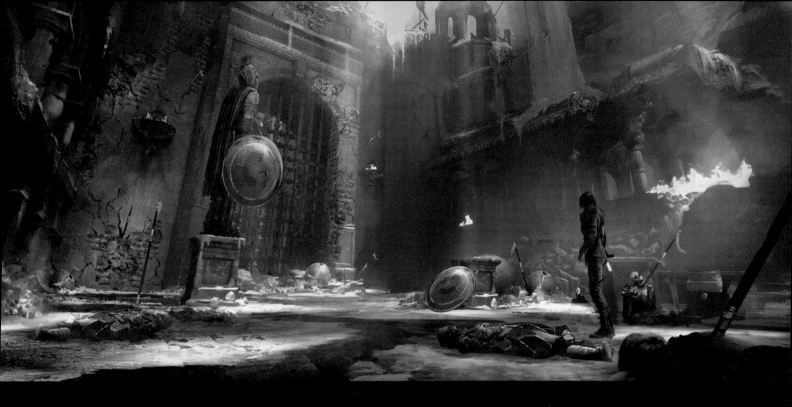

In the storyboards below, Lara scales the tower of an ancient temple to get a better grasp of her surroundings. It is a scripted event for the player, whose view above and below is also directed for the maximum sensation of vertigo. For design purposes, the rendering is done mostly in monochrome as this is a structural challenge that depends on successful route finding as opposed to admiring purely atmospheric special effects.

ABOVE: Art by Michael Baytion
BELOW: Art by Brenoch Adams
OPPOSITE: Art by Brandon Russell

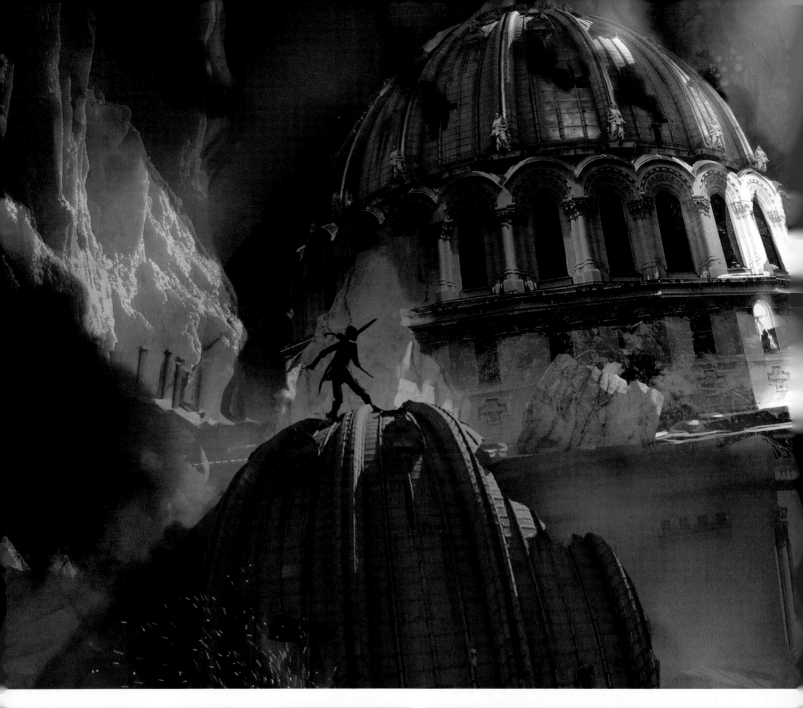

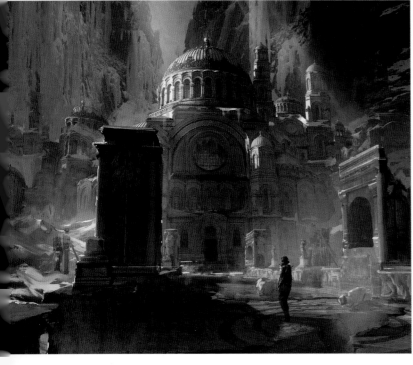

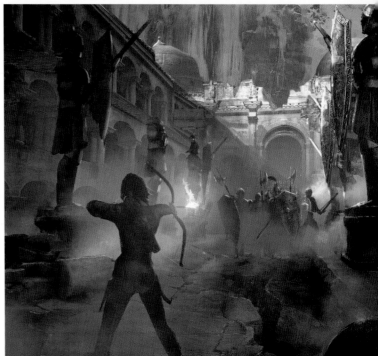

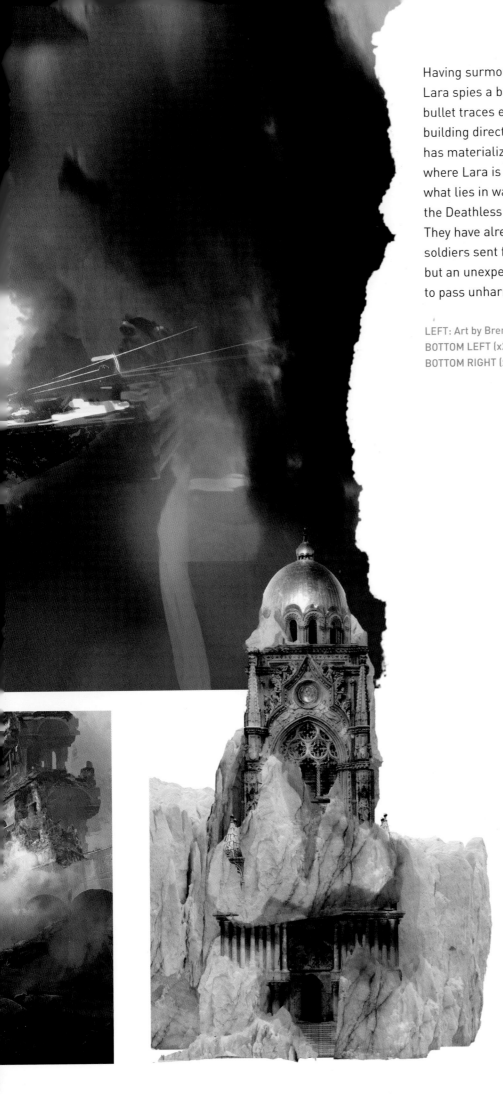

Having surmounted the burning tower, Lara spies a battle raging in the distance; bullet traces emerge from beyond the building directly opposite. A chilling secret has materialized just out of view, precisely where Lara is headed. Below, a glimpse of what lies in waiting: a ghoulish army called the Deathless Ones that serve the Prophet. They have already overwhelmed the Trinity soldiers sent for Lara and the Divine Source, but an unexpected turn of events allows Lara to pass unharmed.

LEFT: Art by Brenoch Adams
BOTTOM LEFT (x2): Art by Mark Castanon
BOTTOM RIGHT (x2): Tower designs by Brenoch Adams

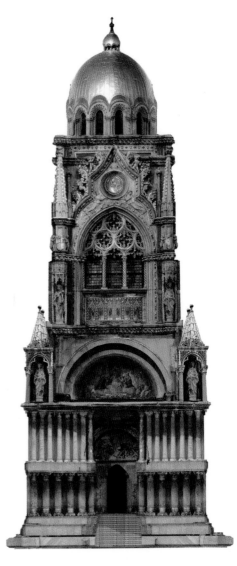

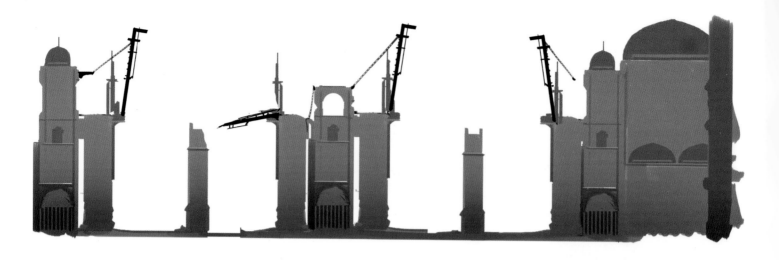

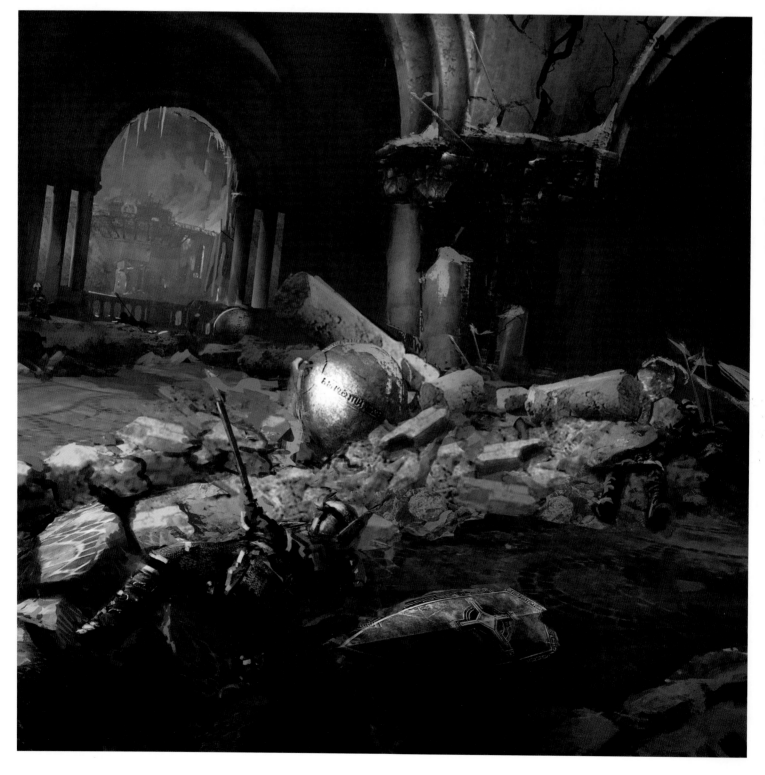

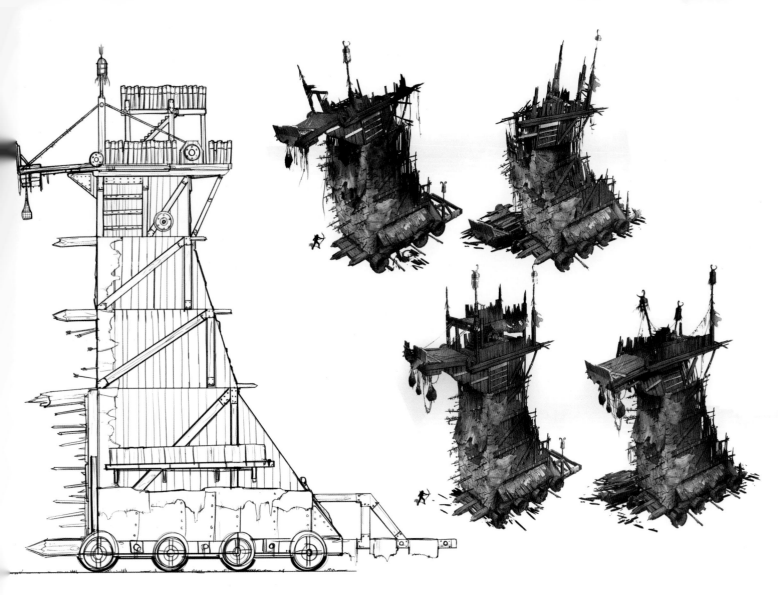

Ancient siege towers, trebuchets, and ballistas are explored in various stages of decrepitude and decoration, tools fit for a Deathless army. The ballista is an ancient weapon of war but still very effective. In the concept shown left, a Mongolian trap has shattered masonry and flattened soldiers caught in its path.

OPPOSITE TOP: Art by Brenoch Adams
OPPOSITE BOTTOM: Art by Nate Wells
TOP: Art by Mark Castanon
BOTTOM: Art by Brenoch Adams

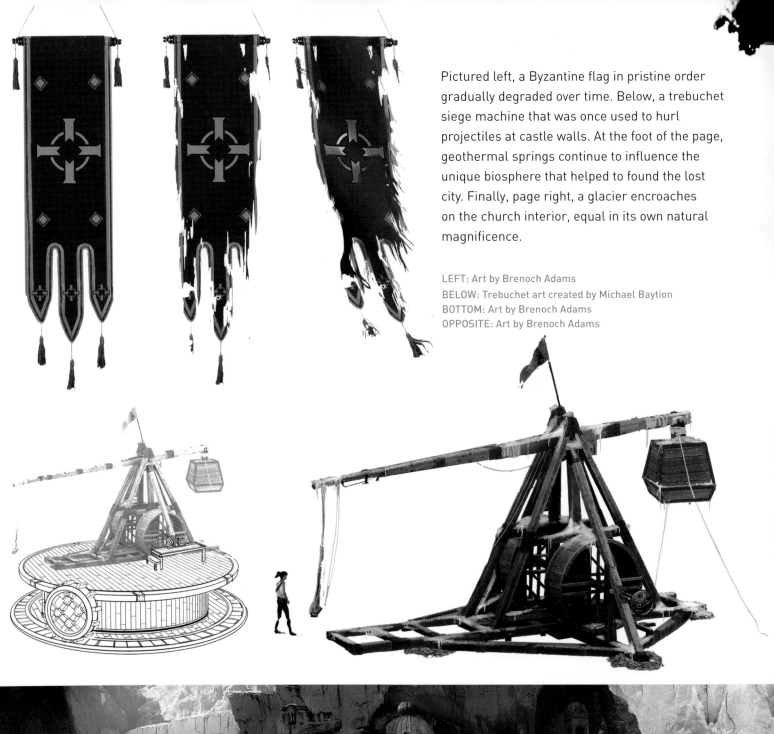

Pictured left, a Byzantine flag in pristine order gradually degraded over time. Below, a trebuchet siege machine that was once used to hurl projectiles at castle walls. At the foot of the page, geothermal springs continue to influence the unique biosphere that helped to found the lost city. Finally, page right, a glacier encroaches on the church interior, equal in its own natural magnificence.

LEFT: Art by Brenoch Adams
BELOW: Trebuchet art created by Michael Baytion
BOTTOM: Art by Brenoch Adams
OPPOSITE: Art by Brenoch Adams

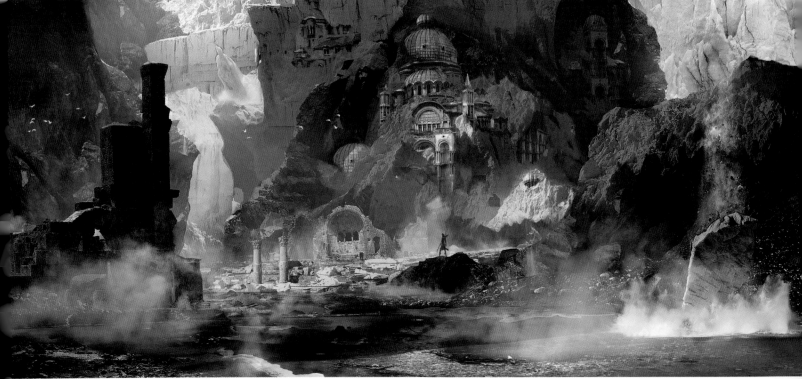

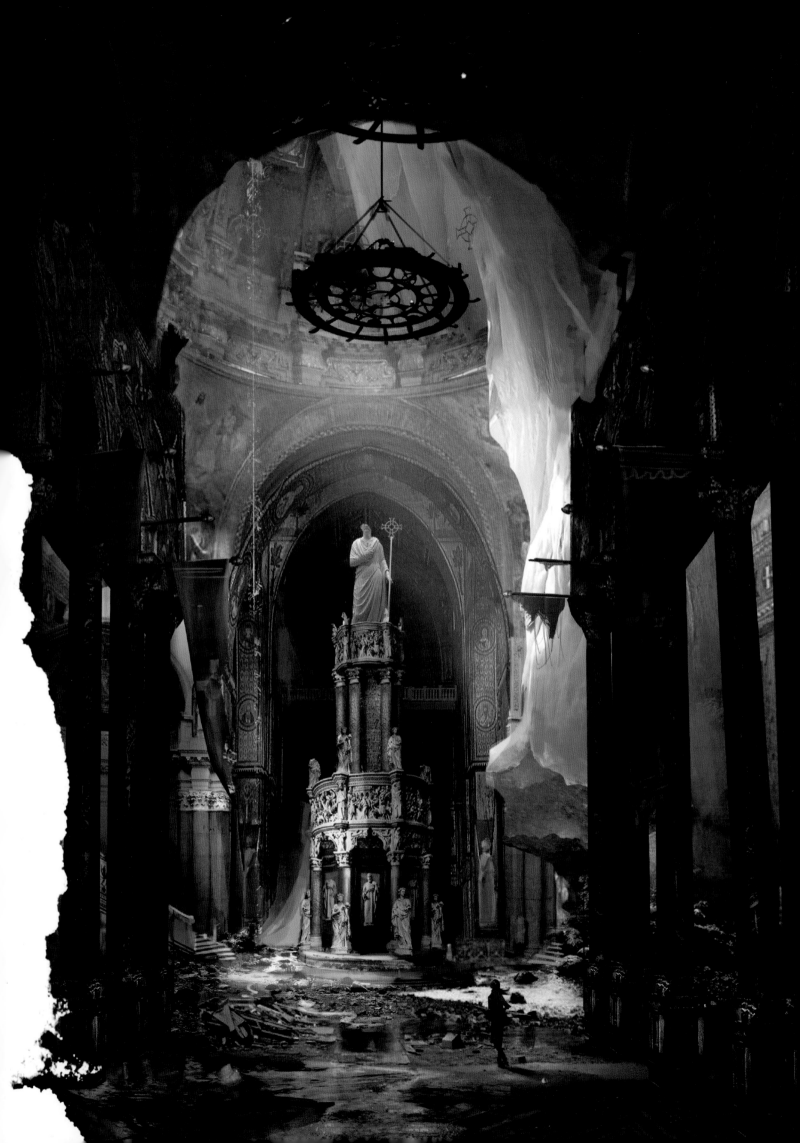

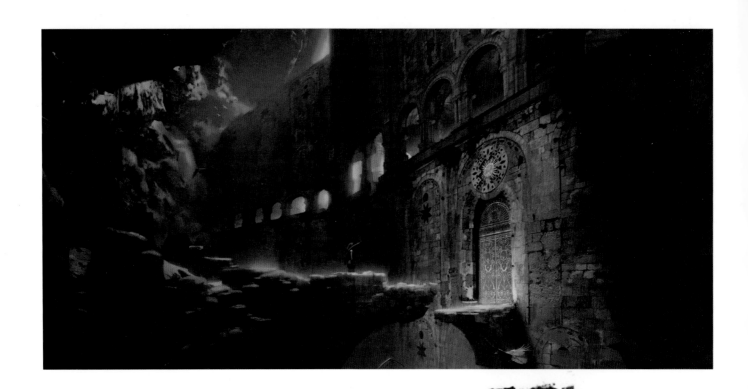

PATH OF DEATHLESS

The Deathless Ones are the hollow shells of Byzantine-era soldiers, kept alive by the ritual to make them immortal. Their only remaining motivation in existence is to protect the center of Kitezh, and the Chamber at its heart from invaders. The Remnant thinks of them as spirits in the ruins—both protecting and threatening. Their legend says that the Deathless Ones gave up their souls to protect their descendants, and are ever vigilant to make sure their sacrifice was not in vain. Many a disobedient Remnant child is kept in line by the threat of the Deathless Ones taking them away in the night. Remnant elders know that the Deathless Ones truly do haunt the darkness of the old cities, giving these places a wide berth.

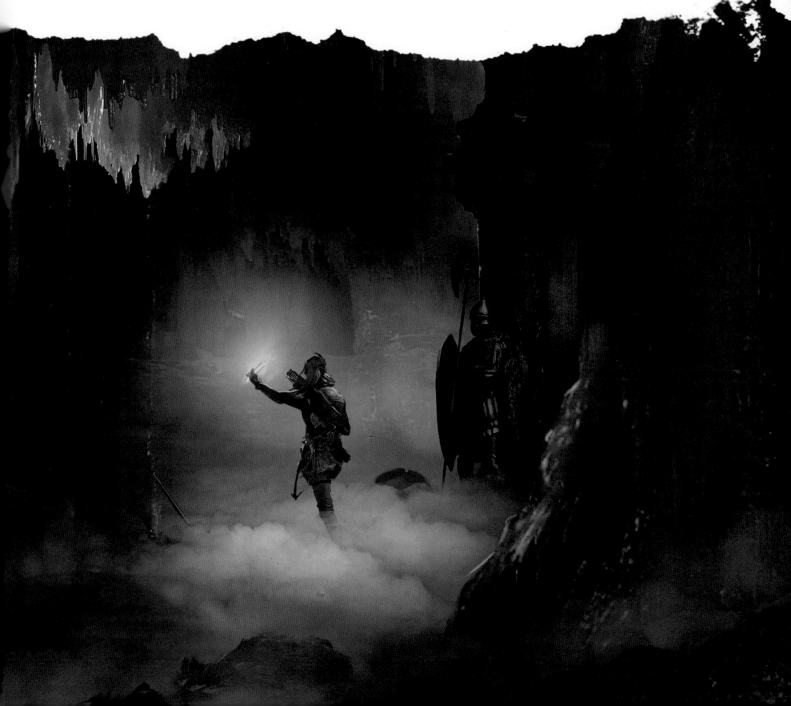

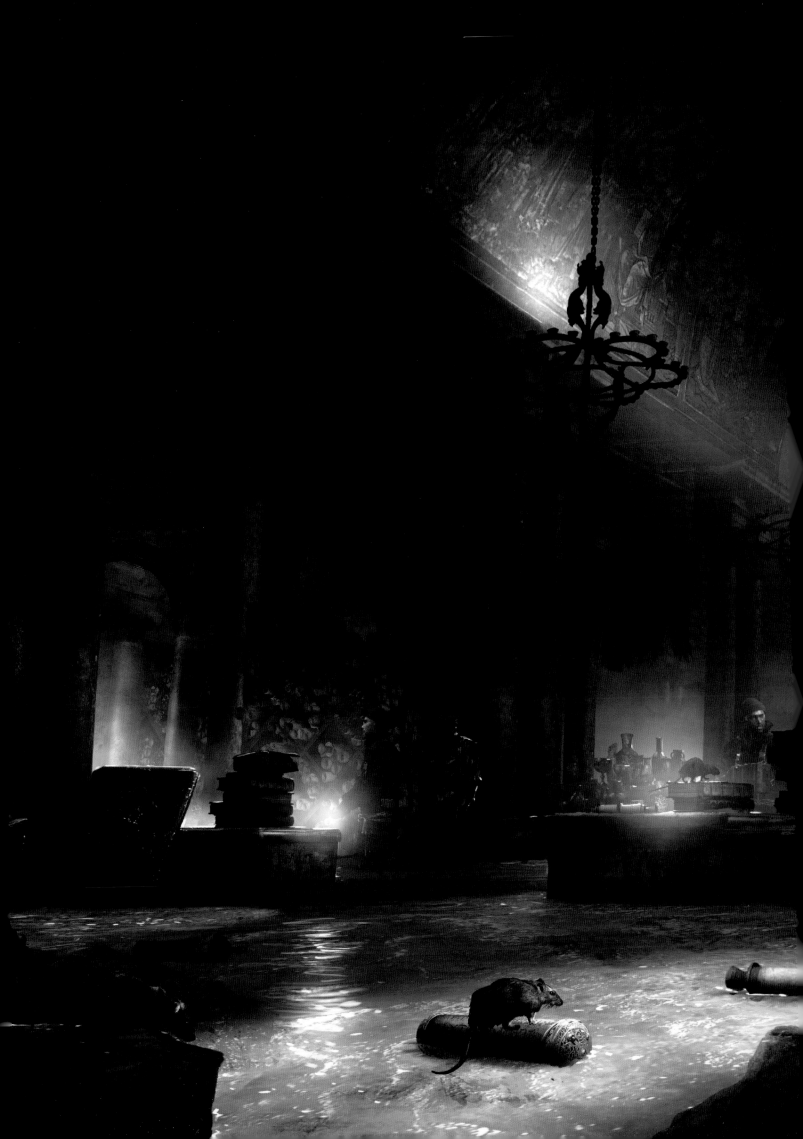

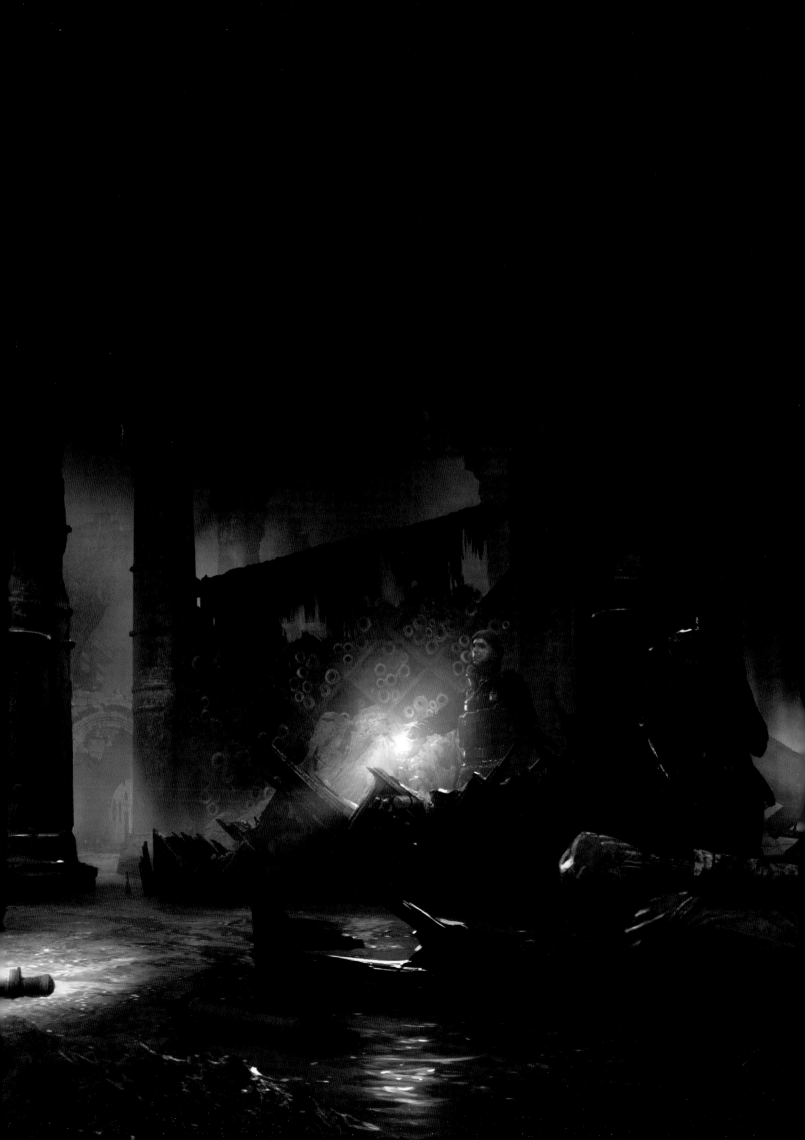

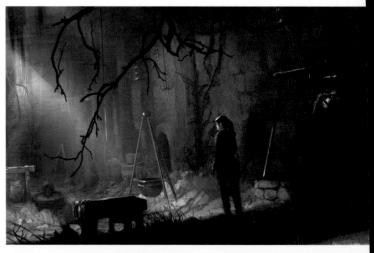

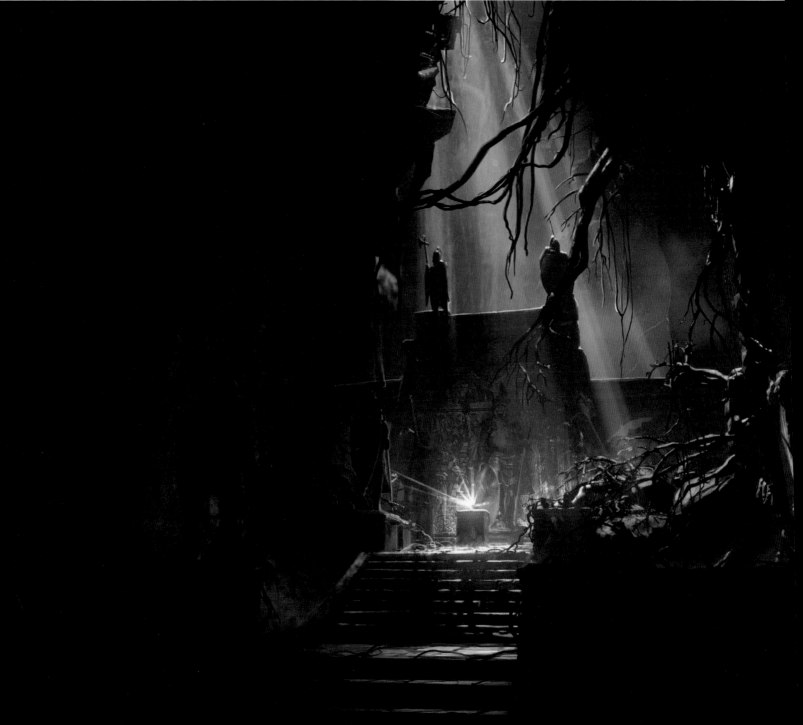

FLOODED ARCHIVE

The concept team's handwritten notes make the end product seem all the more incredible—from the most basic of line-drawings to extremely complex, interactive 3D models rendered in high-definition. Below, the working layout of the flooded archive, an ornate, treasure-filled chamber deep within Kitezh's heart. The Deathless Ones stalk the corridors of the archive, ever vigilant and ever ready to strike down intruders.

OPPOSITE TOP: Art by Brandon Russell
OPPOSITE BOTTOM: Art by Mark Castanon
BELOW: Sketches by Mark Castanon

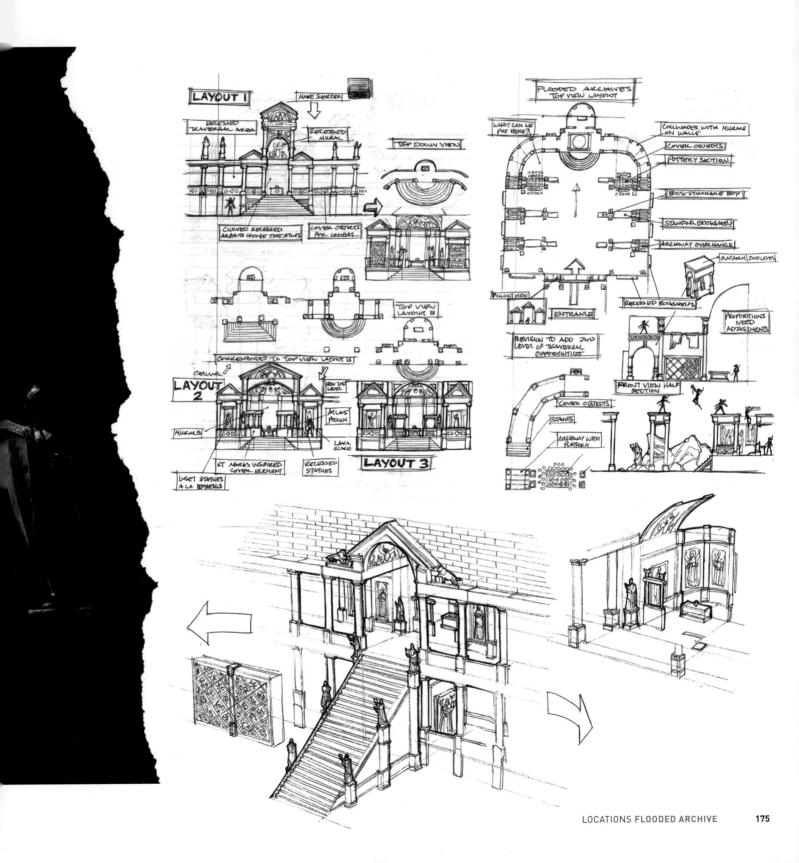

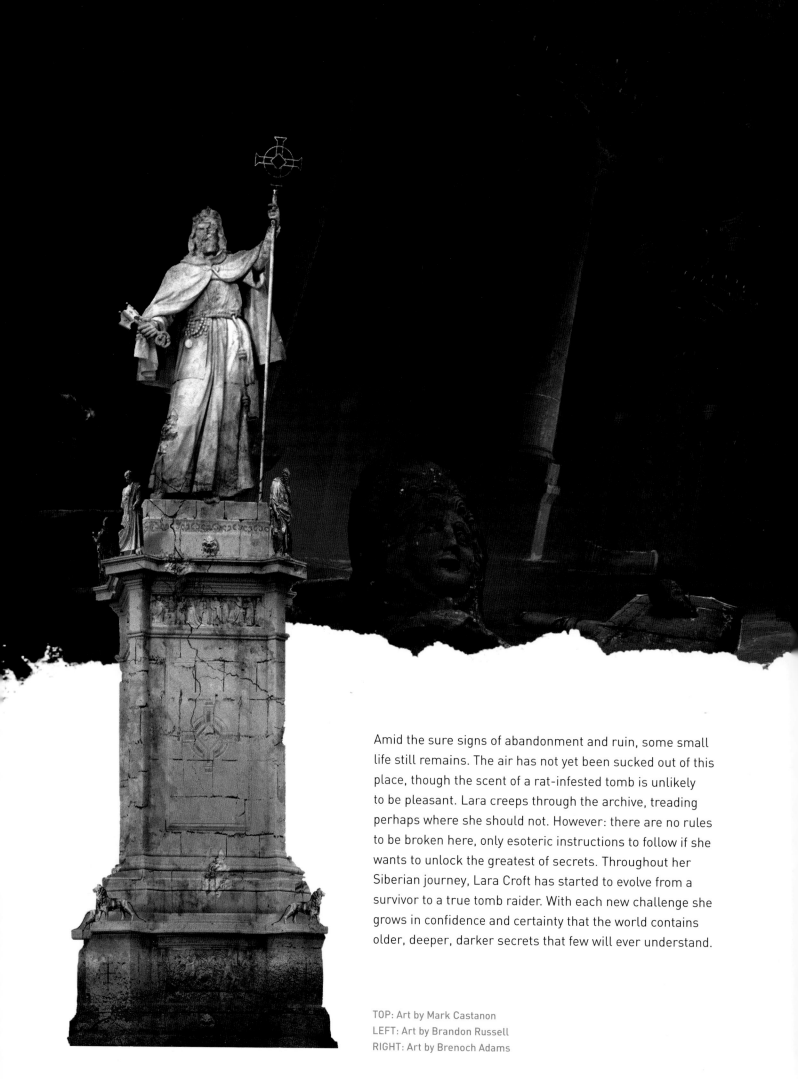

Amid the sure signs of abandonment and ruin, some small life still remains. The air has not yet been sucked out of this place, though the scent of a rat-infested tomb is unlikely to be pleasant. Lara creeps through the archive, treading perhaps where she should not. However: there are no rules to be broken here, only esoteric instructions to follow if she wants to unlock the greatest of secrets. Throughout her Siberian journey, Lara Croft has started to evolve from a survivor to a true tomb raider. With each new challenge she grows in confidence and certainty that the world contains older, deeper, darker secrets that few will ever understand.

TOP: Art by Mark Castanon
LEFT: Art by Brandon Russell
RIGHT: Art by Brenoch Adams

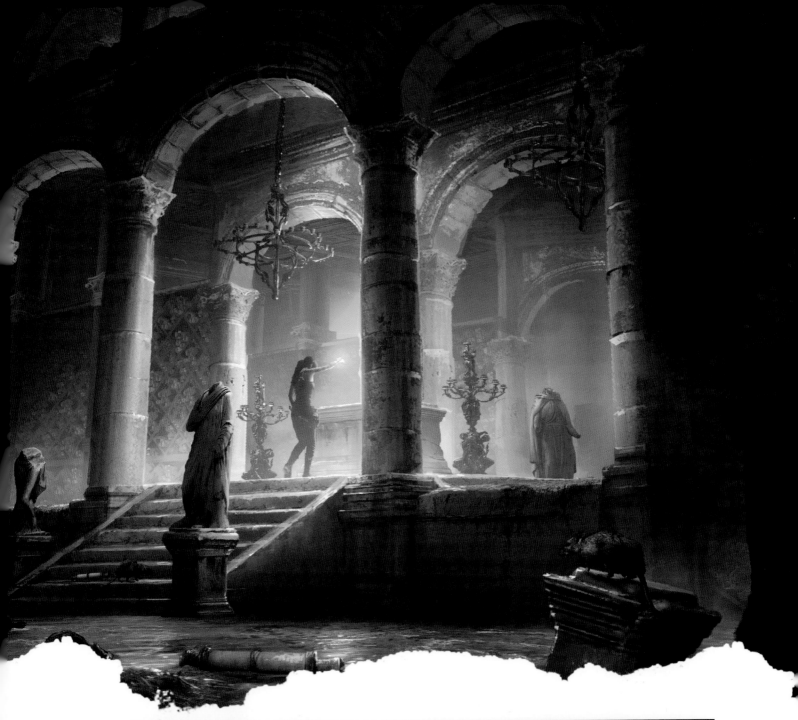

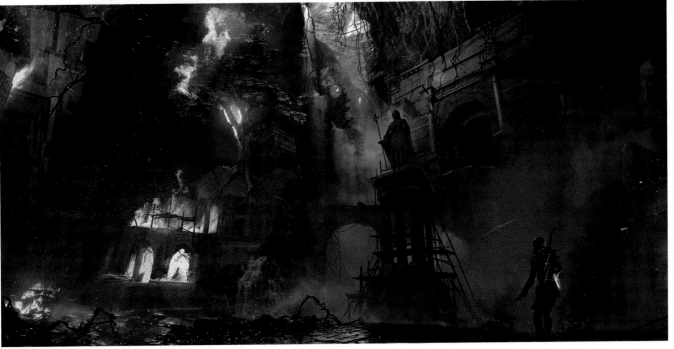

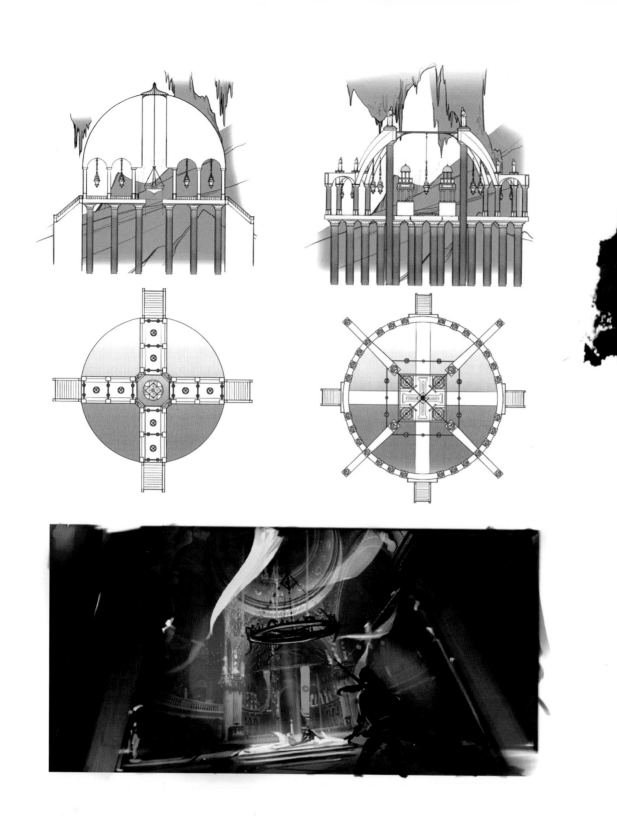

CHAMBER OF SOULS

The Chamber of Souls lies in the very center of Kitezh. Four pathways over vertiginous drops lead to the main suspended area, featuring a plinth with a glowing spherical object on it, covered by an ornate cloth. The entire room is adorned with religious imagery—including the Byzantine adaptation of the Christian cross. Without its fabled occupant, or any signs thereof, Lara's path seems to reach a dead end—but Lara is so close to uncovering the secret of the Divine Source, she must endure.

ABOVE: Art by Mark Castanon
OPPOSITE: Art by Brenoch Adams

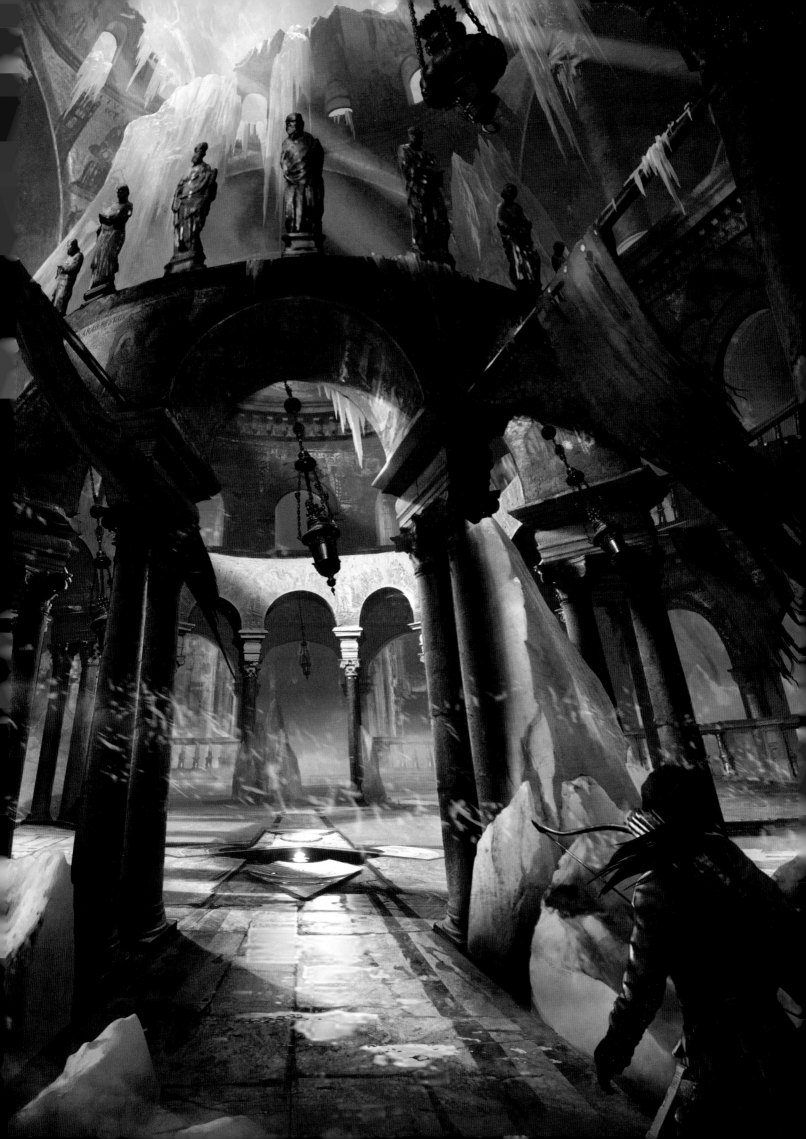

These pages show exploratory designs for the Chamber of Souls, with the various treatments based on Byzantine architectural themes. When fully realized, the development team intended players to step into an authentically Byzantine space. Rise of the Tomb Raider's art team worked throughout to the mantra 'credibility trumps spectacle', meaning that environments in the game should feel as though they legitimately exist somewhere in the world. Attention to detail in design was a core factor in realizing the game.

THIS SPREAD: Art by Mark Castanon

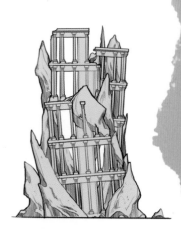

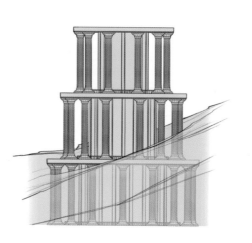

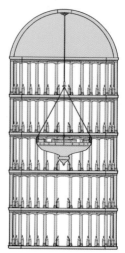

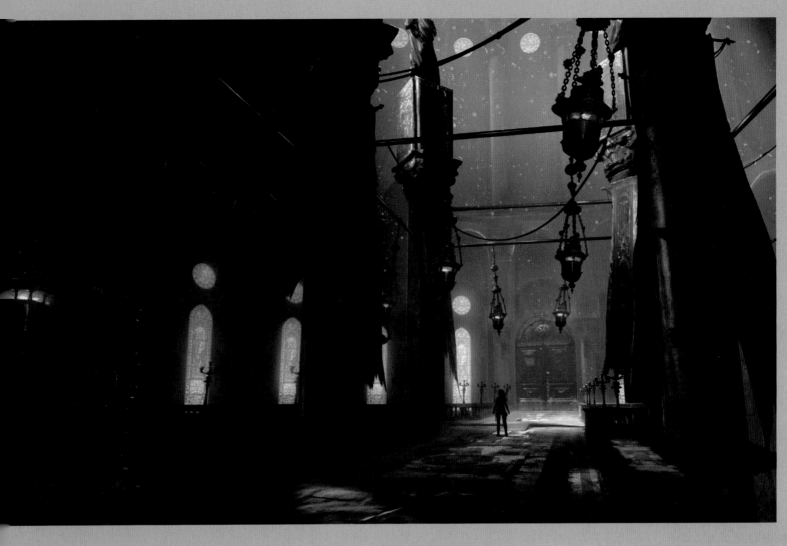

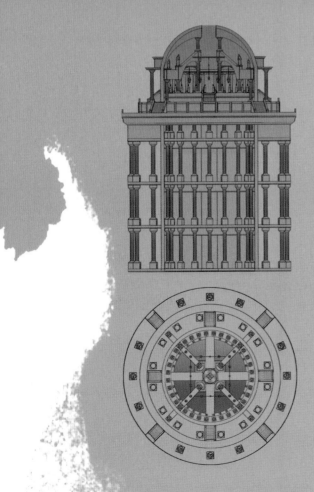

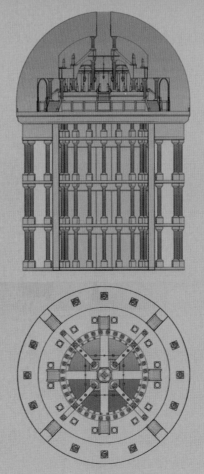

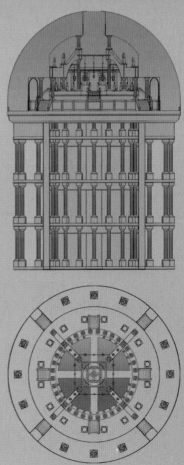

CHALLENGE TOMBS

Brenoch Adams says of the Challenge Tombs: "These are designed to be the most foreign and exotic areas in the game as opposed to the other spaces that are grounded in realism. We wanted to heavily incorporate the *Tomb Raider* fantasy into these spaces." Isolated examples of physics based riddles transfixed *Tomb Raider* fans in Lara's previous quests. Owing to their tricky nature, they became one of the most talked about features as friends discussed possible solutions and shared the joy of finally solving them. In *Rise of the Tomb Raider*, Crystal Dynamics modernizes and evolve these mechanics to create the most ambitious spaces they've ever created.

ABOVE RIGHT: Book art by Michael Baytion
OPPOSITE: Art by Richard Healy
BELOW: Art by Richard Healy
NEXT SPREAD: Art by Yohann Schepacz

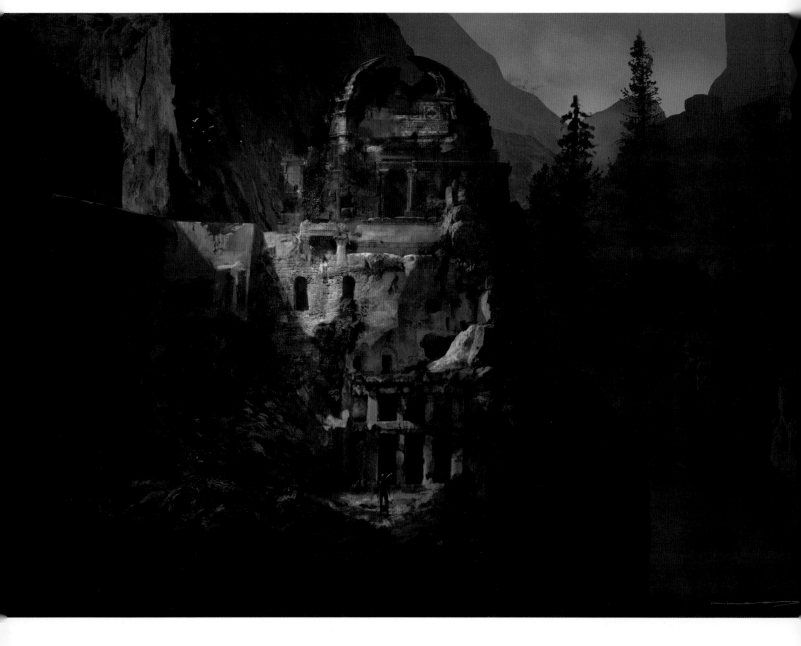

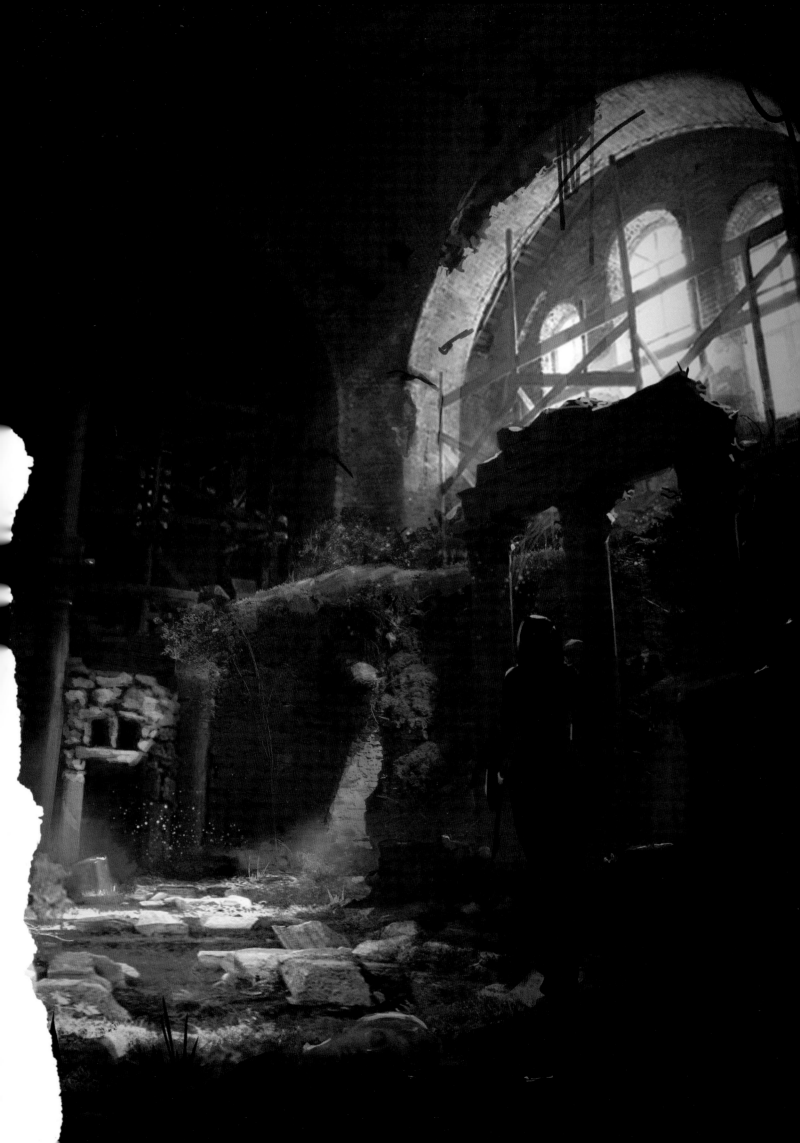

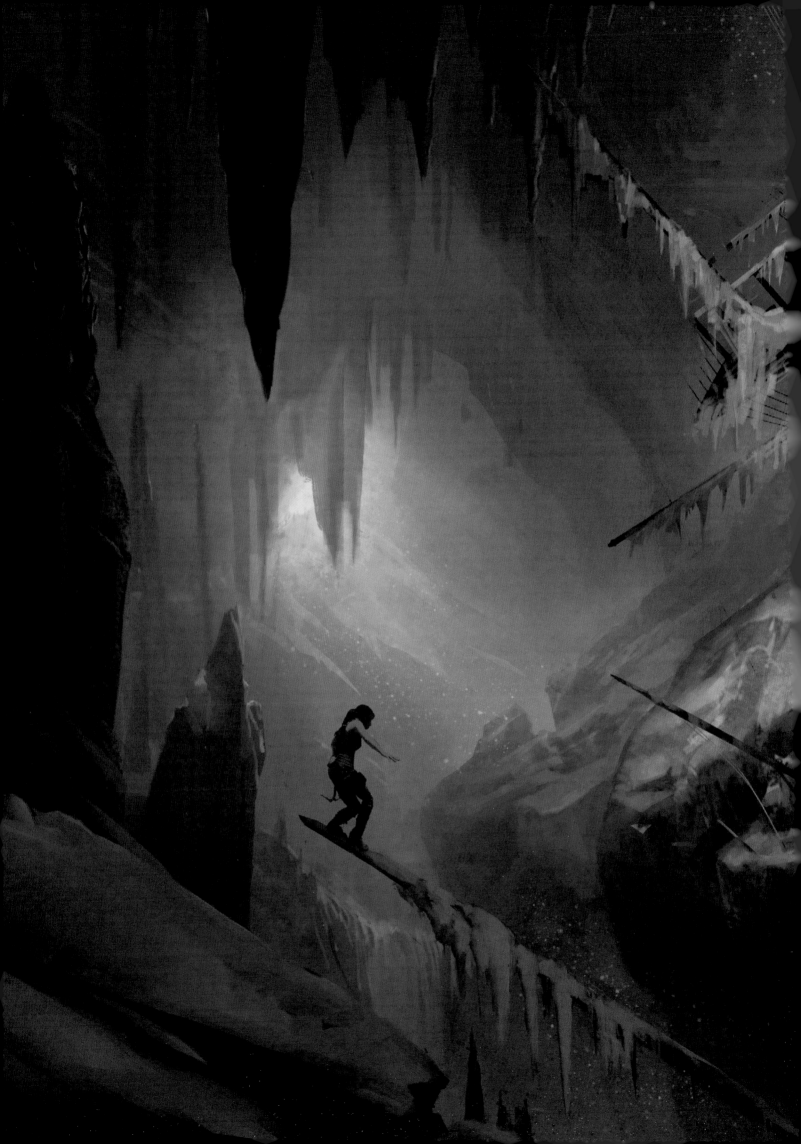

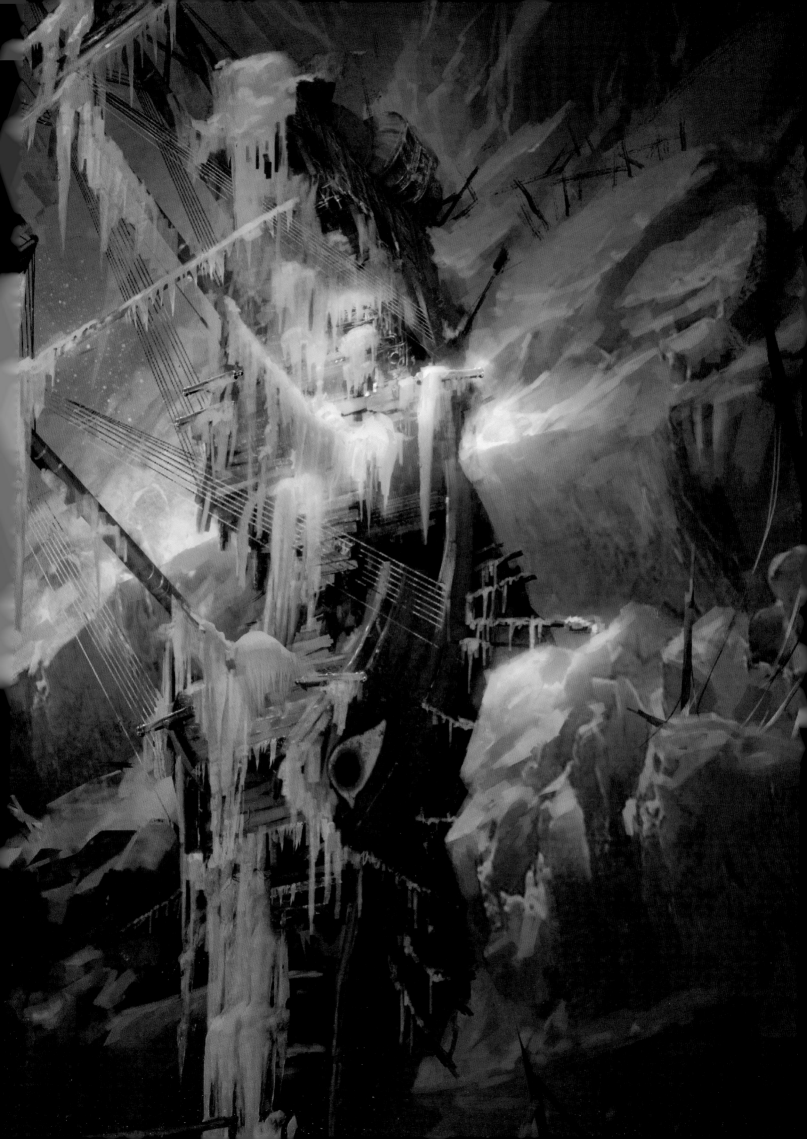

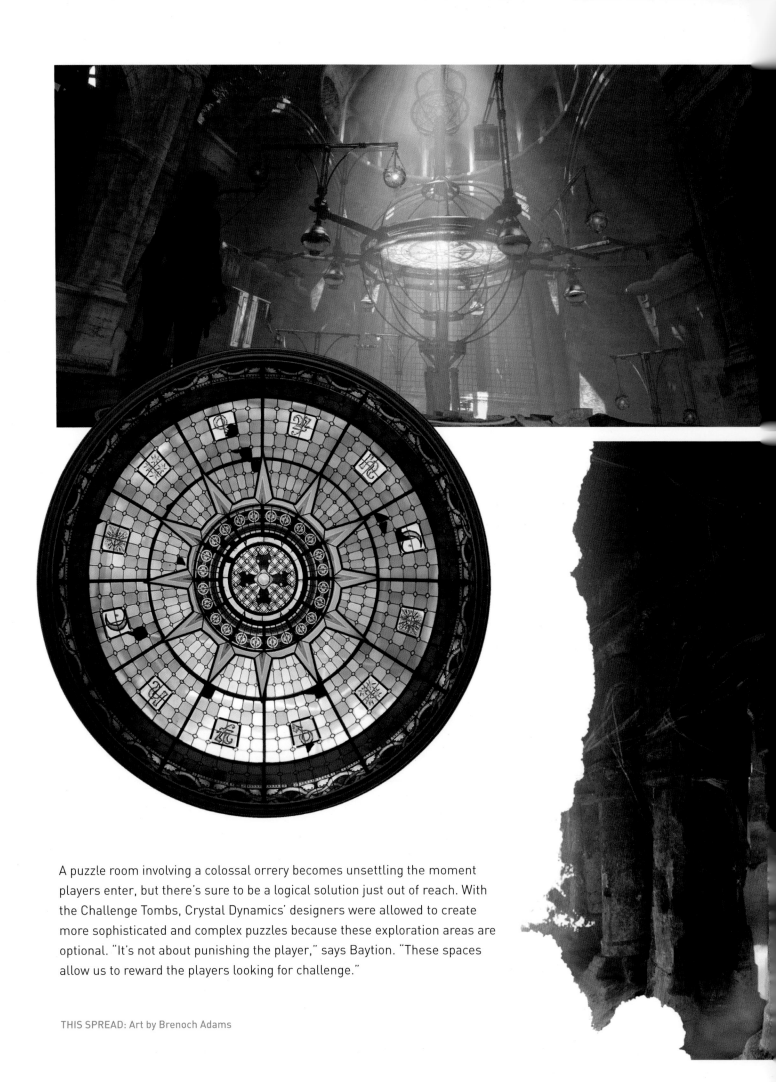

A puzzle room involving a colossal orrery becomes unsettling the moment players enter, but there's sure to be a logical solution just out of reach. With the Challenge Tombs, Crystal Dynamics' designers were allowed to create more sophisticated and complex puzzles because these exploration areas are optional. "It's not about punishing the player," says Baytion. "These spaces allow us to reward the players looking for challenge."

THIS SPREAD: Art by Brenoch Adams

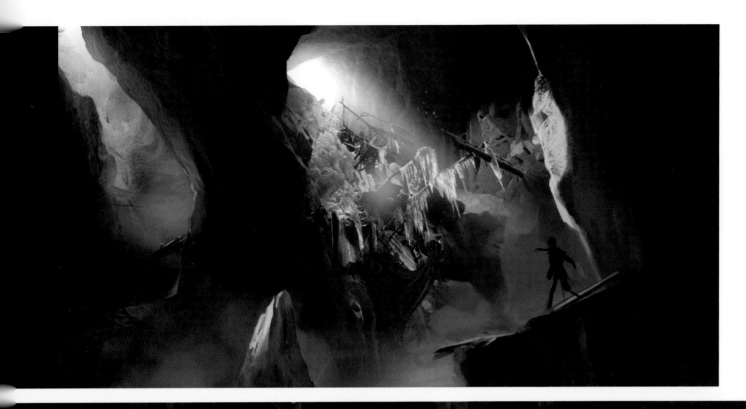

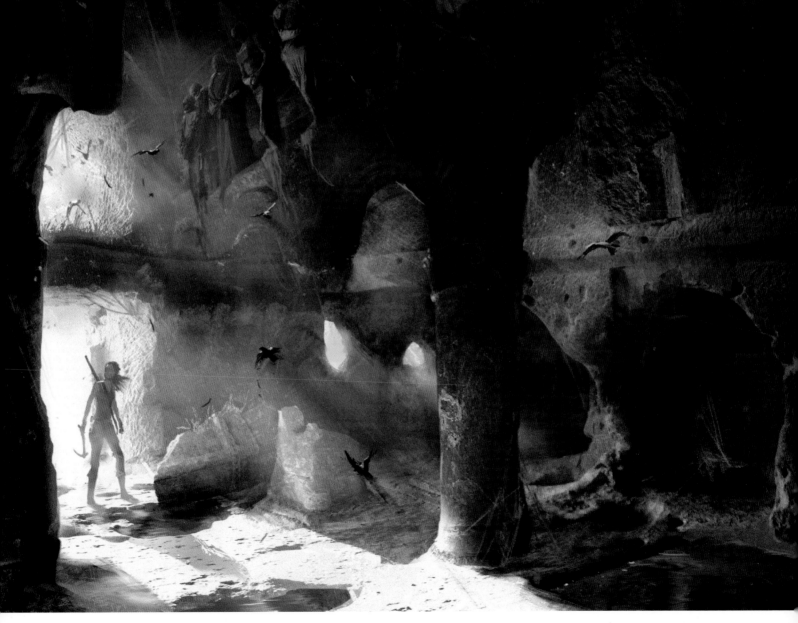

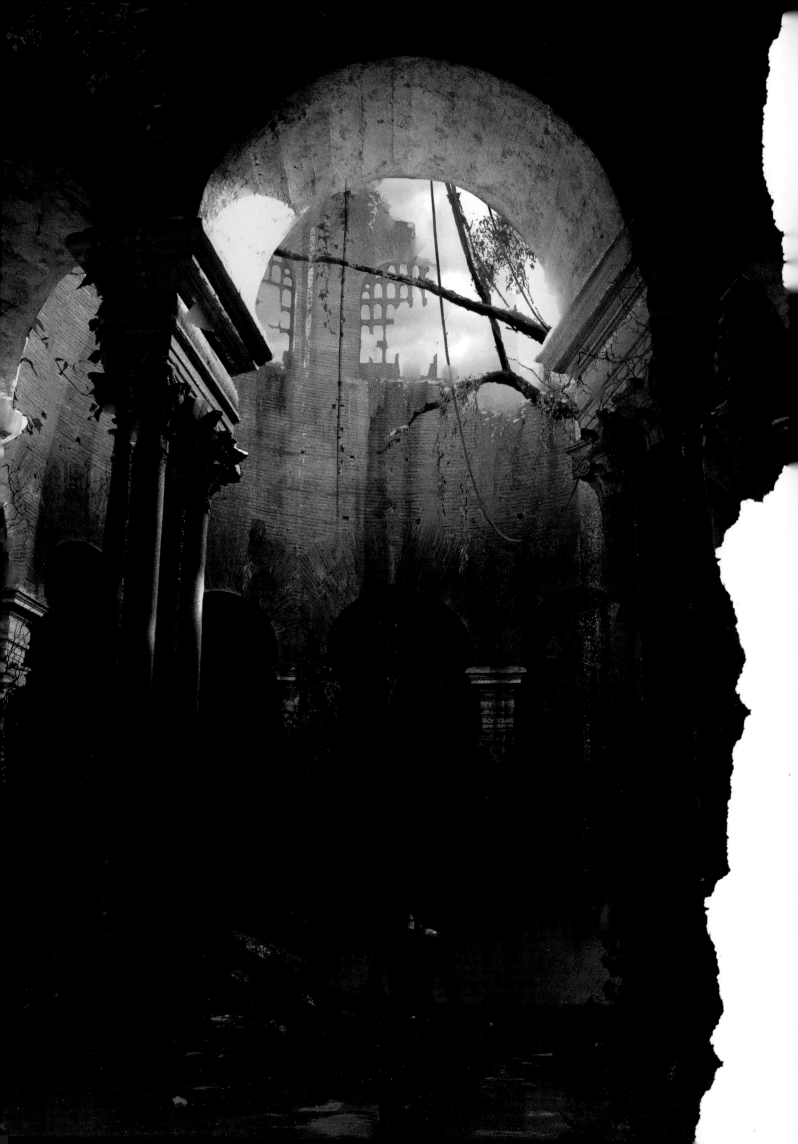

Just as solving the problem often becomes a social activity, their initial creation requires input from several sources in order for them to make sense. Virtual three-dimensional models are made to explain prop motion methods, such as peeling open an ancient podium with Lara's climbing axe. Mood lighting and stage setting for the final reward is also rendered in multiple ways, to test level atmosphere. Challenge Tombs are about living the moment, where actions speak louder than words, and time stands still (unless time is of the essence). They have distinguished Lara's indefatigable wits for almost two decades—and will continue to as her journey pushes her towards becoming the Tomb Raider.

OPPOSITE: Art by Brandon Russell
BELOW: Pedestal art by Brenoch Adams
BOTTOM: Art by Yohann Schepacz
NEXT SPREAD: Art by Brenoch Adams

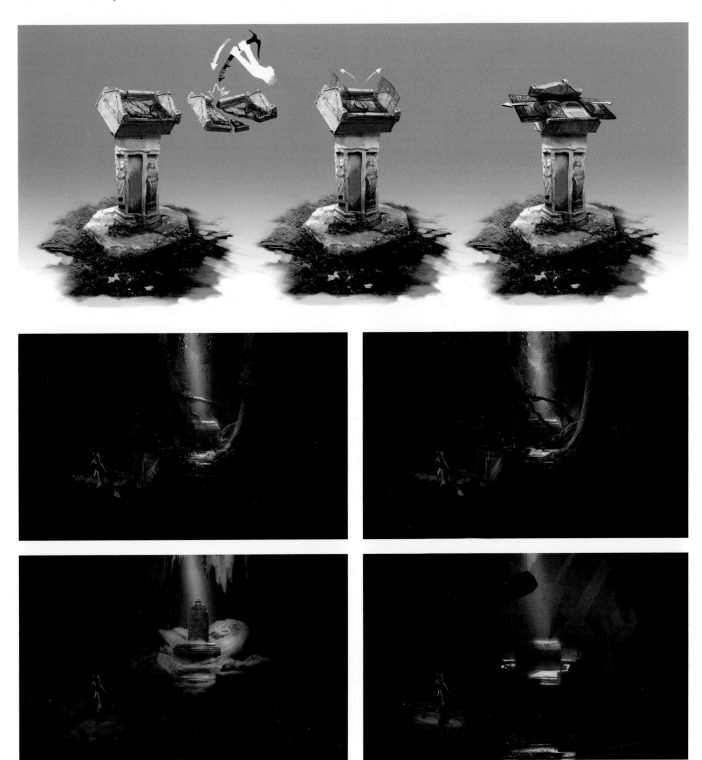

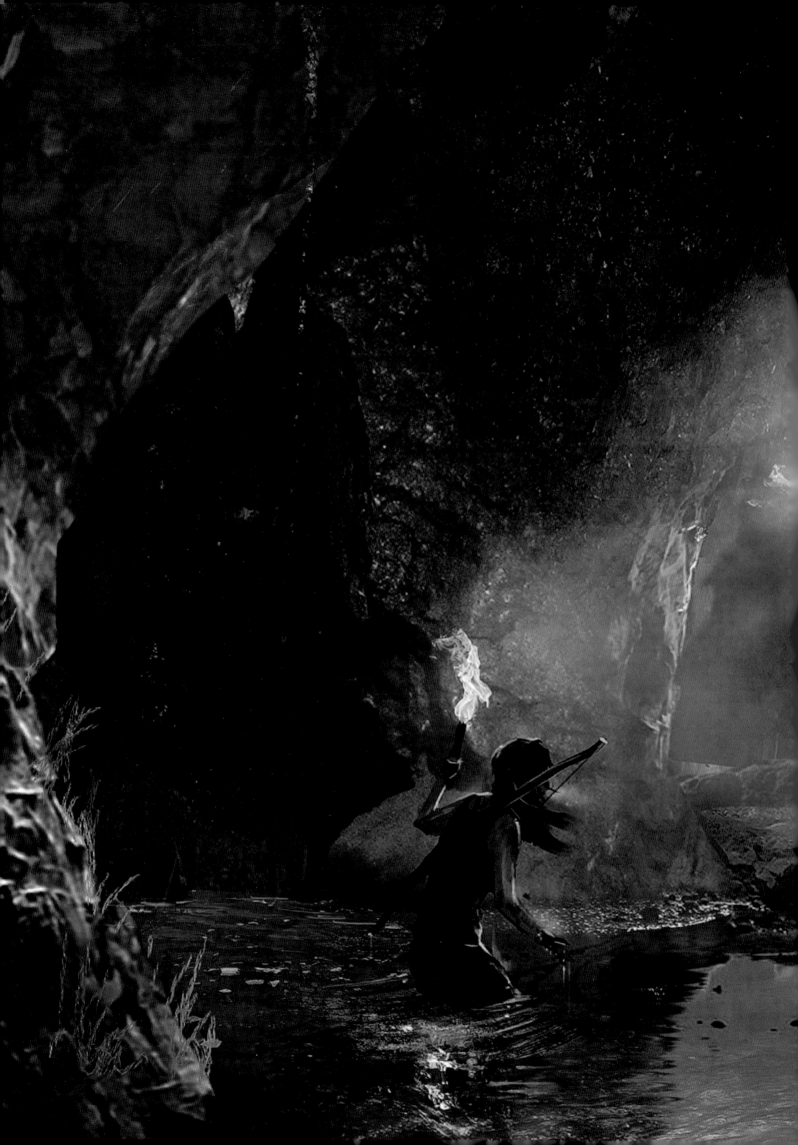

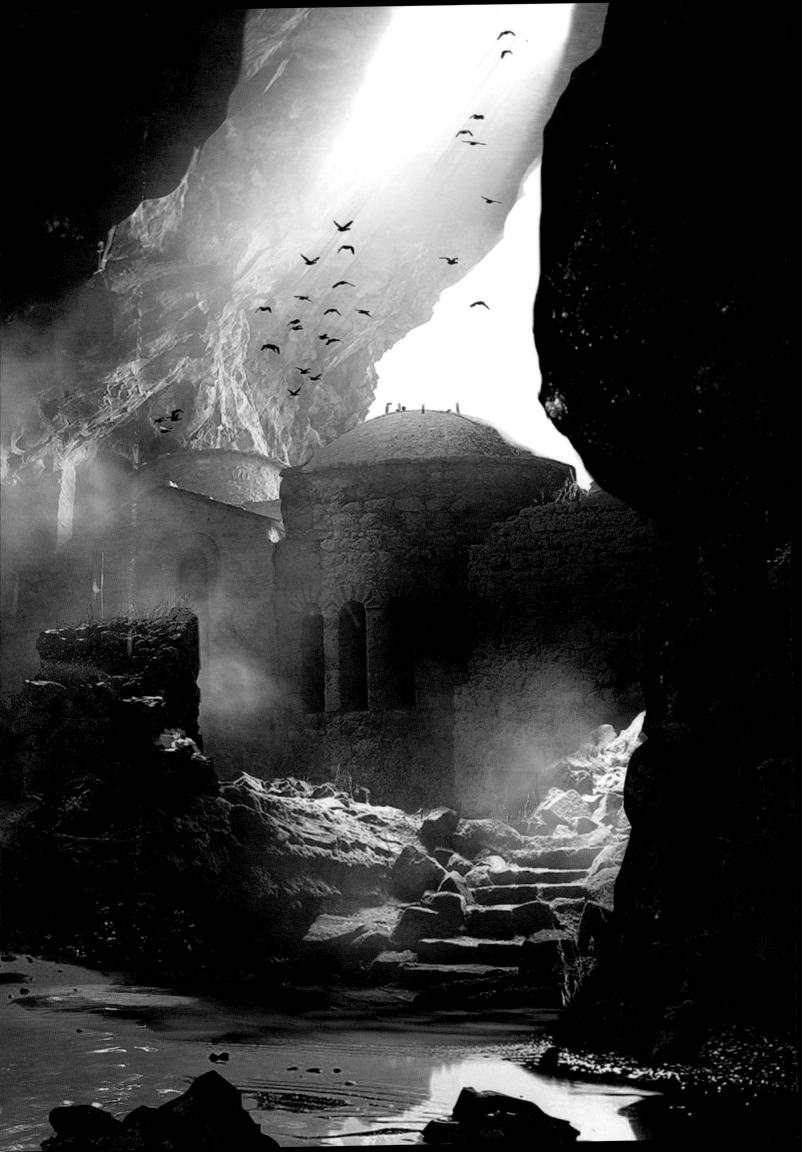

ACKNOWLEDGMENTS

This book is a collection of the art that was created to inspire Lara's journey and the *Tomb Raider* franchise. Our goal was to push exploration, discovery, and puzzles, all things that are nostalgic to the franchise, but now built through our modern, survival lens. This book is dedicated to the talented team at Crystal Dynamics for their passion and commitment, and to our fans for their dedication and support.

ART TEAM CREDITS

Brenoch Adams • Jeffrey Adams • Joshua Bapst • Matthew Bard • Christopher Bartlett • Michael Baytion • Leonardo Braz da Cunha • Mark Castanon • Dannie Carlone • Joel Crook • Norman DeYoung • Richard Healey • Sze Jones • Scott Kennedy • Heather Knudsen • Matthew McCulloch • Richard Pau • Zachary Perez • Aubrey Pullman • Brandon Russell • Louis-Philippe Sanschagrin • Yohann Schepacz • Reed Shingledecker • Patrick Sirk • Caleb Strauss • Paul Svoboda • Mike Svymbersky • Nicole Tan • Osvaldo Villa • Michael Viscio • Mark Wahlquist • Kam Yu •